FERNANDO

BOTERO

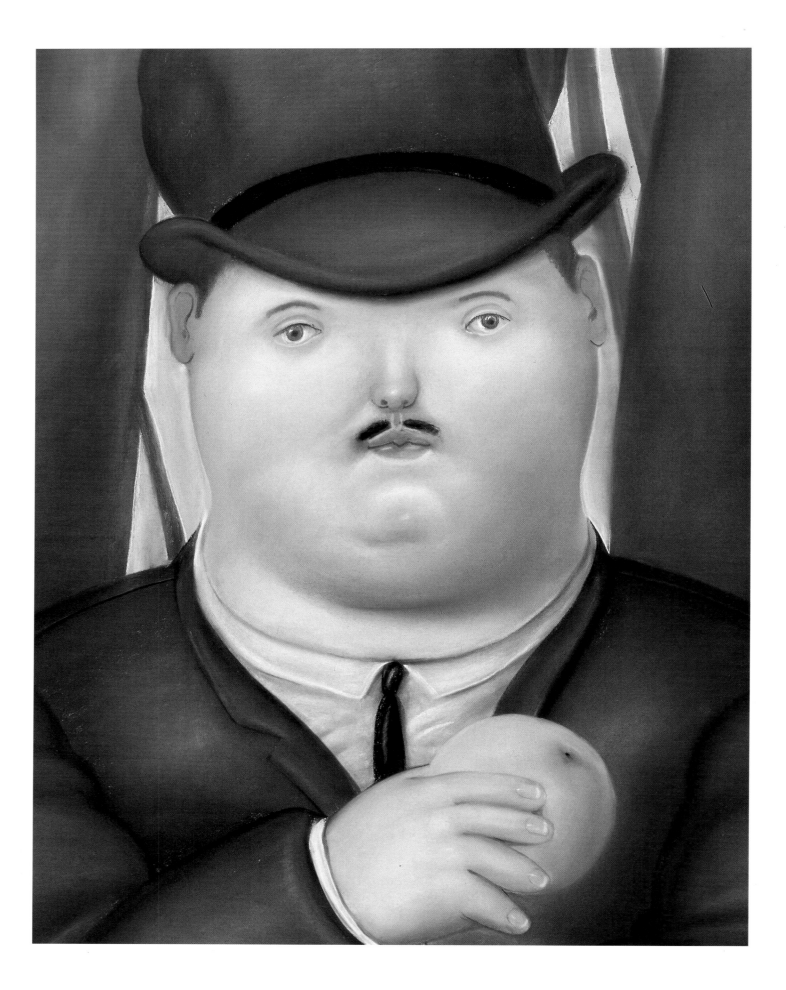

FERNANDO BOTERO

Paintings and Drawings

Edited and with an introduction
by Werner Spies

With six short stories by
the artist

Prestel

This book is partly based on the German edition,
Fernando Botero: Bilder, Zeichnungen, Skulpturen,
published by Prestel in 1986
in conjunction with the exhibition of that name held
in Munich, Bremen, and Frankfurt am Main

© 1992 by Prestel-Verlag, Munich, 1997
© of works by Fernando Botero by the artist
Photograph Credits: p. 180

The interview on pp. 154-64 was conducted by
Peter Stepan on May 8, 1986, in Munich

Introduction translated from the German by John William Gabriel
Biographical Notes translated from the German by John Ormrod
Short stories translated from the Spanish by Alison Hughes

Front cover: *The Letter,* 1976 (detail of plate 29)
Back cover: *Still Life with "Le Journal",* 1989 (plate 97)
Frontispiece: *Man,* 1969 (detail of plate 9)

Library of Congress Cataloging-in-Publication Data

Botero, Fernando, 1932–
Fernando Botero : paintings and drawings / edited and with an introduction by Werner Spies : with six
short stories by the artist.
p. cm.
"This book is partly based on the German edition, Fernando Botero, Bilder, Zeichungen, Skulpturen,
published by Prestel in 1986 ..."–
– T.p. verso.
Includes bibliographical references and index.
ISBN 3-7913-1810-1 (pbk.)
1. Botero, Fernando, 1932– . 2. Short stories, Colombian.
I. Spies, Werner. 1937– . II. Title.
N6679.B6A4 1997
97-3598
759.9861—dc21

Prestel-Verlag, Mandlstrasse 26, D-80802 Munich, Germany
Tel. (89) 38 17 09-0; Fax (89) 38 17 09-35
and 16 East 22nd Street, New York, NY 10010, USA
Tel. (212) 327-8199; Fax (212) 927-9866

Prestel books are available worldwide. Please contact your nearest
bookseller or write to either of the above addresses for information
concerning your local distributor

Printed in France

ISBN 3-7913-1810-1

Contents

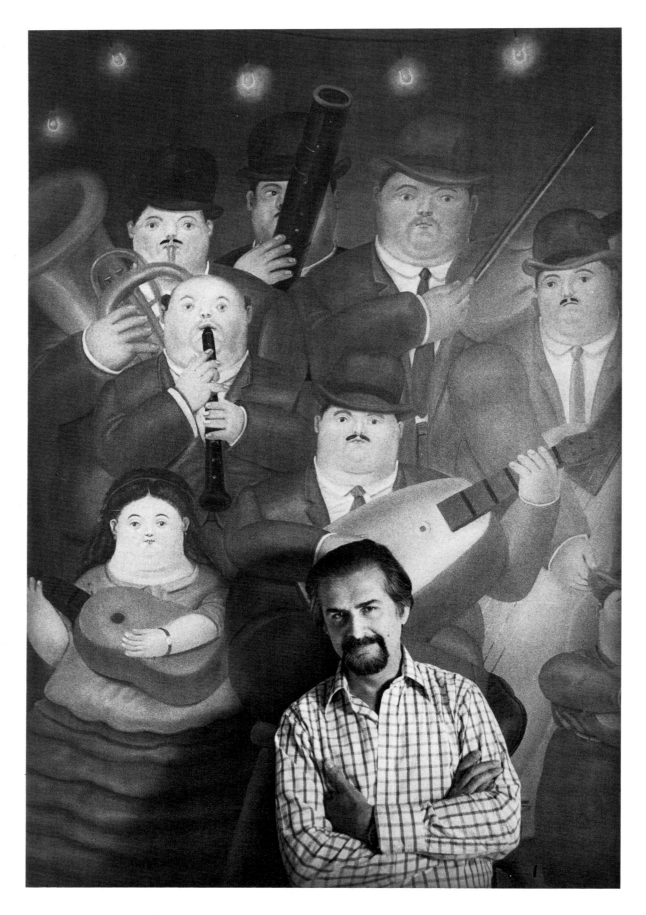

Fig. 1 Botero with his painting *The Musicians*, 1977

WERNER SPIES

An Introduction to the Art
of Fernando Botero

FERNANDO BOTERO'S development can now be traced back over a period of decades. His oeuvre encompasses a great variety of themes: self-portraits, portraits, nudes, loving couples, bishops, cardinals, saints, military men, still lifes, bordello scenes, bullfights, landscapes. Other subjects have been developed out of the still lifes of the Spaniards Luis Meléndez, Zurbarán, and Cotán or the Dutchman Heda. These are supplemented by continually fresh variations on works by such other earlier masters as van Eyck, Dürer, Rubens, Velázquez, Rigaud, Bonnard, and Cézanne. The enjoyment of storytelling apparent in many of his paintings can be compared to the narrative Baroque panels of his South American homeland.

The paintings have been accompanied by drawings, large-format red chalk or charcoal drawings alternating with pastels, works in pen and ink, or watercolors. Finally, over the past decade or so Botero has translated a number of his motifs into the three-dimensional terms of sculpture.

One thing becomes obvious from the evolution of Botero's oeuvre: his temperament is not of the nervous type that reacts seismographically to every tremor of the art scene. The persistence and imperturbability with which, from the outset, he has followed his chosen path have probably contributed to the mistrust that so many critics have felt toward his oeuvre. His imagery is not easily related to avant-garde movements of the 1950s and 1960s; in fact, it seems virtually inoculated against their influence. Despite his very early success in Europe, Botero ran up against great obstacles to acceptance on the American art scene, as the history of the reception of his work amply indicates. In none of the many descriptions of New York painting, in not one of the so compendious lexica devoted to artists of the United States and the New York School, does the name Botero occur. His achievement is passed over in silence—and this despite the fact that works of his entered the collections of the Museum of Modern Art, the Metropolitan Museum, and the Guggenheim Museum at a very early date. Botero spent thirteen years of his life in New York. Perhaps the best description of his situation there is given by fellow artist Grace Hartigan: "I thought he had a unique vision, and that he was quite brave in preserving it and being solitary This showed great strength. He was a remarkable young talent The abstract artists in New York hated his work. I defended him, just as I did Francis Bacon."

RESISTANCE TO "COSMOPOLITAN ARROGANCE"

Botero's biographer, Germán Arciniegas, blames these circumstances on the "cosmopolitan arrogance" of the New York critics, and quotes, as an example of the truly rabid rejection of his work, the *Art News* reviewer who likened his figures to "fetuses begotten by Mussolini on an idiot peasant woman."

It speaks in favor of Botero that, in spite of absolute isolation and a conspiracy of silence, he made no attempt to swim with the stream and adopt the expressionist gesture which was then so *de rigueur*. He kept company with very few artists in New York; most of his friends, like himself, were natives of South or Central America, and they

faced, as Cynthia Jaffee McCabe remarked, "special discrimination in a city that dismissed anyone with a Spanish accent as 'Puerto Rican.'" Being a Latin American in New York was not the only handicap Botero had to contend with. As he later recalled: "If you weren't Abstract Expressionist, you were not a painter, you didn't exist. Everyone was against me. I didn't have friends, the whole atmosphere was hostile. And, of course, when you are struggling so hard against the whole thing, you don't have any strength to do your own work. When everyone's against you, you are working in empty space."

Certainly the explanation is not to be found solely in the circumstance that Botero stood his ground in the face of Abstract Expressionism and practiced a figurative, and thus seemingly anachronistic, art: he was by no means the only artist to turn to figuration at that time, yet no other suffered such extreme isolation. It had to do with the content of his painting. As Vargas Llosa has emphasized, Botero advanced a visual polemic, in the form of "grandiose fullness," against the prudish denigration of the human body that is prevalent in the Anglo-Saxon Protestant world: "Seeking beauty in thinness is Western and modern, probably an Anglo-Saxon prejudice which certainly derives from Protestantism." Vargas Llosa refers to the association, still common in Spanish-speaking countries, of *hermosa* (beauty) with the roundness of a handsome, well-nourished person. Botero's figuration, as even the earliest reactions indicate, was just as provoking to the Puritan mind as Dalí's or Buñuel's exaltation of the flesh. Something of Dalí's necrophiliac fascination with "edible beauty" is indeed found in Botero's deliciously prepared figures. This obsessive and sensual communion of artist with model informs one of Botero's short stories, "The Painter and his Delicious Model" (pp. 174–75).

Today we are able to begin seeing Botero's oeuvre in a larger context. It represents one facet of the resistance, which has been apparent for years, to an avant-garde art that has all too frequently become academic, repetitive, and noncommittal. More than most contemporary artists, Botero has accepted the challenge posed by the art of the museums. This is not to say that he has succumbed to that brand of eclecticism that treats the art of previous ages as a grab bag from which elements for a picture can be picked at random. The subjects and stimuli Botero derives from early Italian or Spanish painting or from Dürer undergo a transformation in his hands. As he himself once said about the provocation through existing art which every artist requires: "Art emerges from a divergence from the stylistic norms of its era, and of every era. The true artist needs a divergent form of expression, and in a sense his significance will stand in direct relation to his resistance and his protest. That is why art is a permanent revolution." In Botero's case, the revolution is conducted in a conscious and intellectually well-founded manner; he is right when he calls himself one of the most serious painters alive today. His sense of responsibility in face of the history of art, he says, is well-nigh oppressive. One does well to keep this in mind when reviewing Botero's oeuvre.

In conversation he is careful to emphasize that the obvious and shocking deformation in his imagery arises from aesthetic necessity. As paradoxical as it may sound, this ubiquitous tendency to deformation can best be compared to that of Giacometti. The incessant repetition of emaciated thinness in Giacometti's figures absorbs the satirical aspect of a treatment of the human figure the social and psychological associations of which have been established since Grandville, Daumier, or Wilhelm Busch. Both artists, Botero as well as Giacometti, seek by dint of repetition to transform a divergence from the norm into the normal state of things. This unlikely comparison of two such different artists may be rendered more feasible by the fact that Botero, too, seeks to express himself as radically as possible. As he himself puts it, the search for a style, the development of a style, automatically leads to radicality. And this is what he admires so much about Giacometti, for Botero knows—and these, again, are his own words—that nothing is more difficult than to *remain* radical.

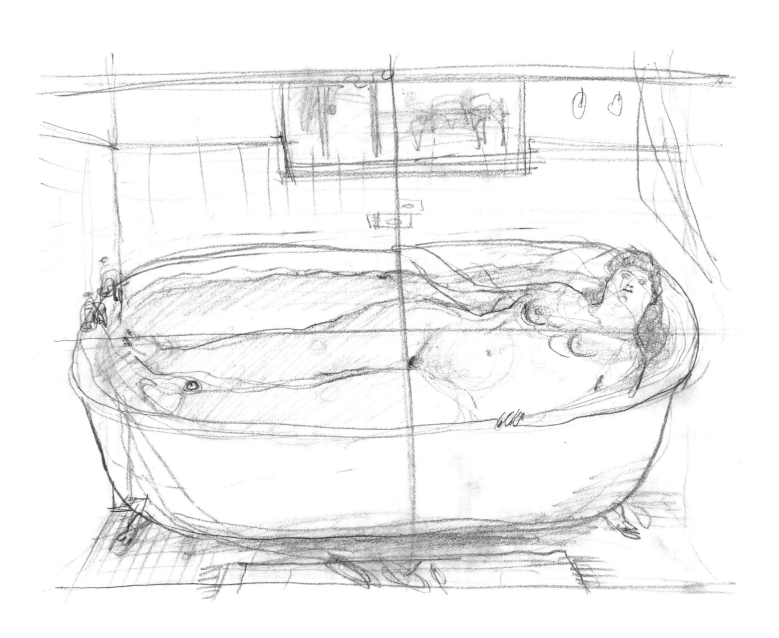

Fig. 2 Study for *Homage to Bonnard* (plate 26), 1975

Both Botero and Giacometti avoid an emphasis on effect—that of fatness or thinness in themselves—by eschewing contrasts between the two poles. With Botero, fatness is merely the visual manifestation of a possibility to which no alternative is presented in his images. It is a world in which, as in Swift's, altered perspectives on the human condition become the rule. Yet unlike Swift, Botero offers us no counterpoint in the shape of normally proportioned figures. That is why it is so difficult to pin down the meaning of his distortions. In the case of Giacometti, Existentialism provided a convenient notional crutch, yet no such literary model can be made to apply to Botero. Nor does the detail in which his painting is so rich offer a handhold to explanation. Which elements in these pictures are evil, frightening, or bloodthirsty, and which merely bathetic? Everywhere we look, we find only the same unchanging inflation of the flesh.

The South American themes *par excellence* in Botero's work—military juntas, clericalism—may convey the artist's abhorrence of conditions there, but they cannot be regarded as a direct attack. Accusation dissolves in the tender treatment of the painted surface. As Botero says: "You start to paint the head of a dictator. You begin to caress him, he appeals to you, and, touched, you give him a kiss." Basically this approach is true to the artist's intentions in that it is unqualified: with Botero, everything, human beings young and old, natural phenomena and insentient objects, military leaders and models in the studio, fat people and thin, are all unqualifiedly fat. Mind and matter are taken to extremes, as if seen in a convex mirror. The factor of swelling, balloonlike rotundity is raised to the determining element of style. It dominates in every figure, every object; it dominates, one is tempted to say, without discrimination, without prejudice. Volumes inflated to bursting point are omnipresent.

Reviewing the broad spectrum of figures and objects in Botero's work, one cannot help but conclude that his constant exaggeration robs exaggeration of its significance, that the continual repetition of a single formal principle makes exaggeration seem normal. We soon control our desire to laugh, because, as we find upon closer scrutiny, the note of caricature in the imagery is only one among many. Botero's deformation is persistent and continually in evidence, and by this very fact it becomes the prime regulatory factor governing all his imagery. Unchanging distortion is raised to a canon, and one that we are gradually compelled to accept: any type of presence other than the rotund soon becomes unimaginable. In this way the plump, stocky figures and objects that Botero depicts are gradually divested of the narrative character traditionally associated with fat, pyknic figures in art.

Although precedents for such imagery can be found in the history of art and *mores*, Botero's approach ultimately rests on an aesthetic decision: a conscious change in the artistic canon of representation. His involvement with distortion goes back to the insight that proportion is not an unvarying, eternally valid system but is redefined from period to period. It was his study of Italian painting, in particular, that led Botero to recognize, in divergences from the Renaissance canon, a subjective expressive urge.

His morphology, Botero says, has nothing in common with caricature: "No, I'm no caricaturist. Like almost every artist, I employ deformation. Natural phenomena are deformed to a greater or lesser extent, corrected in accordance with the composition." This is why he prefers the term "divergent expressive form." Botero goes on to explain that every divergence arises from a definite aesthetic need. The essential thing, in his

Fig. 3 Study for *Woman Undressing* (plate 35), 1980

Fig. 4 Study for *The Maid*
(plate 24), 1974

eyes, is an exaltation of form. He finds justification for this exaltation in the writings of art historians Bernard Berenson and Roberto Longhi, as well as in the observation that subjective elements are present in every artistic style. This is the source of Botero's reference to "divergent expressive form," and also the reason why he counters the typical reaction to his pictures by stating, seemingly paradoxically, "I don't depict fat people." Then he adds: "My attitude to proportions is not in the least abnormal. I have no personal preference at all for pyknic people." He explains his inflated forms by saying that he attempts to create a concentrated, as it were, accentuated, corporeality. Instead of caricature, Botero prefers to speak of a tactic of distortion that is basically nonpsychological in thrust: "The deformation you see is the result of my involvement with painting. The monumental and, in my eyes, sensually provocative volumes stem from this. Whether they appear fat or not really does not interest me. It has hardly any meaning for my painting. My concern is with formal fullness, abundance. And that is something entirely different."

SYNTHESIS OF KNOWLEDGE AND SKILL

Botero refers again and again to art-historical parallels: the roots of his art in the past are an obvious concern to him. His origins in a largely acultural, provincial environment may play a part in this. At any rate, Botero's isolation from history produced in him an extreme sensibility for things of the past, and in conversation with him it becomes obvious that he is anxious to defend and ramify this position. It is a position not simply based on a random confrontation with certain works of art. To a greater extent than any other contemporary artist I know of, Botero holds the museums and collections of the world in his mind. He operates with this knowledge and, at the same time, adapts it to his own needs. Instead of reproducing it in his work as a series of "quotations," he subjects it to continual synthesis; and it is this synthesis of knowledge and personal skill that determines the technical aspect of his work.

In this regard, too, we are confronted with an anachronistic but precise mastery of studio practices and recipes. It is no coincidence that one of Botero's favorite books is Max Doerner's renowned *The Materials of the Artist and their Use in Painting* (1921). Reviving, indeed reconstructing, lost techniques is a fascinating concern for Botero. His oeuvre contains an entire inventory of painting methods, and in the field of drawing, too, he is incessantly involved in expanding his experience and repertoire. A case in point are the great numbers of often large-format pastels, and red chalk and charcoal

drawings he has produced. Botero's technically outstanding revival of the pastel technique would have been unthinkable without his impassioned connoisseurship of museum art. Such a masterly command of the medium and its potential for painterly effects has not been seen since the eighteenth century, since Carriera, Quentin de La Tour, Perroneau, and Liotard. In contrast to the more graphically oriented employment of pastel by Degas and Toulouse-Lautrec, as well as by Picasso in the early 1920s, Botero carefully rubs and blends the powdered pigments to produce a color continuum.

Ever since the early 1960s he has been reacting with increasing conviction against sketchiness as an end in itself. Here, too, we recognize a stylistic volition that does not accord with contemporary values in its abandonment of open-ended, ambiguous form and the *non finito*. Behind this rejection of the intrinsic value of the sketch one detects a sharp objection to the avant-garde sensibility, which appeals to the viewer's apperception by means of open, evocative lineatures and gesturally applied paint. In the latter aesthetic stance, which accords validity to only one of many possible variants of the artist's touch, Botero sees a one-sidedness that invites protest. His large red chalk and

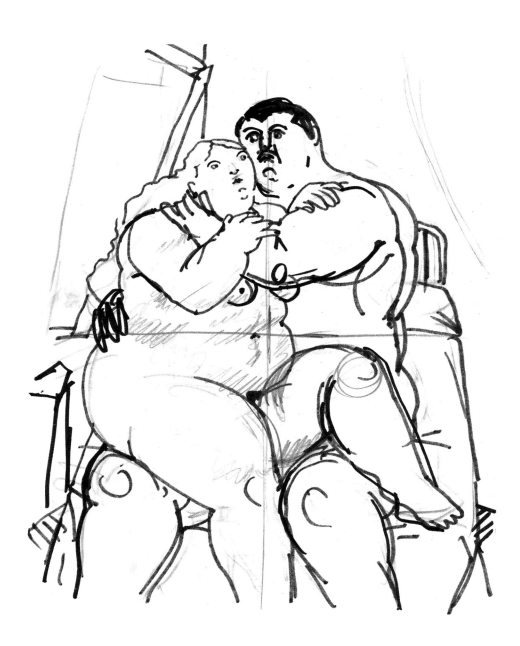

Fig. 6 Study for *Lovers*, 1975

charcoal drawings are expressions of this. Botero employs the techniques in a complementary way. Red chalk permits him, as it were, to transform pigment into light: from the dense red of the pigment he derives a source of illumination, while in the charcoal drawings, on the other hand, the black gradually eliminates the light reflected by the white paper, or, in certain looser passages, heightens its brilliance.

THE ROLE OF THE SPONTANEOUS SKETCH

The rapidly executed sketch, the fleeting record of the movements of the hand, possesses no intrinsic value to Botero. Yet his studios are filled with thousands of such drawings. Very few of them have been made public; they belong to the artist's studio secrets. He has refused to market them as works in their own right, considering them merely as aids in producing more finished work. These sketches are nonetheless of considerable interest for the light they shed on Botero's intentions and working procedures. All of his paintings are accompanied by numbers of such preparatory drawings, in which the principal elements of his compositions are developed in abbreviated form. As a rule, they are done on thin, transparent paper, in sparing, rapidly traced lines. It is an idiosyncrasy of Botero's that he invariably begins at the bottom of the sheet. When he draws a figure, for instance, he starts with the feet. This is the source of the tectonic solidity, the quality of rootedness, that his figures possess. Sketches of this kind are done at lightning speed, at a peak of emotional tension, which is reflected in the result. The lineatures in pencil or ink are dominated by sweeping, rounded, summary traces. Details remain unelaborated at this stage.

Then Botero turns the sheet over. The pencil or ink lines are now visible through the transparent paper, allowing him to work on the reverse image. This creates detachment, permitting him to check, revise, and focus the composition. Sometimes he even turns the drawing upside down and supplements it with forms—as later, in the act of painting—that serve to establish the equilibrium of the compositional arrangement. At this second, modifying stage he has recourse to an entirely different mode of drawing: the rhythm is slower and the lines are traced, parallel to those of the initial sketch, with greater attention to detail. Instead of conforming precisely to the original lines, he follows them at a short, critical distance. The drawing remains largely limited to pure contour. Although the lines are traced with greater exactness and the variety of strokes increases, shading and hatching, which would evoke volume, are generally absent, for Botero's concern at this point is, as he puts it, "to create planes in which, later, the color can take most profitable effect." The outlined fields stand for areas of color, although thoughts of particular colors are still far from the artist's mind. Heads, figures, poses, and objects are interlocked in such a way as to form a unity with the space surrounding them. In order to achieve this solid interlinkage of volumes Botero now proceeds to expand the contours, flattening and enlarging the shapes to the point that they touch, indeed impinge upon, their neighbors. The distortion of form seen here in its initial stages provides the scaffolding for the composition, which undergoes further development in the process of painting.

Finally, Botero transfers the main outlines of the sketch with white chalk to the canvas, which is generally primed in a salmon pink hue. Botero has been using this *imprimatura* for well over twenty years. It is another indication of his profound knowledge of, and reverence for, past masters and techniques. He prefers the reddish grounds of the Venetians and Goya to canvases primed in white, which for him is associated too strongly with Impressionism and Post-Impressionism. Working on the thin layer of primer, guided by the chalk traces transferred from the sketch, Botero now begins to

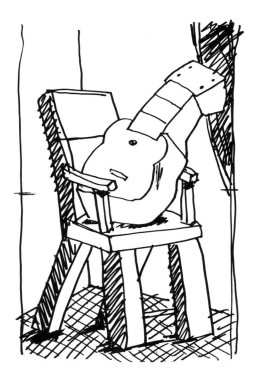

Fig. 7 Study for *Guitar on a Chair*, 1983

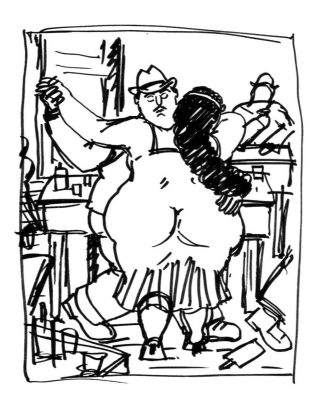

Fig. 8 Study for *Dancing Couple*
(plate 43), 1982

establish the lights using white acrylic (later stages will be executed almost exclusively in oils). This white underpainting brings out the volumes. It is usually followed by what Botero calls the "obligatory colors" of the emerging composition – local colors or those that will predominate in this particular painting. He generally begins with the lighter hues and then moves to darker gradations. This is definitely a painter's approach, in that it makes composition largely a function of color. If in the small preliminary sketch Botero had distributed the masses such that they provided "favorable terrain" for the colors, we can now see why he eschewed accessories and details at that point: these are frequently not introduced until the actual painting is underway, and in many cases they result from decisions regarding its color scheme. One color suggests the next, and in order to be able to employ it Botero decides on the figurative context in which it can plausibly occur. In this regard he retains considerable freedom of choice. One might even say that color choices to a large extent determine the narrative elements of the composition: responding to the suggestions of color, Botero gradually establishes the figurative content of the final image.

As already mentioned, spontaneity of paint application, the autonomous brushstroke, have not concerned him for many years now. Botero's aim remains the perfect, homogeneously articulated color field. A large-format painting or pastel takes him all of three or four days to finish. "I can't understand," says this master of technique, "why a painter should have to battle with his canvas for weeks or months on end. Execution is the easiest thing. That painting has to be a slow, problematical process seems to me a mystification of the avant-garde. Look what Rubens could accomplish in a single day." When seeking to justify the stylistic voluntarism of his work – the inflated volumes and deformations – Botero quite naturally cites outsiders in the history of art, such as El Greco, rather than members of the contemporary avant-garde. Just as El Greco's elongated figures, or the licence the Mannerists permitted themselves with respect to proportions, cannot be traced to actual phenomena, so his, Botero's, freedoms cannot be measured by the mimetic yardstick. This reveals his position within the contemporary

scene to be one of a remarkably independent reaction to the workings of the art market. He simply refuses to take advantage of the liberties that the art of our century has demanded as its right and employed so extensively. In developing his approach, Botero has by no means excluded modernism, but it is to the art of the past that he looks for justification of his autonomy, his freedom.

CONFRONTATION WITH ART HISTORY

What prompted Botero to begin painting? In Medellín, Colombia, where he spent the first twenty years of his life, he came in contact with artists whose interest was limited exclusively to contemporary trends. The earliest works of this period evinced traits of expressionist figuration. The figures were rather loosely conceived, with no indication of that love of detail reminiscent of the Old Masters which would later become so characteristic of Botero. In the first surviving works, such as *Woman Crying* of 1949 (Fig. 4, p. 26), this changes. The expressionist tendency is heightened, the woman's body convulsively twisted into a single symbol of physical and mental suffering. The impulsive pathos of the composition can surely be seen in relation to Botero's own personal circumstances at the time, as he himself has recalled them. He mentions his reading, including an important confrontation with the poems of César Vallejo. He read Vallejo's *Poemas humanos* with his friends, poems expressive of protest and melancholy which Botero calls "the most important influence in my life at that time." Vallejo's hallucinatory sadness struck exactly the tone of the place and age. Botero set out to lend it visual form with the stylistic means then at his disposal.

As regards visual art, the work of José Clemente Orozco stimulated him more than that of any other artist. A familiarity with the Mexican painter's great murals must certainly have encouraged Botero to spend a few months in 1951 on the Caribbean coast of Columbia, in Tolú, where he decorated a restaurant with large-format murals. Public success and effect seeming desirable to him at the time, Botero turned to the mural as opposed to the easel painting. The unprecedented fame of the Mexican muralists — Diego Rivera and David Alfaro Siqueiros, as well as Orozco — captivated the young artist. Accordingly, on his first trip to Europe he went to Florence and learned the technique of fresco painting.

Botero first set foot in Europe in 1952. His ship docked at Barcelona, where he visited the Museum of Modern Art in the Parque de la Ciudadela. It was a disappointing experience. Hoping to find great modern art of the kind he had seen in reproductions, Botero was confronted with a collection of Catalonian modernists — Casagemas, Nonell, Rusiñol — and late nineteenth-century symbolists which simply left him cold. He summed up his impressions in the statement: "I had imagined these European pictures as being much larger. The easel formats surprised and disappointed me." Yet on an evening walk, Botero relates, he suddenly came across imagery of the kind he had been looking for. An illustrated art book lay open in the window of a bookshop, displaying a picture that overwhelmed him. The next day Botero went back and bought the book, a monograph on Piero della Francesca. Shortly thereafter he went to Madrid and enrolled in the Academia San Fernando. In the Prado he copied Velázquez and Goya. The confrontation with these paintings moved him so deeply that in Paris, on his way to Italy, he stopped only briefly in the Musée National d'Art Moderne. It was the first museum of contemporary art he had ever seen, yet it, too, left him unimpressed. Botero decided to cut short his stay in Paris and go on to Florence. There he was to spend over two years — the time he regards as his true apprenticeship.

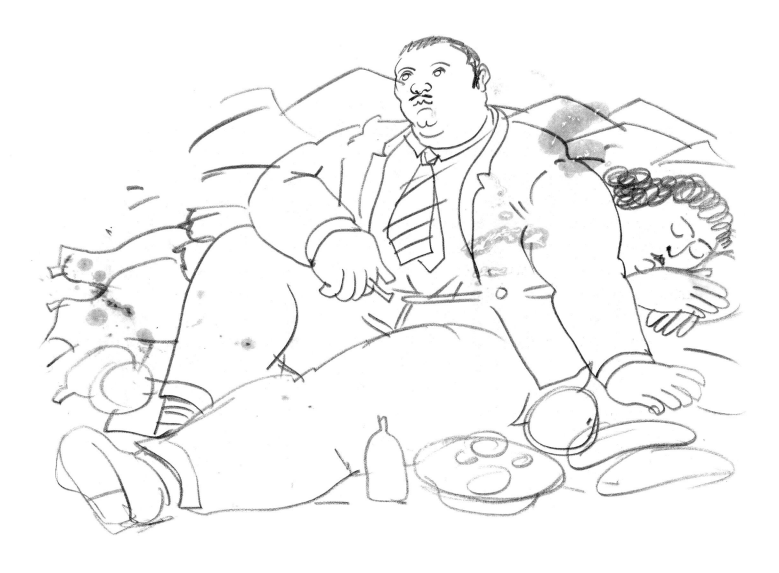

APPRENTICESHIP IN FLORENCE

Fig. 9 Study for
Picnic (plate 55), 1983

His practical training at the Academy in Florence was accompanied by studies in art history. The Florentine Trecento and Quattrocento, the painting of central Italy, Duccio and Piero della Francesca, were an unflagging source of interest to him. He rediscovered something in this imagery that had appealed to him in the frescoes of Rivera and Siqueiros: the static monumentality with which these artists had formulated their new iconography, their broadsheets on current history. There can be no doubt that the currency and popular influence of the Mexican muralists, who also had a great effect in North America, contributed to Botero's interest in Early Renaissance art. They provided the social justification for his work, and their approach and style encouraged him to explore the laconically statuesque figuration of a Giotto, Masaccio, Piero della Francesca, or Uccello.

Botero attended lectures by Roberto Longhi and read the writings of Bernard Berenson. The young Colombian artist was introduced to Berenson by an Italian friend who worked as restorer at the Berenson Collection in Villa Tatti, the art historian's

home at Settignano, near Florence. What Berenson wrote about Giotto made probably the most lasting impression of all on Botero, as it served to confirm his own, anti-expressionist stance and to show him the way to a painting determined by an emphasis on plastic volume. The definition of tactile values and the revolutionary distinction that Berenson explained between the "Virgin Enthroned" as painted by Cimabue and by Giotto provided Botero with practical tips on how to proceed. This is why Berenson's writings offer the best introduction to the oeuvre that Botero was now beginning to create. It was such insights into Florentine painting as the following that Botero adapted to his own ends: "it was of the power to stimulate the tactile consciousness—of the essential, as I have ventured to call it, in the art of painting—that Giotto was supreme master." Later in the same passage Berenson describes the principal task of figurative painting as "to stimulate the tactile imagination." Finally, Botero found in Berenson an observation that might well serve as an implicit manifesto of his own approach: "[Giotto] aims at types which both in face and figure are simple, large-boned, and massive—types, that is to say, which in actual life would furnish the most powerful stimulus to the tactile imagination."

An experience in Colombia increased Botero's fascination with the solid, compact human form. In 1955, after his return from Europe, he saw in Bogotá a performance by a Spanish troupe of dwarf toreros. One dwarf, mounted on two others who played the horse, attacked the bull: "The disproportion increased the sense of danger," Botero recalled. "This lent the spectacle an extraordinary plasticity—the bodies, piled up on each other and welded into a block, appeared to me like a ghostly apparition of my own painting."

This degree of change and distortion, and the potential of a heightened, aesthetically motivated palette, were related to the personal aesthetic position that Botero had already formulated at the age of sixteen, in a newspaper article titled "Picasso and Nonconformity in Art" that was published in *El Columbiano*. In this essay, which created quite a stir at the time and whose revolutionary nonconformity caused him to be expelled from school in Medellín, the young Botero pointed with astonishing perspicacity to Picasso's "gigantomania," the monumental and sensuous aspect of his art. Botero was undoubtedly referring to that biomorphic deformation which first appeared in Picasso's work of the early 1920s and which heightened the corporeality and presence of his figures in disregard of realistic content. That Botero's discussion of Picasso's nonconformism was not merely rhetorical but represented a kind of manifesto of his own semiconscious artistic intentions, is indicated by a glance at the drawings of this period that were published in *El Columbiano*. In one of these, *Painter at the Easel* (Fig. 3, p. 26), the artist depicts himself, in back view, at the easel. While the figures and heads surrounding him recall Orozco, the main figure, the artist with palette, already evinces the expanded volume that was to become the prime characteristic of Botero's work. In this drawing the artist proclaimed his stance in no uncertain terms, opting for a distortion of volumes for which he would later, during his sojourn in Florence, find historical legitimation in the antinaturalistic principles of Giotto.

ASSIMILATION OF HISTORY AND THE AVANT-GARDE

Painter at the Easel reveals a predilection that was to find corroboration during Botero's stay in Italy. It was strengthened not only by his visits to museums, but also by his awareness of the fact that the most effective avant-garde movement of South America, the syncretistic painting of the muralists, was shaped by a process of assimilation of both historical and avant-garde art. Botero's knowledge of contemporary and of Tre-

Fig. 10 Study for *Girl*, 1984

cento and Quattrocento art was now supplemented by an increasing concern with the formal patterns of American art prior to the European conquest of the continent. The repertoire of forms that has continued to characterize Central American ceramics down to the present day was a further influential source. Pre-Columbian art, folk art, the narrative retables of Colonial Baroque, with their figures scaled according not to perspective rules but to significance – these were among the influences that Botero now began to digest and use as a corrective to those of European art. Botero attaches considerable importance to the fact the part of the world that he comes from has its own culture to set against that of Europe: "For me, a personality such as Rivera was of the greatest significance. He showed us young Central American painters the possibility of creating an art that did not have to be colonized by Europe. I was attracted by its *mestizo* character, the mixture of old, indigenous and Spanish culture." Accordingly, Botero began collecting objects of pre-Columbian and Mexican folk art at an early age.

All his later paintings and drawings can be said to revolve around Giotto's discovery of how to depict corporeality in two dimensions, how to superimpose volumes and tie them into units, and how to build up an effect of mass by means of tense contour line. Botero exaggerates these devices. The joints of his figures and the creases of their necks seem to cut into the flesh, tying it off like plump sausage links. Fat little dogs, fat little children, and fruit juicy to bursting point fill his canvases. This agglomeration of

figures and objects into sculptural packages came to dominate Botero's art at an early date. He sought to lend absolute value to a prototype whose tactile density would attain the highest degree of three-dimensional power. The ingredients of his imagery were derived from Central American ceramics, from Mantegna, Giotto, and Uccello, from whose *Battle of San Romano* Botero adopted the clearly articulated chiaroscuro volumes of trees and figures' limbs. His sole concern, he relates, was to emphasize volumes; there was no conscious deformation involved. This was corroborated by his choice of subjects, because, as Botero says, you cannot make ironic visual statements about an apple.

It is not conducive to an understanding of Botero's art to search the real world for correspondences to his distortions. This is particularly evident with regard to his work of the late 1950s, in which isolated forms—among them, apples and heads—are expanded and heightened to the point of monumentality. The influence of Braque, detectable in the preceding canvases—Botero himself speaks of his Braque phase—now began to wane. Cubist structuring had been especially evident in the treatment of space in the earliest paintings. In a work such as *Still Life with Mandolin* of 1957 (Fig. 9, p. 28) the relationship between objects and the surrounding space is still uncertain, although an attempt is made to link them by means of a Cézannesque *passage*. The volumes possess no definite tactile quality, since they continually revert to flatness. Their positioning in pictorial space is such that the confrontation of motif and space is perceived in terms of extreme constriction; motif and space interlock. This is again apparent in *Camera degli Sposi (Homage to Mantegna) II* of 1961 (plate 3). At this point Botero's involvement with Cubism was augmented by memories of his Italian sojourn. He began to set individual heads, seen frontally or in profile, like building blocks into a solidly constructed composition. A synthesis occurred, as a Cubist orientation that went back to the 1940s was deepened by a confrontation with the Italian Renaissance and with the concepts propounded by Berenson and Longhi. This is undoubtedly the cause of the increase in conceptual rigor that now became evident in Botero's painting.

The liberating extent to which Cubism allowed artists to embrace eccentric organic deformation is apparent from the development of one of its pioneers, Picasso. While his turn, after 1914, to a neoclassical, realistic figurative style entailed a partial abandonment of Cubism, the subsequent "monstrous" women in his work again made use of the principle of a denial of mimetic truth to nature. In these canvases Picasso increasingly resorted to a distortion of contour. Gradually his figures began to establish a new canon—that heightened voluminosity to which Botero referred in his early essay in the newspaper *El Columbiano* and which he termed "gigantomania." Picasso's distorted figures resisted psychological interpretation. As they were frequently nudes, and as the accessories were limited to classical draperies, and the figures' gestures and surroundings evoked Mediterranean divinities, the "monstrosity" of this anticlassical canon very soon lost its associations with pain or suffering.

STYLISTIC DEVELOPMENT

Botero's fascination with the art of the museums—Velázquez and Goya, the Italian Trecento and Quattrocento—and with concepts developed by art historians is reflected throughout his oeuvre. They determine his approach to painting, yet it cannot be said that they have caused him to turn his back on the contemporary age. His historical bent merely serves as a background against which he can reflect on contemporary art and on the place of his work within it. A review of his painting of the 1950s and 1960s indicates that his unique style was evolved not least out of an involvement with current trends. The canvases of that period—for example, *Mona Lisa, Age 12* (plate 1) and *Niño de Val-*

Fig. 11 Study for
Seated Woman (plate 28), 1976

Fig. 12 Study for
Self-Portrait Dressed as Velázquez
(plate 65), 1986

lecas (after Velázquez) (Fig. 11, p. 28)—reveal a playful preoccupation with the Abstract Expressionism of the New York School. Their coloristic approach, and the gestural brushwork that plays over the otherwise tectonically rigorous framework of the compositions, recall Kline or the de Kooning of the "Women" series. Yet Botero is able to absorb this challenge on the part of a contemporary style by referring it to historical paradigms—to his knowledge of the Quattrocento and to the painting techniques he had systematically studied during his stay in Florence. As mentioned, Botero concerned himself primarily with fresco painting at that time. The visible brushwork, the macro-structure of fresco interested him, and indeed the tempera technique as such. Although he never actually painted in tempera, he did attempt in a number of canvases to translate its characteristic short, hatched stroked into the oil medium. He employed oil paint like tempera, Botero says, imitating its fine strokes and additive effect. This resulted in a "blowup" of texture that was ultimately comparable to the semiautomatic, expressive approach to be seen in the work of de Kooning, Kline, Rauschenberg, and the early Hockney.

In the early 1960s this graphic application of paint began gradually to disappear from his work, as can be seen from a chronological review. Paintings such as *Girl on a Donkey* (ca. 1959), *Girl with Flowers* (1960), and *Girl* (1962) reveal an increasing rhythmical emphasis and ordering of the gestural paint application. In *Girl on a Donkey* the handling is still full of contrasts: while some areas show carefully executed parallel strokes, others slough over details in favor of agitated brushwork. In such canvases as *Madame Cézanne in the Garden* (1963) and *Ambrogio de Predis Painting his Wife* (1963) Botero arrives at the systematic, controlled handling that culminated in his first group portrait, *The Pinzón Family* (Fig. 13, p. 29). Here, distortion has taken on that generalizing character which links all the motifs of the image together, producing a pictorial continuity that is supplemented by homogeneity of treatment.

Despite a fully developed historical awareness that relies as strongly on the traditions of European art as does that of Giacometti or Balthus, Botero has never denied his origins in the Latin American world. Numerous motifs in his paintings are derived from this background, and his short stories (some of which are included here) are also set in this milieu. They show Botero employing memories and fantasies that are deeply rooted in his Colombian origins. It is no coincidence that among Botero's first illustrations were some for a story by Gabriel García Márquez, "Tuesday Siesta." In this connection it is worth mentioning that the meeting between Botero and García Márquez led to mutually influential results. At the time, García Márquez's style was still descriptively realistic by comparison to his later books. Botero's illustrations seem to have set the tone for the baroque rhetoric that subsequently characterized García Márquez's narrative excessiveness.

ROOTS AND DETACHMENT

Although Botero's themes may frequently be related to South America, his work is anything but folkloristic or naive. On the contrary: from the very beginning Botero has faced the insurmountable discrepancy that exists between roots and exile. And not only has he accepted this detachment; he has cultivated it. Distinguished South American intellectuals realized this long ago. They consider Botero a man of resistance to a uniform period style, a man who reacts to his origins from a distance both physical and mental. His incessant traveling, his changes of place, serve to sharpen his focus because, as he himself says: "I prefer to observe my country from a distance, so that I can trans-

Fig. 13 Study for *Stroll in the Woods*, 1979.
See also plate 87

form it better and dream about it with greater freedom. Reality can sometimes be overwhelming." This detachment permits him, as Sam Hunter noted, to "preserve the fabulous and heraldic qualities of Borges's work of the imagination without sacrificing the bitter revelations of social existence in his native Latin America." And Mario Vargas Llosa recognizes Botero to be a highly conscious artist who, in keeping with his, Vargas Llosa's, own intentions as a writer, opposes his existential experience and origins to the social deracination of the cosmopolitan avant-garde: "It is not necessary to have seen the Colombian villages of Antioquias in the 1940s yourself to recognize the social reality behind Botero's imagery. Everything I see in it is without question the Peru of my childhood—Arequipa in the south, Piura in the north. Every Latin American will find in this kaleidoscope of images certain feelings, dreams, and modes of behavior that are entirely typical of towns and villages throughout the continent."

In sum, Botero's oeuvre is not only suffused with stupendous technical mastery and unparalleled knowledge of the museums; it is also imbued with a lucid awareness of personal origins that prevents him from succumbing opportunistically to the blandishments of the international art scene. What Vargas Llosa notes with regard to his own experience applies to Botero as well: "In everything Latin America has produced in the way of authentic art one finds a strange combination of attraction to, and rejection of, things European: the European tradition is either employed to different ends, or forms, motifs, and ideas are introduced into it that call the heritage in question or put it to the test, without, however, denying it." It is significant in this context that Botero, after his travels in Spain, France, and Italy, should have achieved his decisive breakthrough at a distance both from Europe and the United States. This occurred during a protracted stay in Mexico, a country which, as Botero realized, had mounted resistance to both.

Continual references to his personal origins, and a sense of responsibility toward them, mark a number of passages in the conversation with Botero published here (pp. 154–64). These, and all that has been said above, point to the same conclusion: Botero defends, with incorruptible frankness, his right to his own identity in the face of avant-garde positions that are often enough superficially radical but fundamentally noncommittal. Botero is proud of his origins, and his painting draws sustenance from them. For our part, they grant us insights into the intentions underlying his exclusively figurative art and into the background behind his striking subject matter. By now it will have become clear that Botero, despite his tendency to minimize the significance of content in his paintings and drawings, ultimately derives his motivation from a blend of fascination and rejection. This is corroborated by his subtly composed short stories. Botero confronts us with a kind of *faux naiveté*, which he continually undermines. Both stories and paintings present a healthy, rosy-cheeked world—or so it would seem. Yet it is a world that swarms with insidious details that cast doubt on its happiness, its abundance somehow rotten at the core. When we consider Botero's remarks on the clerical and military subjects in his oeuvre and on the society that he depicts, we begin to realize that, in his renderings of the military junta and loving couples, in the meetings of flesh with flesh where arms and hands rest numbly on other arms and hands, some of the coolly recording gaze with which Goya viewed the family of Charles IV lives on.

Biographical Notes

1932–1937

Fernando Botero Angulo is born on April 19, 1932, in Medellín, a regional center of industry and trade in the province of Antioquía, high up in the Colombian Andes. He has two brothers: David (born 1928) and Rodrigo (born 1936). His father, David Botero (1895–1936), was a traveling salesman who used pack-mules to visit the outlying areas, which were inaccessible by any other means (see Fig. 1). At the time of his father's death, Fernando is barely four years old. Like his father, Fernando's mother, Flora Angulo de Botero (1898–1972), came from a small village in the Andes.

1938–1949

Fernando attends primary school and is awarded a scholarship that enables him to continue his education at the Jesuit secondary school in Medellín. His uncle, a passionate devotee of bullfighting, sends him at age twelve to a school for trainee matadors, where he remains for the next two years. The bull-ring is the main subject of Fernando's early drawings; his first recorded painting is a watercolor of a toreador.

In 1948 Botero shows his work in public for the first time, in an exhibition in Medellín of work by artists from the province of Antioquía. At age sixteen, while still a schoolboy, he begins to draw illustrations for the Sunday supplement of *El Colombiano*, Medellín's principal newspaper. The Mexican school of mural painting, whose main exponents are Diego Rivera, David Alfaro Siqueiros, and José Clemente Orozco, plays a major part in shaping Botero's ideas about art. His large-format watercolors from this period—such as *Woman Crying* (Fig. 4)—are particularly influenced by Orozco. From early childhood on, he is fascinated by pre-Columbian art and by the brightly painted altarpieces and figures of saints characteristic of the South American style known as "colonial Baroque." It is not until 1948 that information about contemporary European art begins to trickle through to Medellín: up to this point, there was not a single modern painting to be seen in the town.

During the Colombian civil war, a brutal and bloody conflict between the liberals and the die-hard conservatives, the country's younger generation of intellectuals discovered the work of such modern writers as Federico García Lorca, Pablo Neruda, Miguel Asturias, and, above all, César Vallejo. Botero encounters the name Picasso for the first time in a history of modern art written by the Argentinian critic Julio Payro. His nude drawings for *El Colombiano* incur a formal rebuke from the headmaster of his school; shortly afterward, he is expelled for publishing an article titled "Picasso and Nonconformity in Art."

1950–1952

Botero is admitted to another school, the Liceo San José in the nearby town of Marinilla. He supports himself by doing illustrations for newspapers. In 1950 he completes his secondary education by sitting the university entrance examination. After leaving school, he works for two months as a set-designer with a Spanish theater company, named for the playwright Lope de Vega, which appears in Medellín on a tour of Colombia.

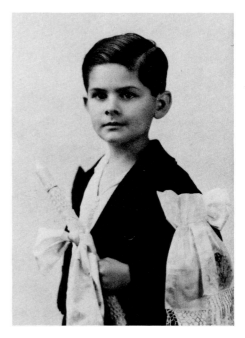

Fig. 2 Botero dressed for his first Communion

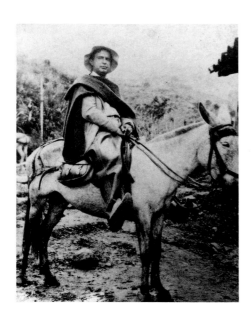

Fig. 1 The artist's father, David Botero

Fig. 3 *Painter at the Easel*, 1949.
Illustration for *El Colombiano*

Fig. 4 *Woman Crying*, 1949. Watercolor on
paper, 23¼ x 17″ (59 x 43 cm)

In January 1952 Botero moves to Bogotá,
the capital of Colombia, where he quickly
gains access to the avant-garde circle that
meets at the Café Automática; its members
include the writer Jorge Zalamea, a former
ambassador to Mexico who is a close friend of
García Lorca. Botero and the other painters in
the group discuss the latest developments in
art, taking a particular interest in abstraction.

Only five months after his arrival in Bogotá,
Botero holds his first one-man exhibition,
comprising twenty-five watercolors, gou-
aches, drawings, and oil paintings, at the Leo
Matiz gallery. Heartened by his success in sell-
ing a number of pictures, he spends the sum-
mer on a painting holiday in Tolú on the
Caribbean coast and on the islands in the Gulf
of Morrosquillo. The pictures from this
period reflect the influence of Picasso's Blue
and Rose periods, and of Gauguin (see Fig. 5).
In the Isolina restaurant in Tolú Botero pays
for his meals by painting a mural that can still
be seen today.

In May 1952 Botero holds a further exhibi-
tion at the Leo Matiz gallery, featuring pic-
tures from the previous summer. Three
months later his painting *On the Coast* (1952)
earns him second prize in the ninth Salon of
Colombian Artists, held at the Biblioteca
Nacional in Bogotá. The prize money is 7,000
pesos, and this, together with his savings,
enables Botero to travel to Europe.

In August 1952 Botero buys a third-class
ticket on a boat to Barcelona and travels with
a group of other artists to the city where
Picasso spent his youth. However, after only a
few days Botero leaves Barcelona and moves
to Madrid, where he enrols at the Academia
San Fernando. In the Prado he encounters the
work of the Spanish masters Velázquez and
Goya, whom he uses as models for his paint-
ing.

Botero supplements his meager funds by
painting copies of Old Masters for tourists. As
he later recalls: "Everybody at the Academy
was trying to develop his own style, but all I
wanted was to learn a technique." At the end
of his second semester in Madrid he travels to
Paris. His former interest in Modernism has
waned, and he is disappointed by the French
avant-garde art that he sees in the Musée
National d'Art Moderne. He spends nearly all
his time in the Louvre, studying the works of
the Old Masters.

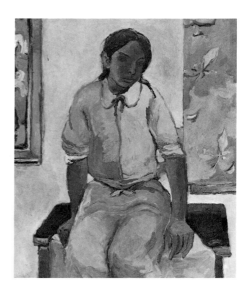

Fig. 5 *Indian Girl*, 1952. Oil on canvas

Fig. 7 *Departure*, 1953. Oil on canvas,
44 x 59″ (112 x 150 cm).
Collection H. J. Kircherer, Rockville,
Maryland

1953—1954

At the end of the summer Botero travels to Florence, where he enrols at the Accademia San Marco. At the time when Tachism is celebrating its first triumphs in Europe, Botero works in the manner of a Renaissance artist; instead of Velázquez and Goya, he begins to copy Giotto and Andrea del Castagno. For the next eighteen months he spends part of his time studying the technique of fresco painting. In the evenings he paints in oils, using a studio in the Via Panicale that once belonged to the *Macchiaioli* painter Giovanni Fattori. His enthusiasm for Renaissance art is additionally fired by the writings of Bernard Berenson and the lectures of Roberto Longhi on the Quattrocento. He travels around northern Italy on his motorbike, visiting Arezzo (in order to see Piero della Francesca's paintings), Siena, Venice, Ravenna, and other historic centers of Italian art.

In the spring of 1954 Botero visits an exhibition of Renaissance painting in Florence, featuring works by Piero della Francesca, Paolo Uccello, Andrea del Castagno, and Masaccio. One of his characteristic pictures from this period is *Departure* (Fig. 7), in which the painting of the horses is inspired by Uccello; in the atmosphere of mystery one also detects the influence of Giorgio de Chirico.

1955

In March Botero returns to Bogotá. Two months later he exhibits twenty paintings, the artistic results of his stay in Florence, at the Biblioteca Nacional. The exhibition is a resounding flop: Botero's work is vehemently condemned by the critics, who take their lead from the latest developments in the Paris art world, and not a single picture is sold. He finds occasional work producing illustrations for various magazines. In December he marries Gloria Zea.

1956

At the beginning of the year the couple moves to Mexico City, where his first son, Fernando, is born. While working on *Still Life with Mandolin* (Fig. 9), Botero hits on the idea of modifying form by exaggerating its volume. In Mexico he is able to live by selling his pictures.

Fig. 8 Botero in his studio, Bogotá, 1957

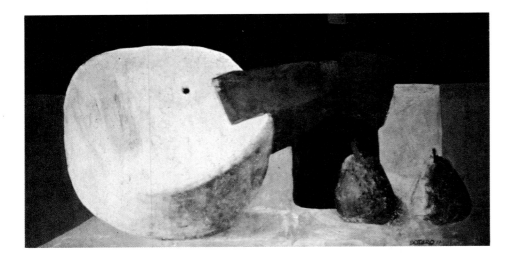

Fig. 9 *Still Life with Mandolin*, 1957
Oil on canvas, 26¼ x 47¾" (67 x 121 cm).
Collection David Barrett, New York

1957

In April Botero travels to Washington, D. C., for the opening of his first one-man show in the USA, organized by the Pan-American Union. During the first week of his stay he visits several museums in New York, where he discovers Abstract Expressionism. He makes the acquaintance of Tania Gres, who later opens a gallery in Washington and becomes an important source of financial and moral support.

In May Botero returns to Bogotá. The following October he is awarded second prize at the tenth Colombian Salon for his painting *Counterpoint*.

1958

Botero's daughter, Lina, is born. At age twenty-six, Botero is appointed professor of painting at the Bogotá Academy of Art, a post that he holds for the next two years. His prestige is on the increase: widely regarded as Colombia's foremost young artist, he is asked to draw a set of illustrations for García Márquez's story "Tuesday Siesta." The drawings are published in *El Tiempo*, the leading Colombian newspaper, and are the subject of an enthusiastic article by Jorge Zalamea in the art magazine *Cromos*. As his contribution to the eleventh Colombian Salon, Botero submits his largest painting to date, a work entitled *Camera degli Sposi (Homage to Mantegna)* (Fig. 10), which is a loose interpretation of Mantegna's famous frescoes in the Ducal Palace at Mantua. The picture is initially rejected by the jury. However, following a storm of protest in the Bogotá art world and in the press, the jury meets again to reconsider its verdict and decides to award the first prize to Botero.

In October *Camera degli Sposi* and the painting *Sleeping Bishop* go on show in Botero's first exhibition at the Gres Gallery in Washington, D. C. The exhibition is a major personal success: nearly all the pictures are sold at the opening. In the same year Botero takes part in the Guggenheim International Award exhibition at the Guggenheim Museum.

1959

At the Colombian Salon Botero exhibits *The Apotheosis of Ramon Moyos*, a picture of the national cycling champion. In *Niño de Vallecas* (Fig. 11) Botero presents a personal interpretation of Velázquez. There are over ten different versions of this picture, executed in a style that is redolent of Abstract Expressionism in its combination of monochrome painting and impulsive brushwork.

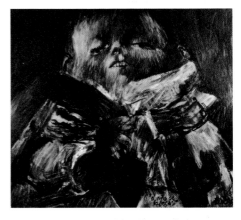

Fig. 11 *Niño de Vallecas (after Velázquez)*, 1959.
Oil on canvas, 52¾ x 56¼" (134 x 143 cm).
The Baltimore Museum of Art;
Gift of Geoffrey Gates

Fig. 10 *Camera degli Sposi
(Homage to Mantegna) I*, 1958.
Oil on canvas, 67 x 79" (170 x 201 cm).
Private collection.
See also plate 3

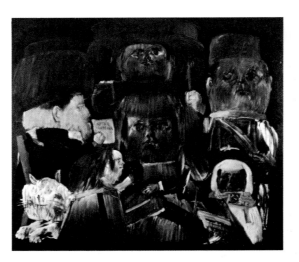

1960

From February to April Botero works on a fresco commissioned by the Banco Central Hipotecario in Medellín (Fig. 14). This is his only large-format work in the medium of fresco painting. His son Juan Carlos is born in Bogotá. A committee, whose members include the Colombian art critic Marta Trada, selects Botero to represent Colombia at the second Mexican Biennale. The decision sparks a violent controversy, resulting in a formal protest by Botero and some of his friends. In October he travels to Washington, D. C., for the opening of his second exhibition at the Gres Gallery. The *Niño* series disconcerts many of the collectors who had flocked to buy his earlier, more colorful pictures.

Botero leaves Colombia for the third time and moves to New York. His means are slender, and his English is rather poor. He rents a loft in Greenwich Village, at the corner of MacDougall and Third Street. At this point, the dominant influence in the American art world is the Abstract Expressionism practiced by the New York School. With the closure of the Gres Gallery, Botero loses a major source of support. His marriage to Gloria Zea is dissolved.

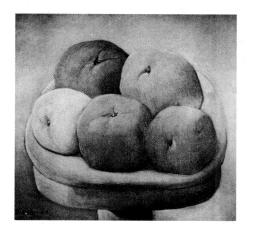

Fig. 12 *Apples*, 1964. Oil on canvas, 50 x 51½″ (127 x 131 cm). The Lowe Art Museum, University of Miami, Coral Gables, Florida; Gift of Esso Inter-America, Inc.

1961

In June the El Callejan gallery in Bogotá holds an exhibition of Botero's work, comprising paintings and twelve illustrations for Jorge Zalamea's *El Gran Burundún Burundá ha muerto*. At the instigation of Dorothy C. Miller, a curator at the Museum of Modern Art, the museum acquires the first version of *Mona Lisa, Age 12* (plate 1), the only figurative picture it bought that year.

1962

In November Botero's first exhibition in a New York gallery — The Contemporaries — is savaged by the critics.

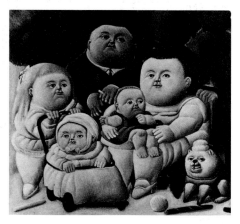

Fig. 13 *The Pinzón Family*, 1965. Oil on canvas, 68 x 68″ (173 x 173 cm). Museum of Art, Rhode Island School of Design, Providence

1963

While Leonardo's *Mona Lisa* is on show at the Metropolitan Museum of Art, the Museum of Modern Art exhibits *Mona Lisa, Age 12*. Botero moves his studio to the Lower East Side.

1964

Botero marries Cecilia Zambrano. His painting *Apples* (Fig. 12) earns him first prize in the Primer Salón Intercol de Artistas Jóvenes at the Bogotá Museum of Modern Art. He builds a summer home on Long Island and rents a new studio on 14th Street.

1965

With *The Pinzón Family* (Fig. 13), Botero's plastic style of painting reaches full maturity. The compacted, often earthy tones of his early work are increasingly replaced by delicate, decorative colors, applied in thin glazes. Regarding his subject matter, he explains: "Although I have painted a number of portraits, I don't like working directly from models. They cramp my style and take away my liberty. I prefer to be completely free, to follow my own imagination." Botero studies the art of Rubens and paints four pictures after the latter's portraits of Hélène Fourment.

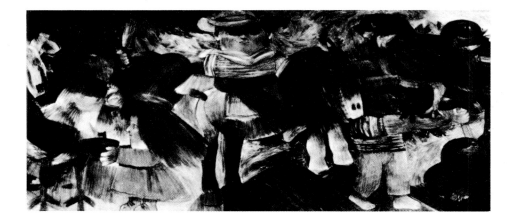

Fig. 14 *Scene with Rider*, 1960. Fresco. Banco Central Hipotecario, Medellín

Fig. 15 *Oswolt Krel (after Dürer)*, 1969.
Charcoal on canvas,
83 x 70¾" (211 x 180 cm).
Private collection

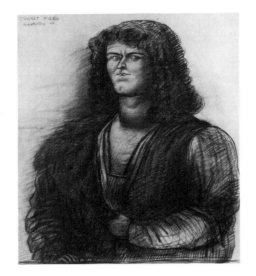

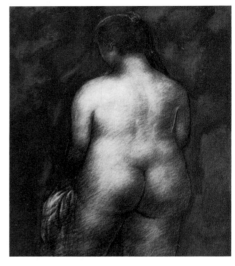

Fig. 16 *Female Nude*, 1969. Charcoal on canvas,
72 x 59½" (183 x 151 cm). Private collection

1966

In January Botero travels to Germany for the opening of the first major European exhibition of his work, held at the Staatliche Kunsthalle in Baden-Baden. The exhibition is later shown in Munich, at the Galerie Buchholz. In September the Galerie Brusberg in Hanover shows a selection of pictures by Botero. Three months later his first exhibition in an American museum—*Recent Works* at the Milwaukee Art Center—is the subject of an enthusiastic review in *Time* magazine.

1967

Over the next few years Botero continually moves back and forth between Colombia, New York, and Europe. He visits Italy and Germany, where he studies the art of Dürer in Munich and Nuremberg. This supplies the inspiration for the "Dureroboteros," a series of large charcoal drawings on canvas, in which Botero paraphrases famous paintings by the German master (see plate 16 and Fig. 15). At the same time, Botero becomes interested in Manet and paints a number of pictures after the latter's *Déjeuner sur l'herbe*. He also does several reinterpretations of Bonnard's pictures of women bathing. In an interview, he later explains: "After centuries of colonialism, we Latin American painters felt a particular need to find our own form of authenticity. Art has to be independent.... I want my painting to have roots, because it is roots that give meaning and truth to what one does. But at the same time, I don't just want to paint South American peasants. I want to paint everything—subjects like Marie Antoinette, for example [see plate 98]. But I always hope that everything I do will be touched by the Latin American soul."

1969

In March Botero exhibits a selection of paintings and large-format charcoal drawings at the New York Center for Inter-American Relations. His first exhibition in Paris is held at the Galerie Claude Bernard in September.

1970

Botero's son Pedro is born in New York. The first years of the boy's life are lovingly documented by his father in a series of pic-

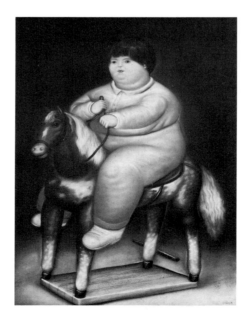

Fig. 17 *Pedro on his Rocking Horse*, 1971.
Pastel on canvas, 69½ x 54" (176.5 x 137 cm).
Collection Joachim Jean Aberbach, New York

tures (see Fig. 17). Beginning in March, an exhibition of eighty paintings by Botero is shown at several museums in Germany, opening at the Staatliche Kunsthalle, Baden-Baden, and moving on to the Haus am Waldsee, Berlin, the Kunstverein, Düsseldorf, the Kunstverein, Hamburg, and the Kunsthalle, Bielefeld.

1971

Botero rents an apartment on the Boulevard du Palais in the Ile de la Cité. He continues to divide his time between Paris, Bogotá, and New York, where he sets up a new studio on Fifth Avenue.

1975

Botero divorces Cecilia Zambrano.

1976

Following a major retrospective of his work at the Museo de Arte Contemporáneo in Caracas, Botero is awarded the Andrés Bello Medal by the President of Venezuela. The Galerie Claude Bernard, Paris, stages an exhibition of large-format watercolors and drawings.

Throughout 1976 and the following year Botero devotes almost all his energies to sculpture. He makes a total of twenty-five sculptures based on a wide variety of motifs: the works include a large human torso, figures of cats and snakes, and a giant coffee pot.

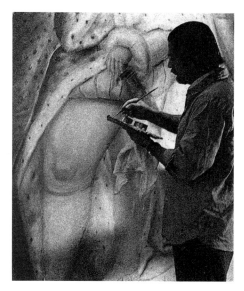

Fig. 19 Botero working on
Self-Portrait with Louis XIV (after Rigaud),
1974

1972

In February Botero has his first major exhibition at the Marlborough Gallery in New York. He moves his Paris studio to rue Monsieur-le-Prince and buys a summer home in Cajica, north of Bogotá, where, from now on, he lives for part of the year.

1973

After thirteen years, Botero finally leaves New York and settles in Paris. He makes his first sculptures.

1974

In April Botero has his first-ever retrospective in Bogotá, featuring works from the period 1948 to 1972. He paints two virtuoso paraphrases—*Self-Portrait with Louis XIV* (see Fig. 19) and *Alof de Vignancourt* (plate 13)—of pictures by Rigaud and Caravaggio.

At age four, Botero's son Pedro is killed in a car accident in Spain. The artist himself sustains serious injuries. After Pedro's death, Botero uses the image of the boy in many of his drawings, paintings, and sculptures (see Fig. 14, p. 164).

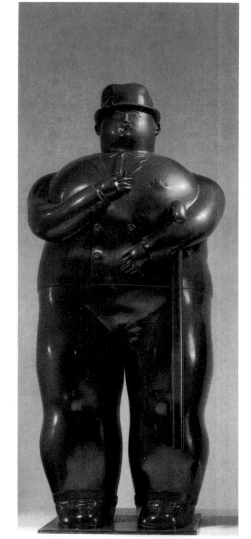

Fig. 18 *Man with Walking Stick*, 1977.
Bronze, 79 x 33¾ x 26″ (201 x 86 x 66 cm).
Private collection

1977

In recognition of his services to Colombian art, Botero is awarded the Boyacá Cross by the regional government of Antioquía. The Museo de Zea in Medellín opens a new room bearing the name Sala Pedro Botero, which contains sixteen works donated by Botero in memory of his son. In October Botero's sculptures are shown in public for the first time in an exhibition mounted by the Galerie Claude Bernard at the Paris Art Fair. Botero works on the *Margarita* cycle (see Fig. 2, p. 156), a series of paintings inspired by Velázquez's portraits of the Infantas. This is his last major exercise in reinterpreting the art of the Old Masters.

1978

Botero transfers his Paris studio to the former premises of the Académie Julian in the rue du Dragon. For the time being, he abandons sculpture and returns to painting.

Fig. 20 Botero in his Paris studio, 1980

Fig. 21 *Woman Smoking a Cigarette*, 1987.
Bronze, 73 x 142 x 62" (185 x 360 x 158 cm)

Fig. 22 *Hand*, 1981.
Bronze, 34¾ x 23 x 18" (88.5 x 58.5 x 45.5 cm).
Private collection

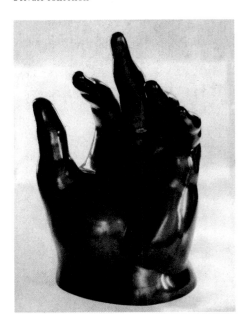

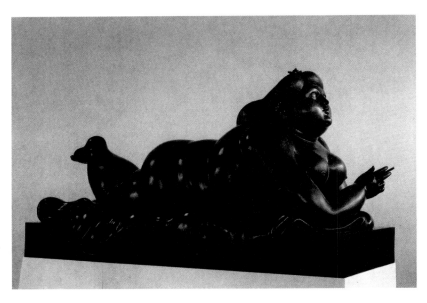

Botero's work is shown in traveling exhibitions at various venues in Belgium, Norway, Sweden, and the USA. His first American retrospective, organized by Cynthia Jaffee McCabe, is held at the Hirshhorn Museum and Sculpture Garden in Washington, D.C., in 1979.

The Galerie Beyeler in Basel stages an exhibition of watercolors, drawings, and sculptures. Botero writes a number of short stories, accompanied by illustrations, which are published in *El Tiempo* in 1980. The following year a retrospective is shown in Tokyo and Osaka, and an exhibition of watercolors and drawings at the Il Gabbiano gallery in Rome.

1983

The Metropolitan Museum of Art, New York, acquires *Dance in Colombia*. Botero does a set of illustrations for García Márquez's *Chronicle of a Death Foretold*, which appear in the first issue of *Vanity Fair*. He establishes a workshop in Pietrasanta, a small town in Tuscany that is noted for the quality of its foundries, and henceforth spends a few months of each year there working on his sculptures.

1984

Botero donates a number of sculptures to the Antioquía Museum in Medellín, which are housed in a purpose-built room. He also makes a donation of eighteen paintings to the National Museum in Bogotá. For the next two years he works almost exclusively on paintings of scenes from the bullring. His fascination with bullfighting, which is almost as much of a cult in Colombia as it is in Spain, dates back to his early childhood. As a connoisseur of the subject, he has the ambition to become the supreme painter of the *corrida*, "so that when people think of bulls, they will automatically think of my pictures."

1985

At the end of April the Marlborough Gallery in New York holds the first exhibition of Botero's bullfight paintings, comprising twenty-five works that depict the various phases of the *corrida*. An exhibition of his work is shown at the Museo di Ponce in Puerto Rico.

1986

In January the Museo de Arte Contemporáneo in Caracas mounts a retrospective of Botero's drawings from the previous four years. Further retrospectives are staged in Munich (traveling to Bremen, Frankfurt, and Madrid in 1987) and in several Japanese cities, including Tokyo.

In December the exhibition *La Corrida*, comprising eighty-six oils, watercolors, and drawings on various aspects of bullfighting and its personalities, is mounted at the Castello Sforzesca in Milan.

La Corrida travels to the Castel dell'Ovo, Naples, and the Albergo delle Povere, Palermo. A retrospective is shown at the Casino in Knokke le Zoute, Belgium.

The *Corrida* exhibition is shown in Venezuela, at the Museo de Arte, Coro (January – February), and the Museo de Arte Contemporáneo, Caracas (March). A selection of the artist's sculptures is displayed at the Los Angeles art fair.

The Fondation Pierre Gianadda in Martigny, Switzerland, mounts a retrospective of Botero's paintings, drawings, and sculptures. His recent sculpture is the subject of an exhibition at the Marlborough Gallery, New York.

Retrospectives are held at the Brusberg gallery in Berlin and at the Forte di Belvedere in Florence.

Fig. 23 *The Rape of Europa*, 1989.
Bronze, 26¾ x 20½ x 18″ (68 x 52 x 46 cm)

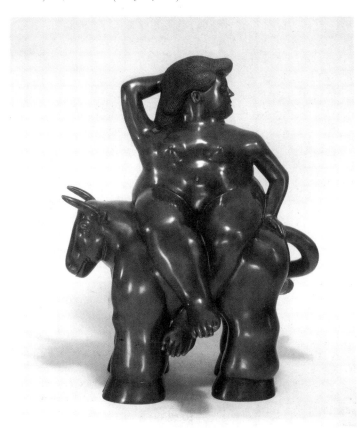

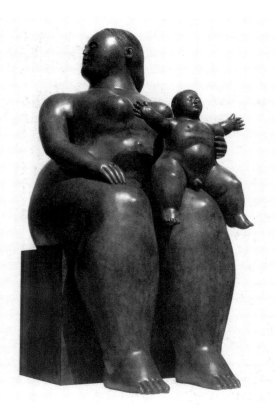

Fig. 24 *Motherhood*, 1990.
Bronze, 97 x 51 x 57″ (246 x 130 x 144 cm)

PLATES

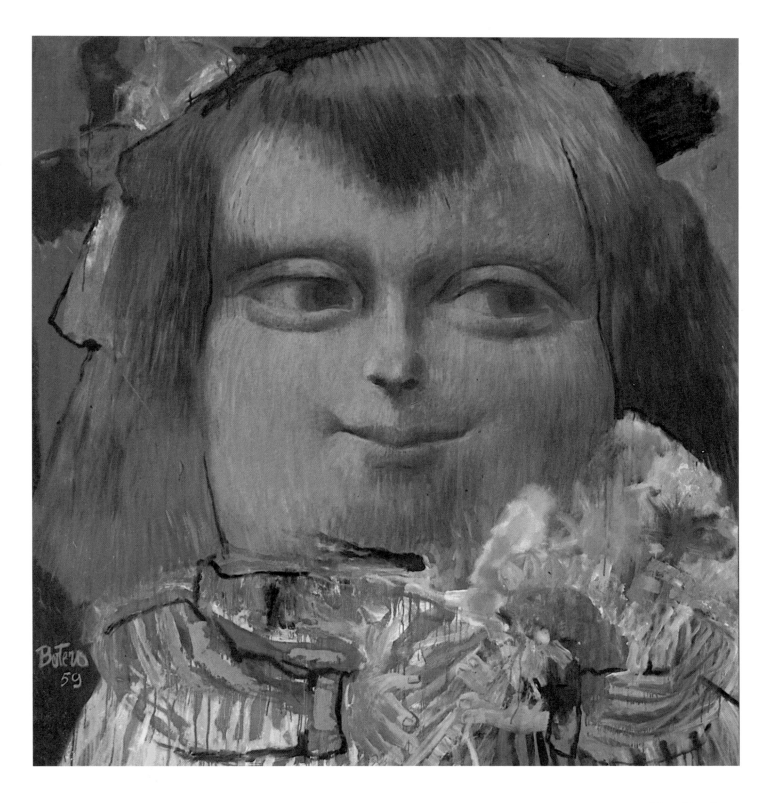

1 *Mona Lisa, Age 12*

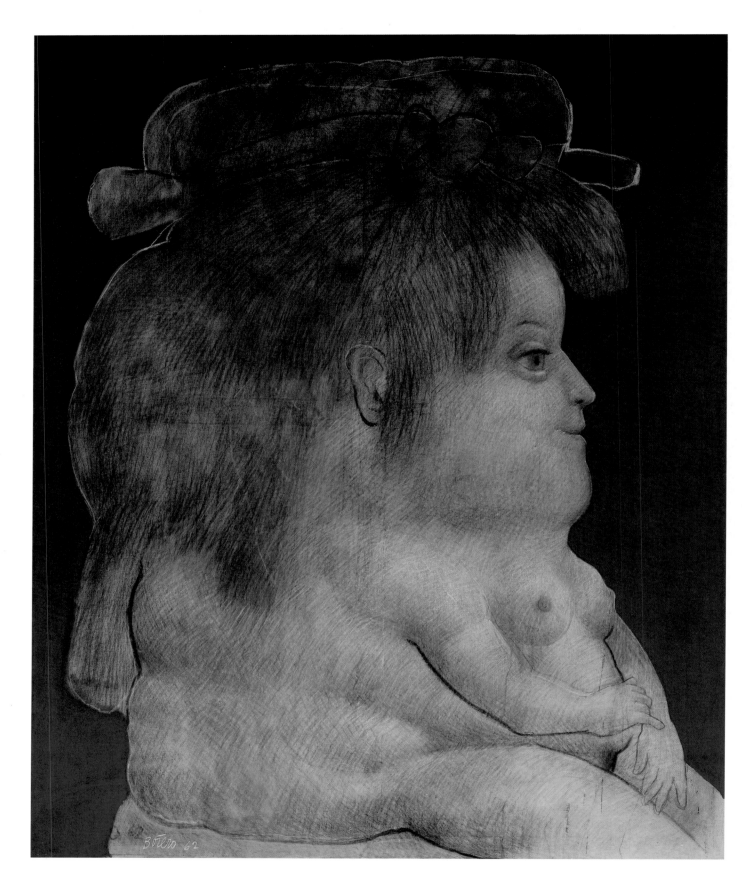

2 *Figure in Profile*

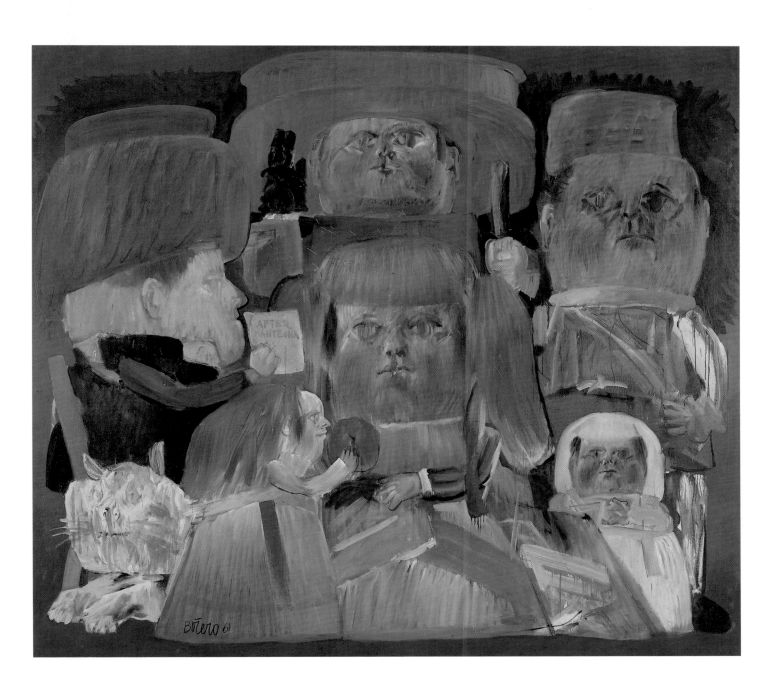

3 *Camera degli Sposi (Homage to Mantegna)* 11

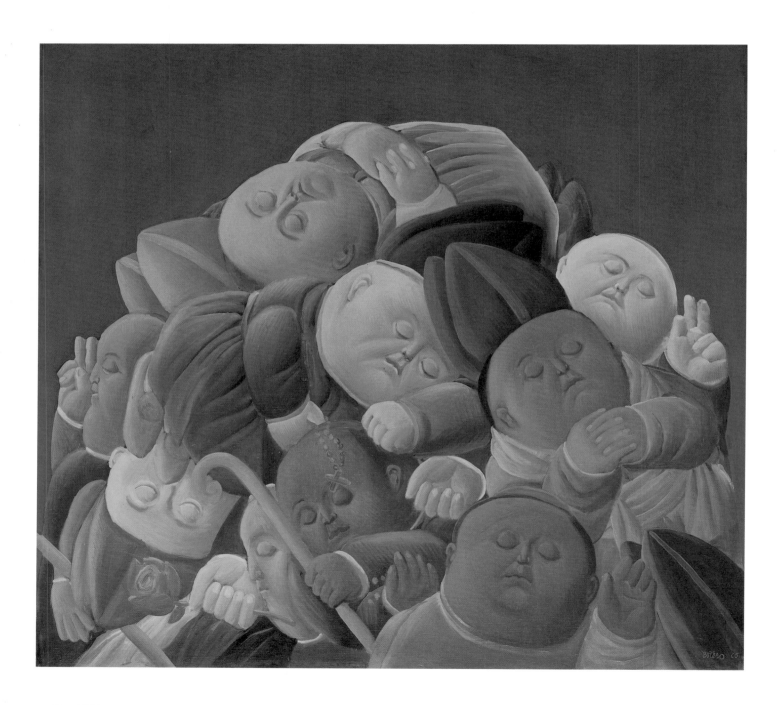

4 *Dead Bishops*

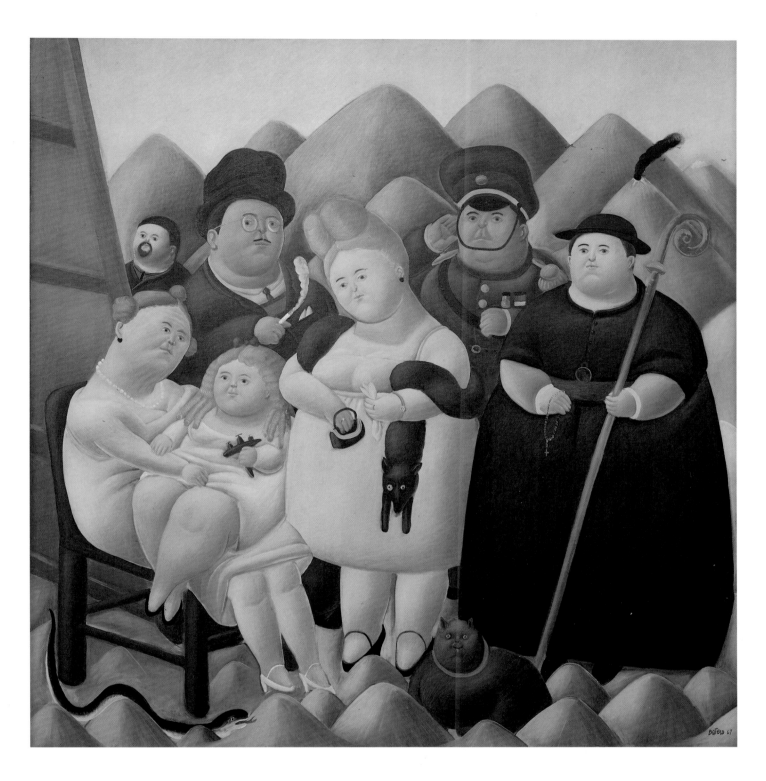

5 *The President's Family*

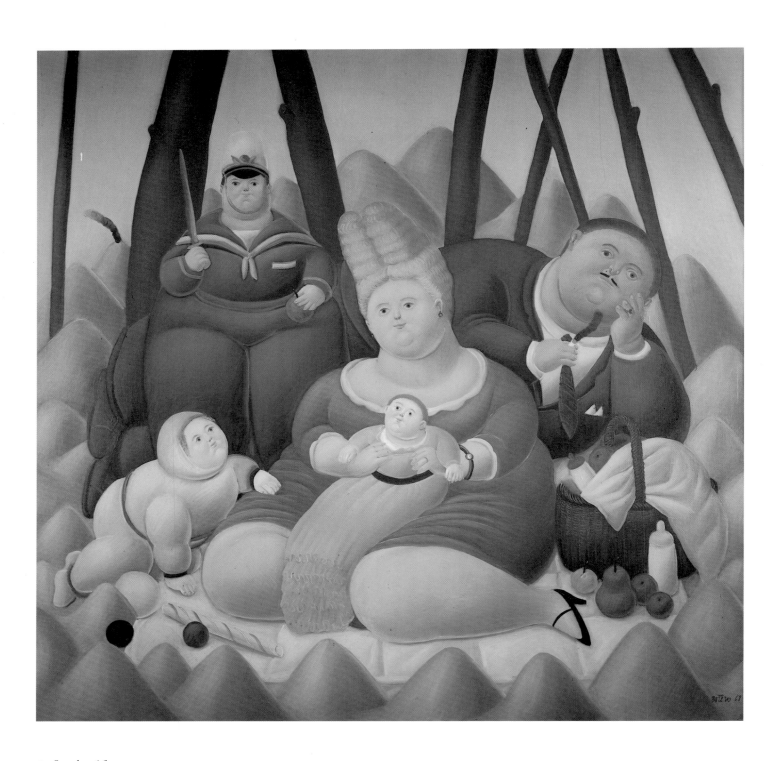

6 *Sunday Afternoon*

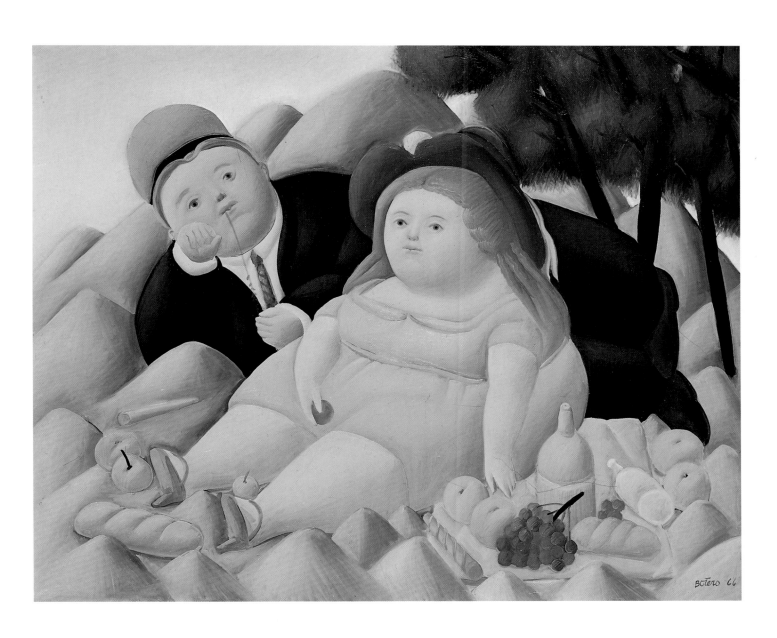

7 *Picnic in the Mountains*

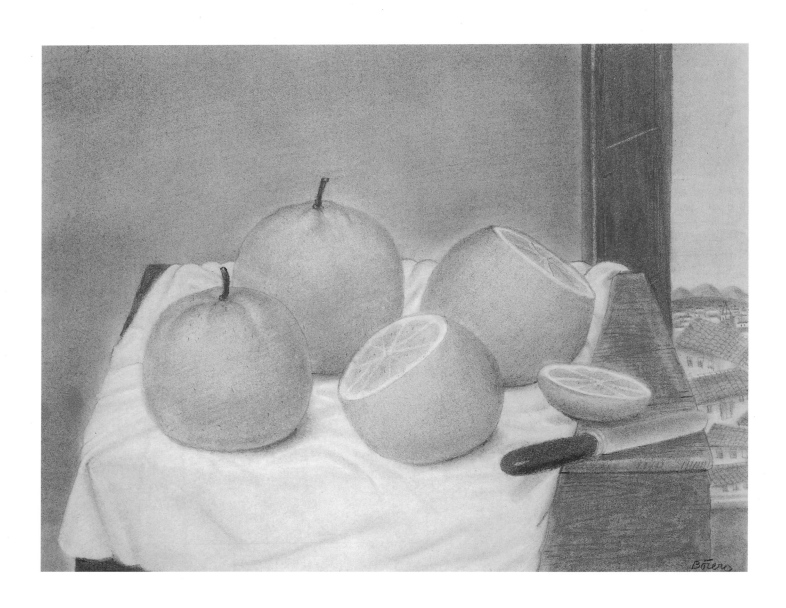

8 *Oranges*

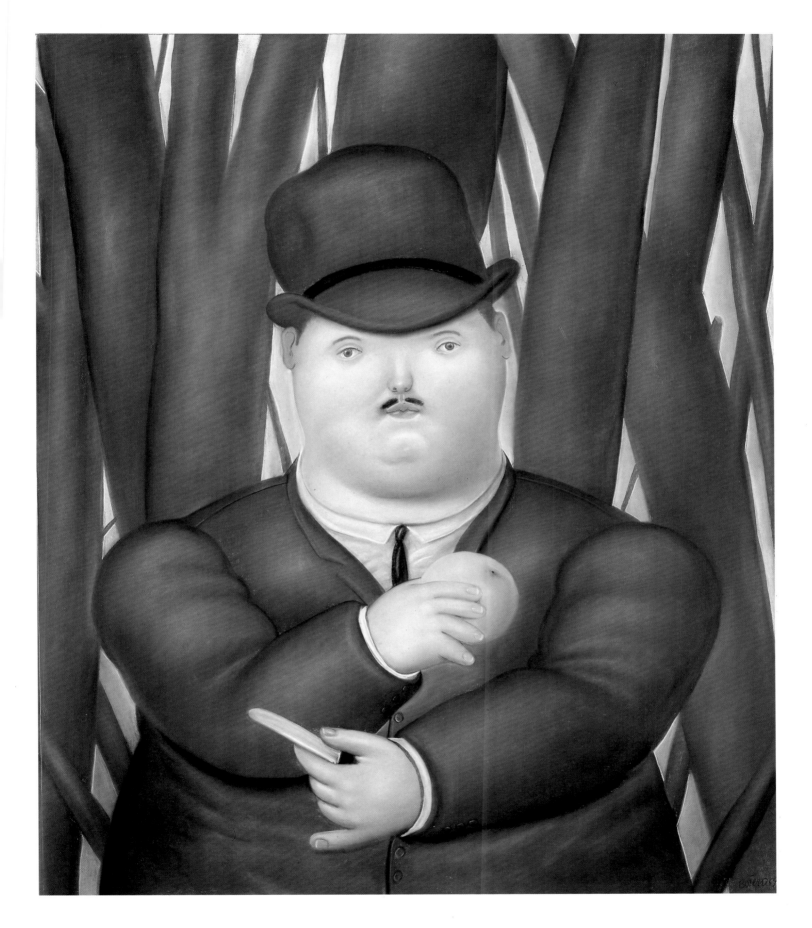

9 *Man*

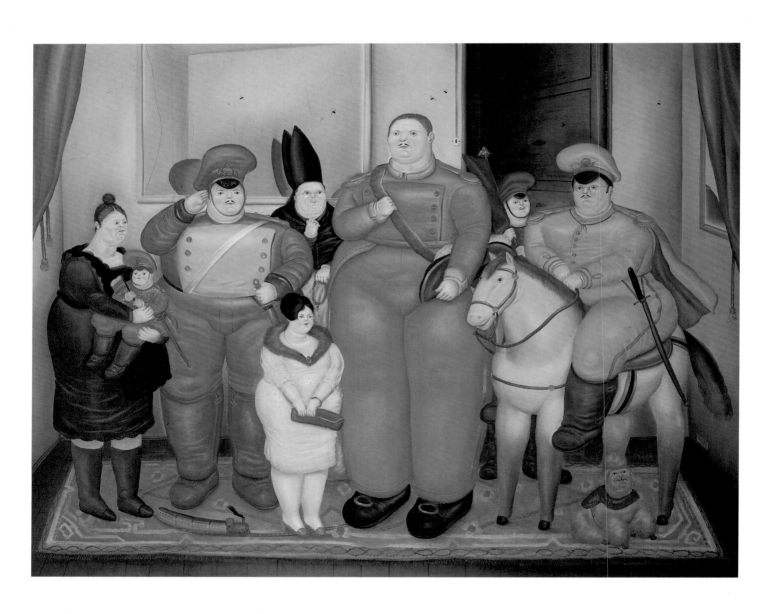

10 *Official Portrait of the Military Junta*

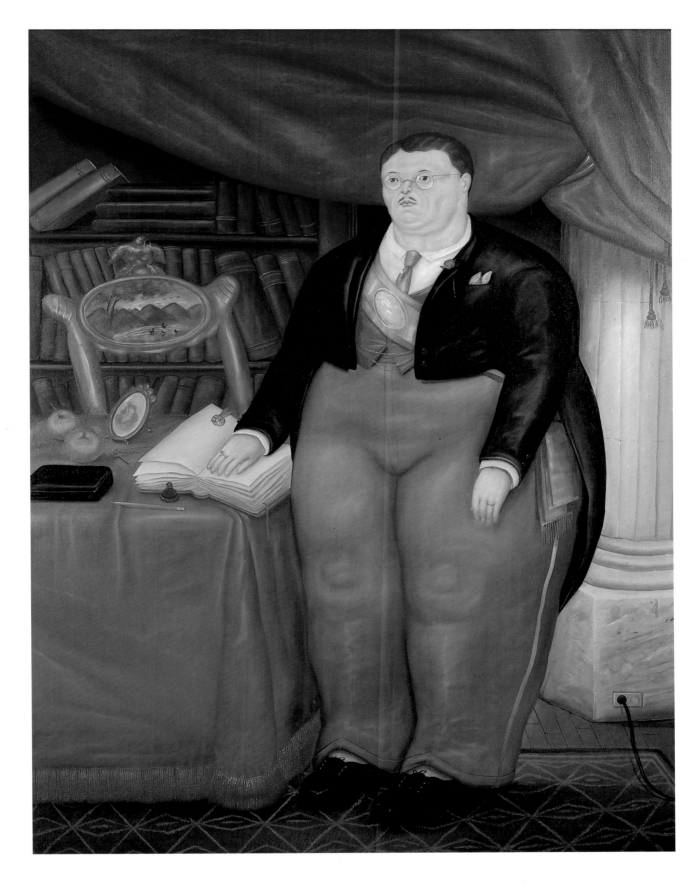

11 *The President*

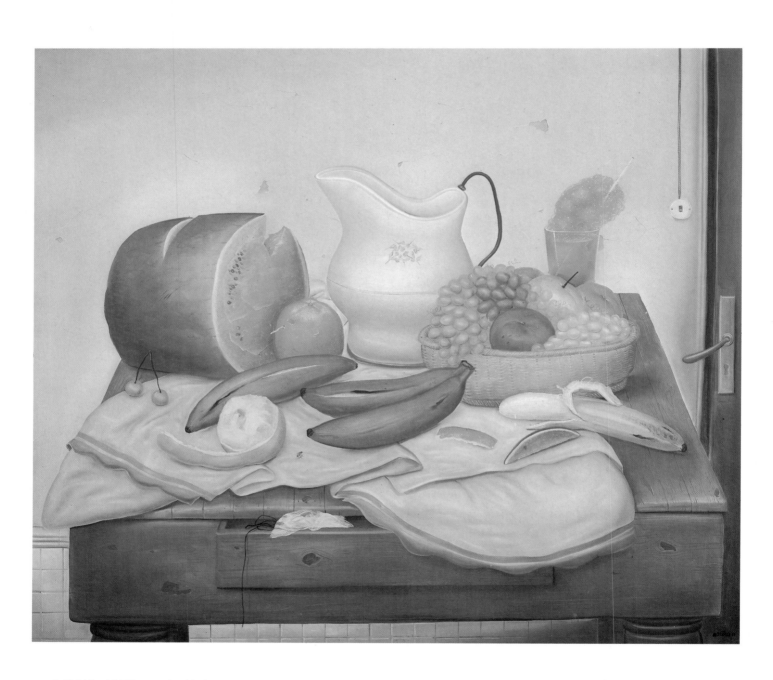

12 *Still Life with Watermelon Shake*

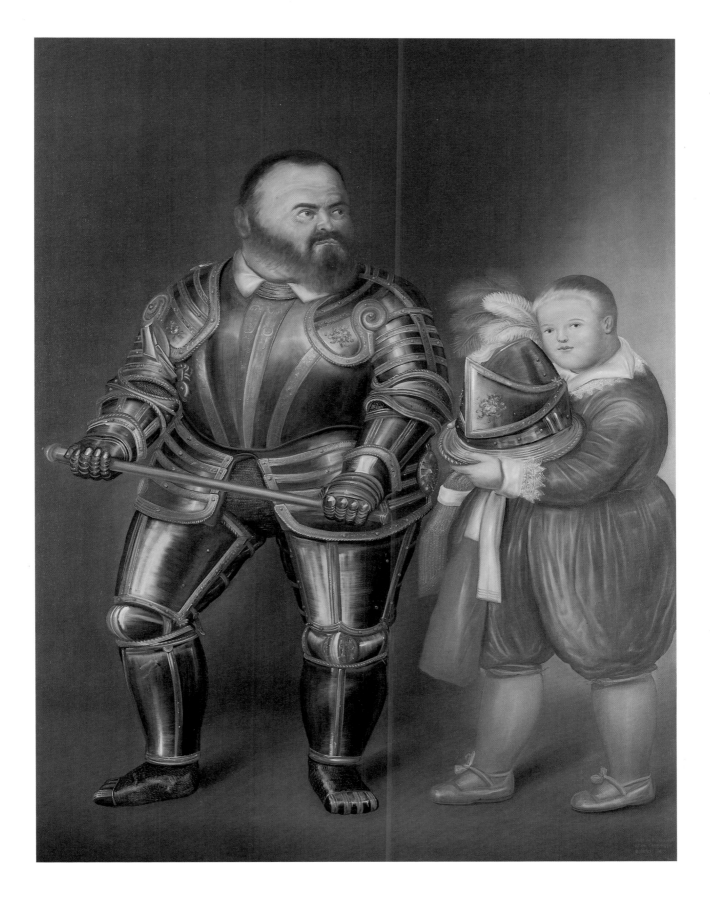

13 *Alof de Vignancourt (after Caravaggio)*

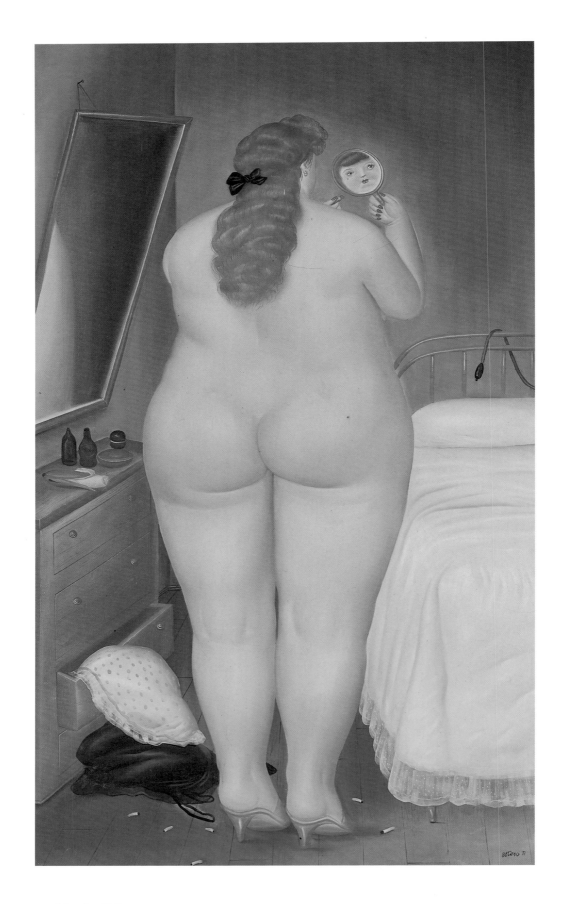

14 *Morning Toilet*

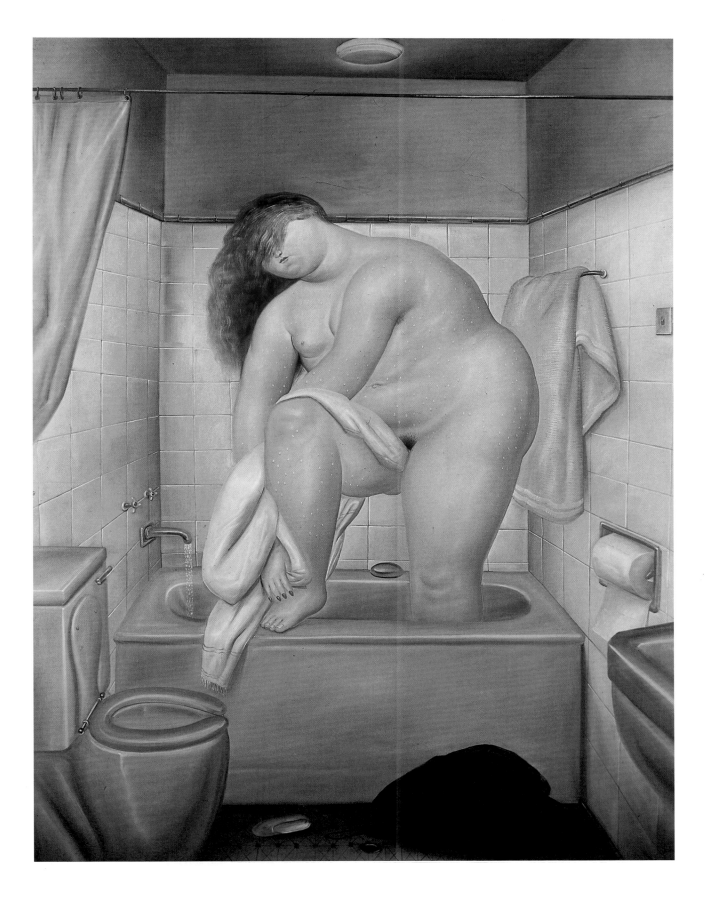

15 *Homage to Bonnard*

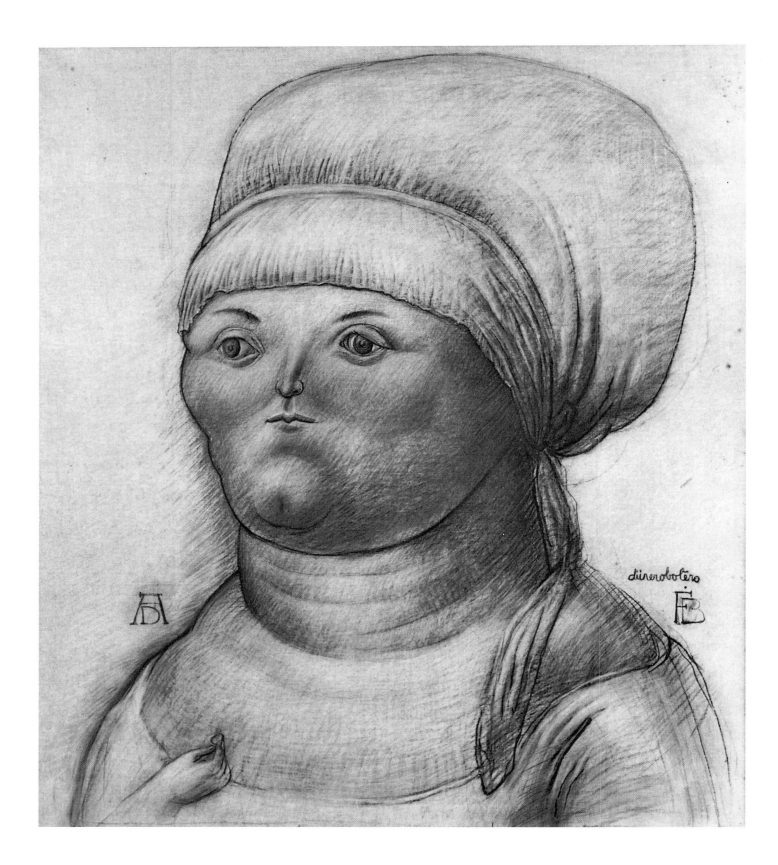

16 *Elspeth Tucher (after Dürer)*

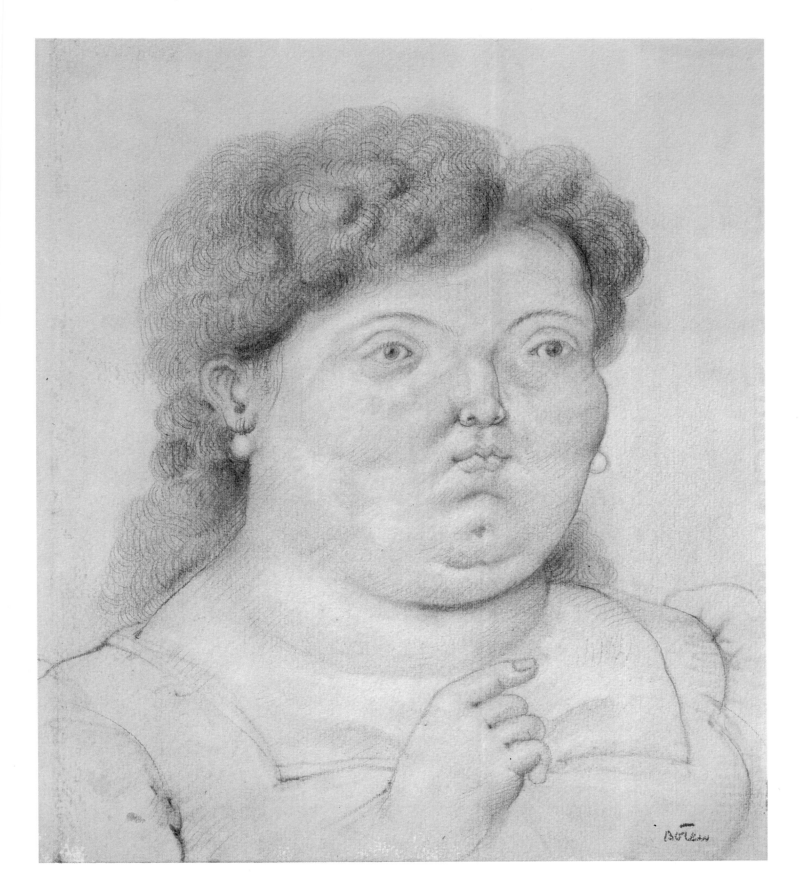

17 *Woman*

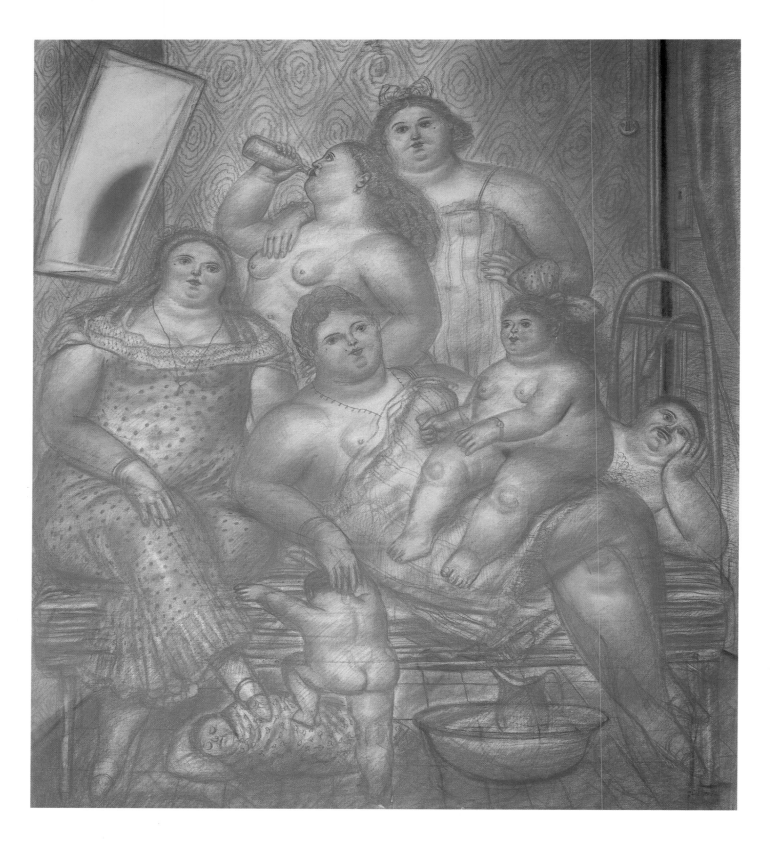

18 *The House of Anna Molina*

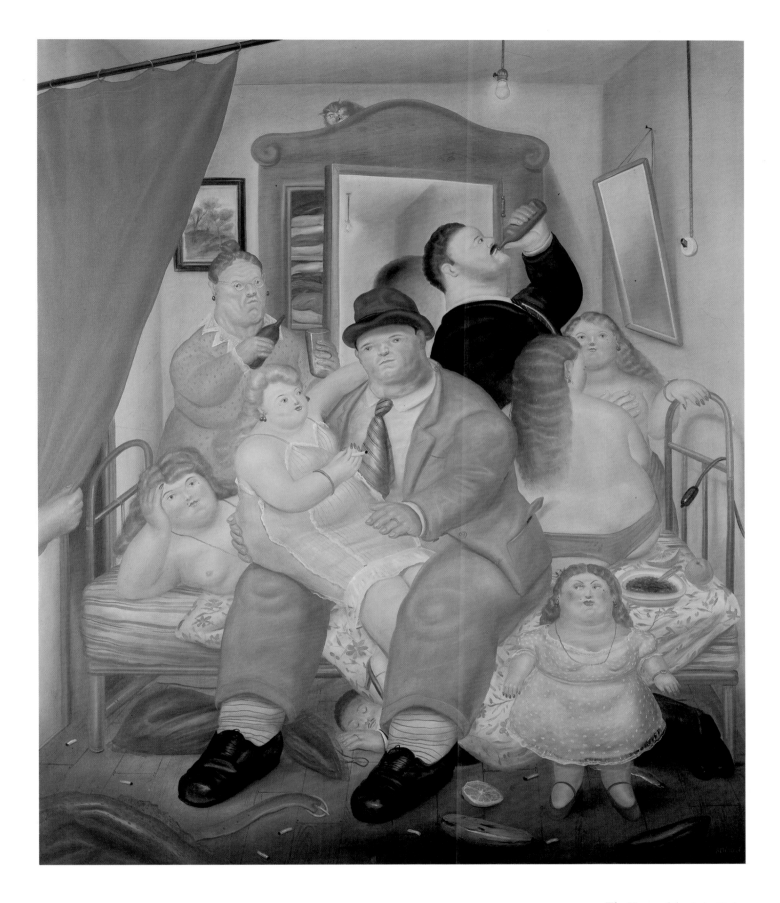

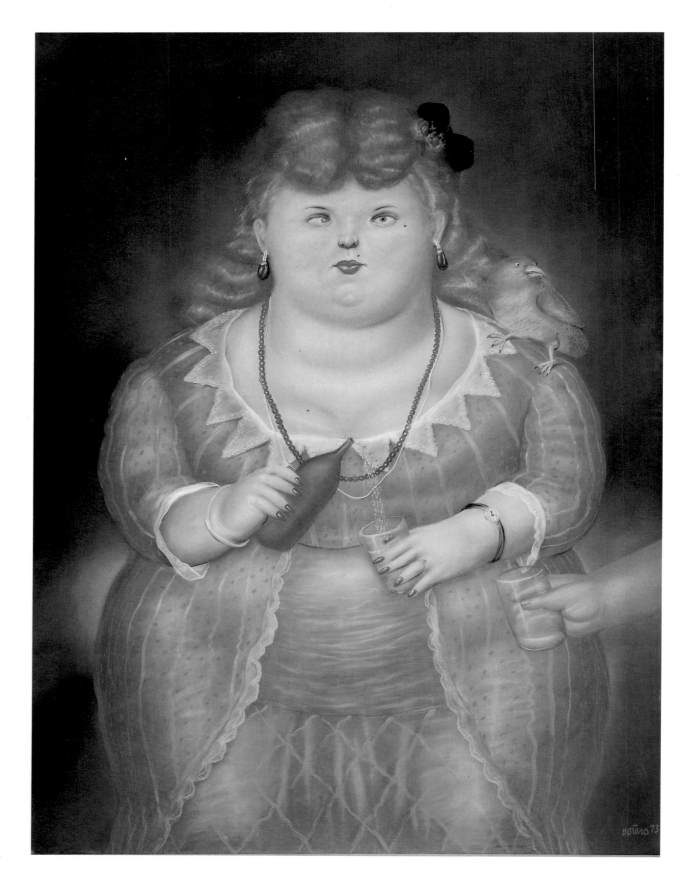

20 *Woman with Parrot*

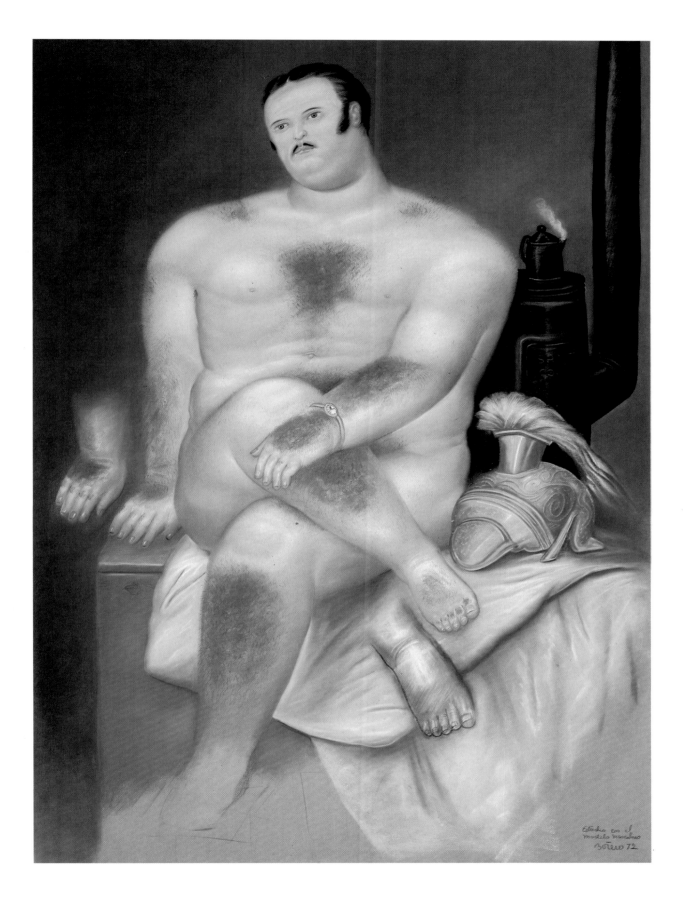

21 *Study with Male Model*

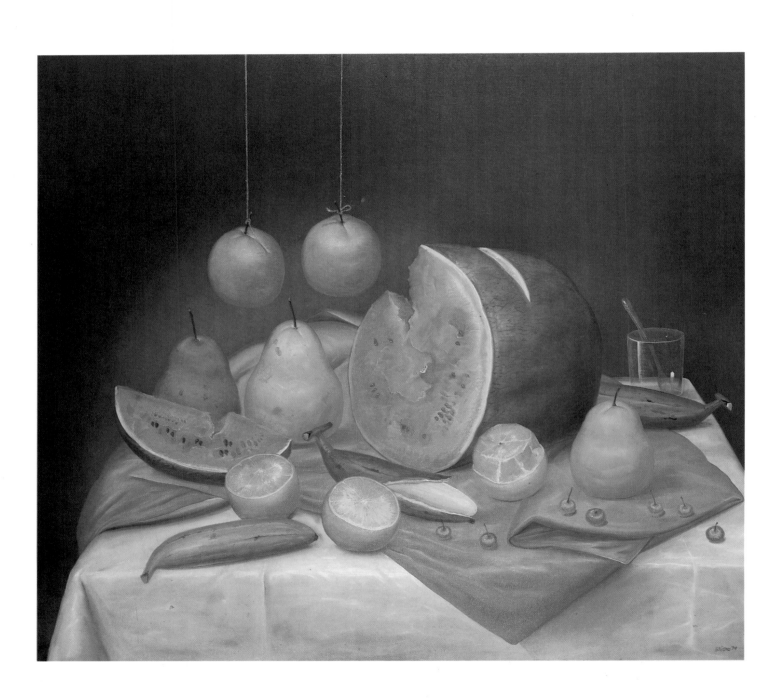

22 *Still Life with Watermelon*

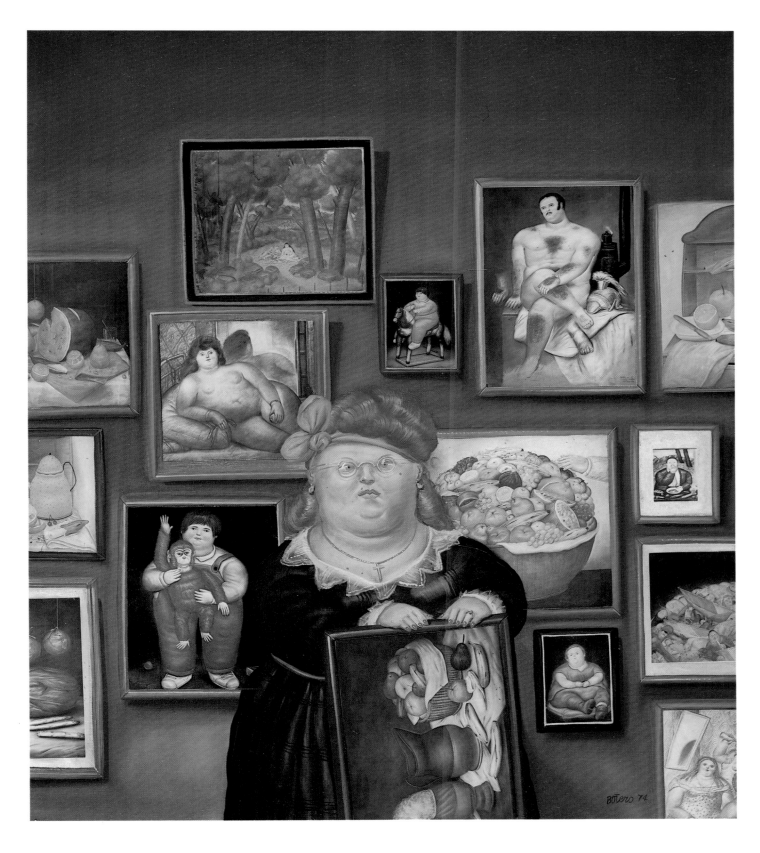

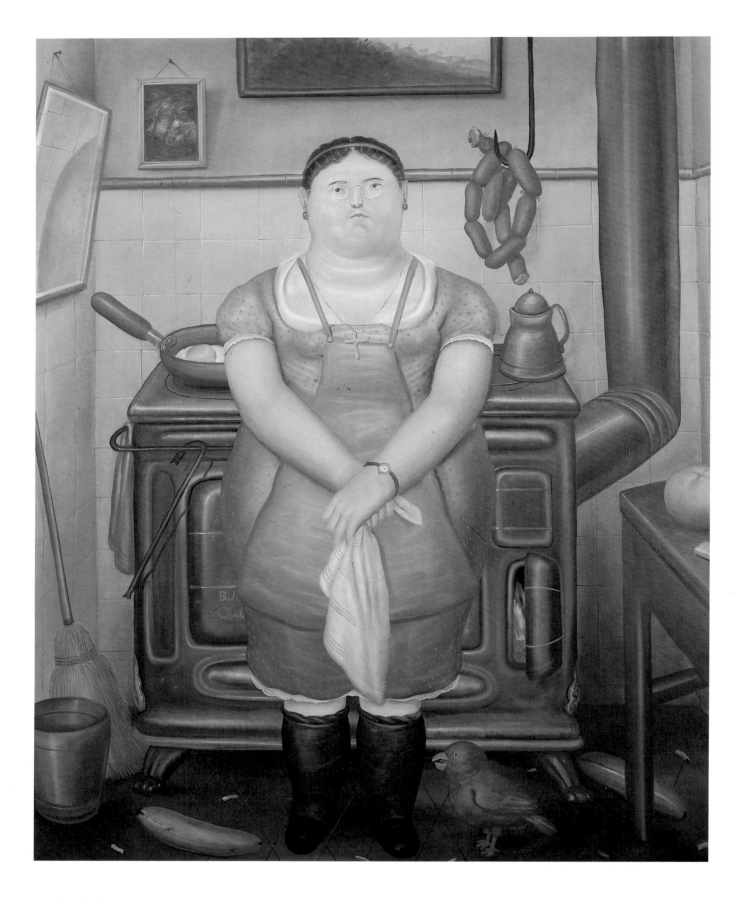

24 *The Maid*

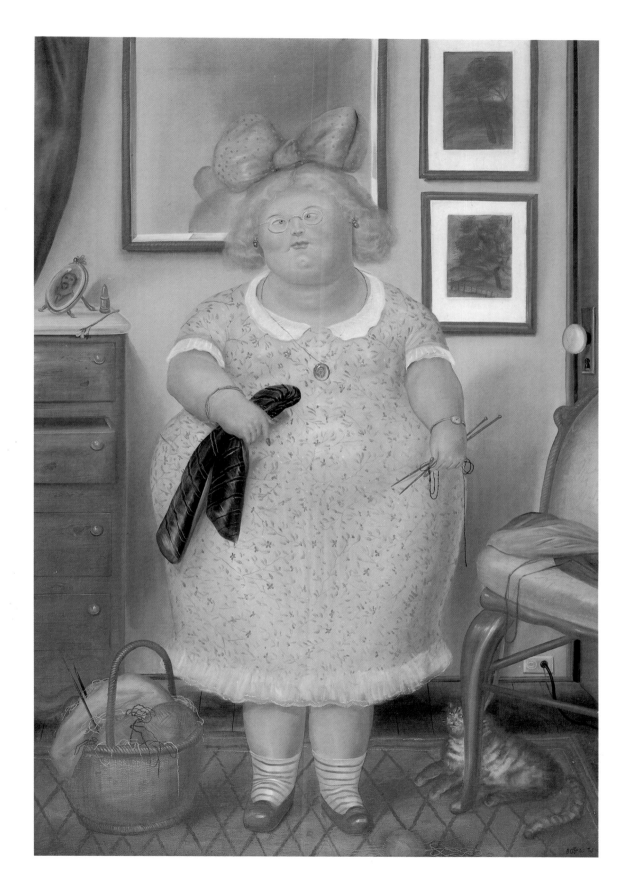

25 *The Old Maid*

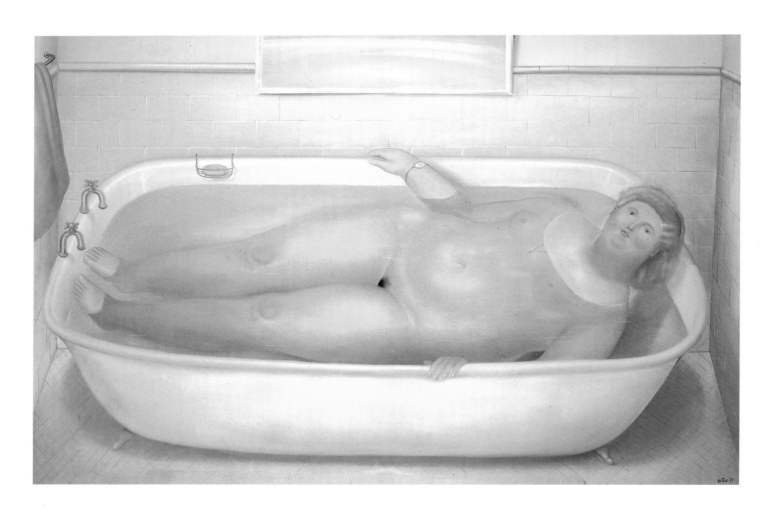

26 *Homage to Bonnard*

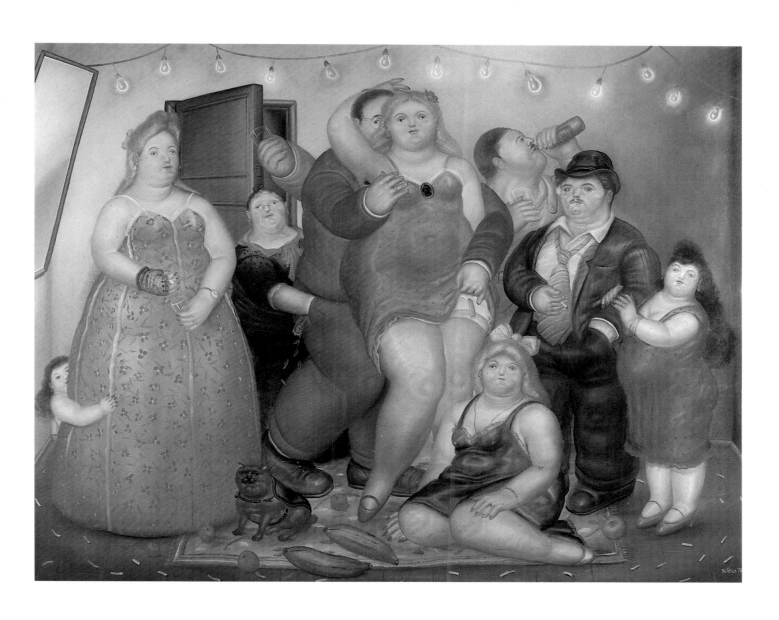

27 *The House of Raquel Vega (Medellín, Colombia)*

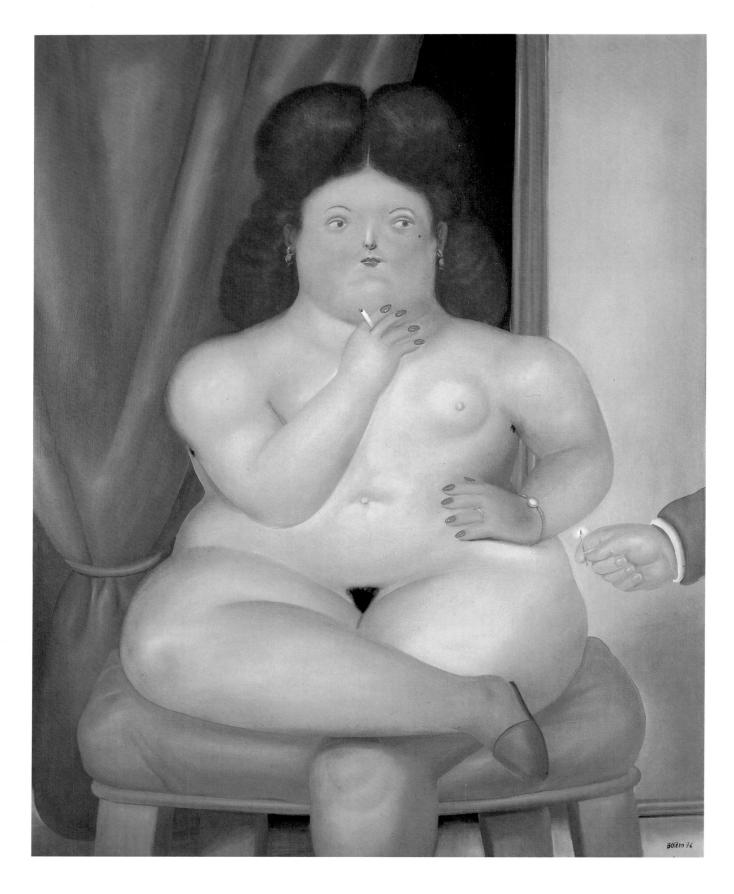

28 *Seated Woman*

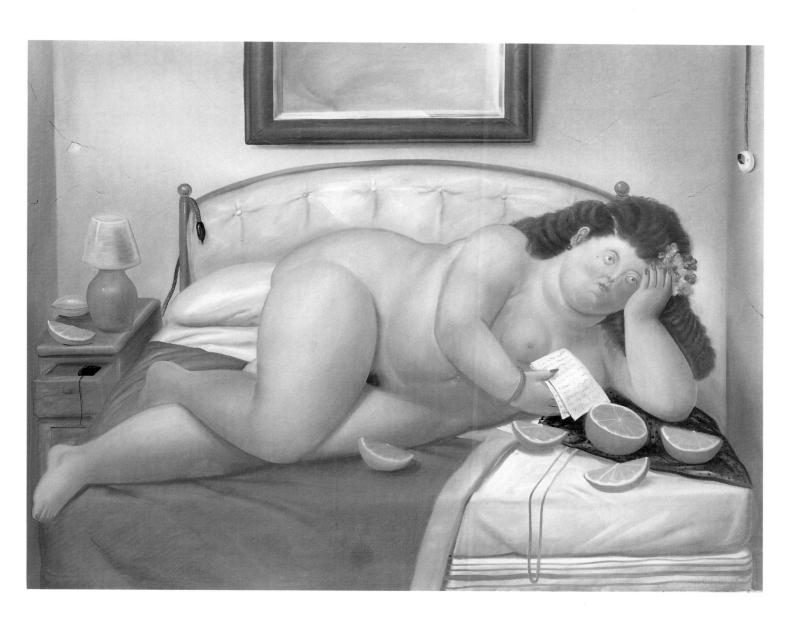

29 *The Letter*

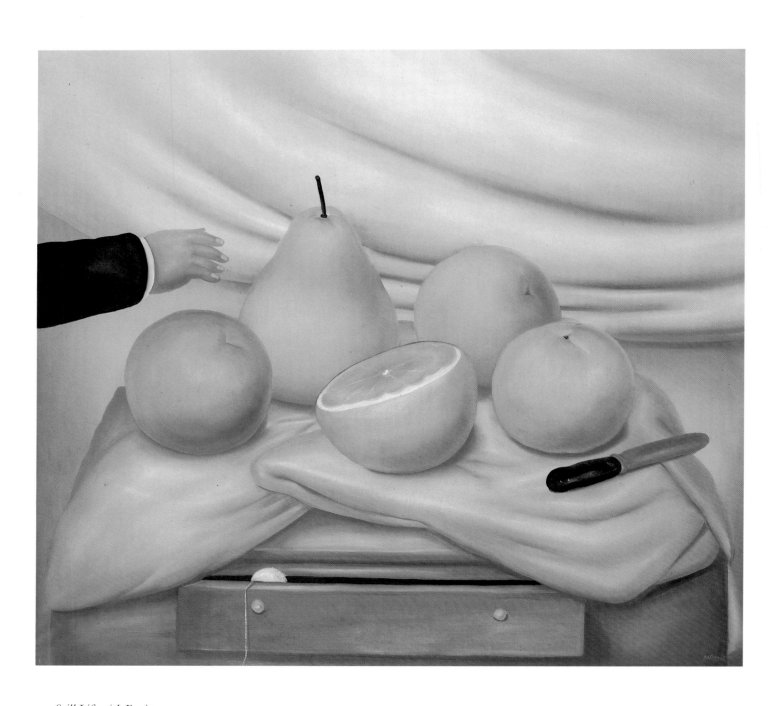

30 *Still Life with Fruit*

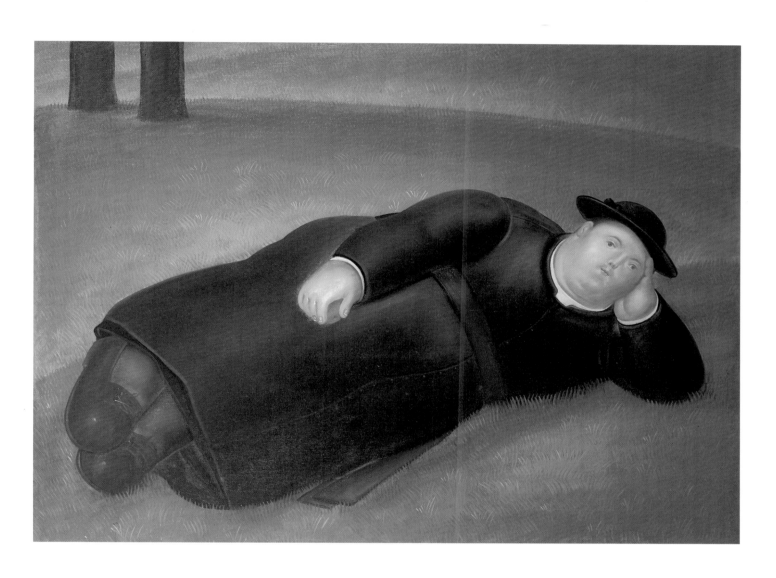

31 *Reclining Priest*

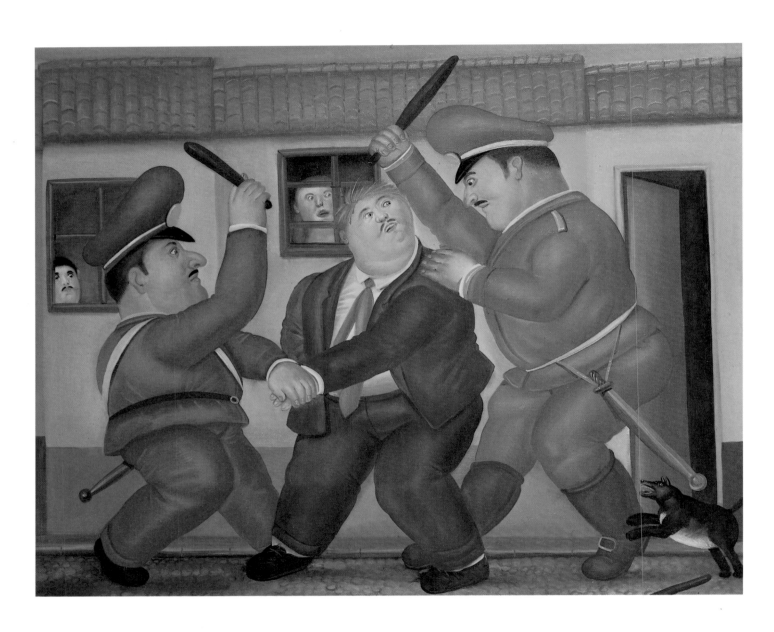

32 *Untitled*

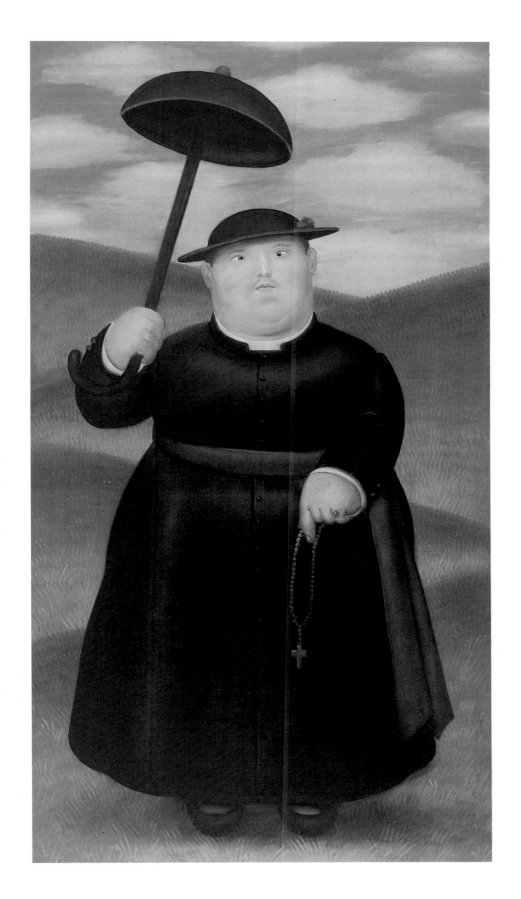

33 *Stroll in the Hills*

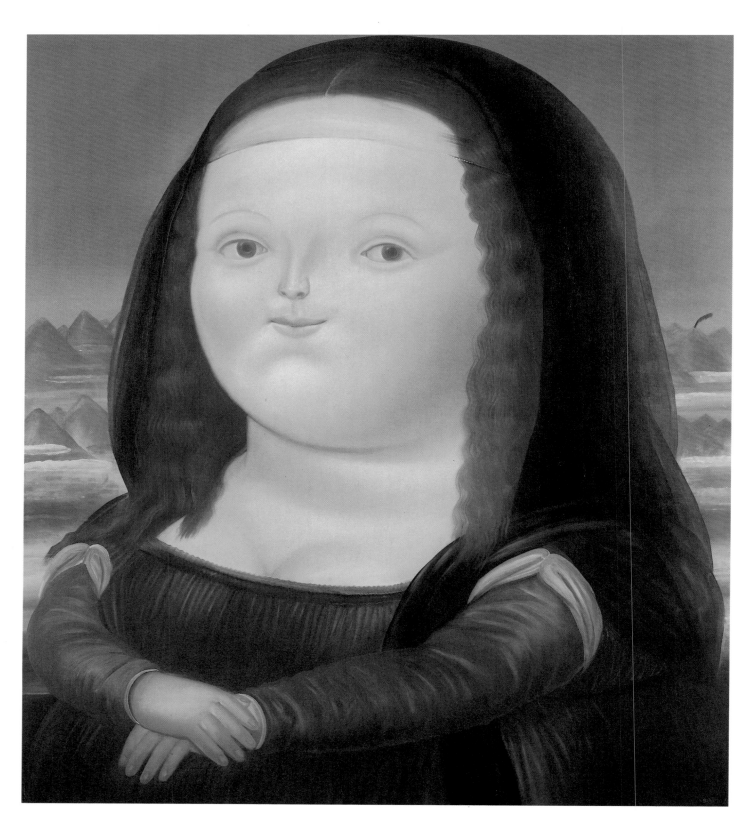

34 *Mona Lisa*

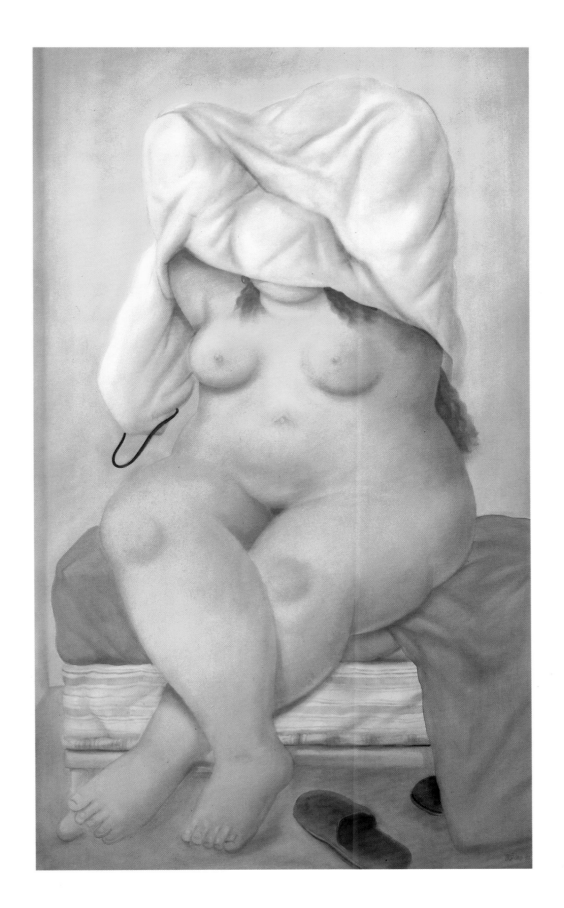

35 *Woman Undressing*

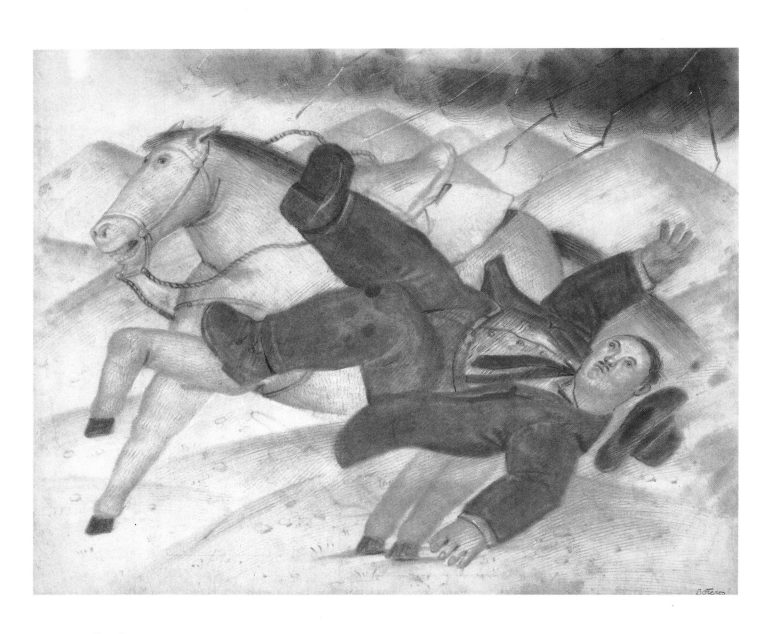

36 *Man Falling from a Horse*

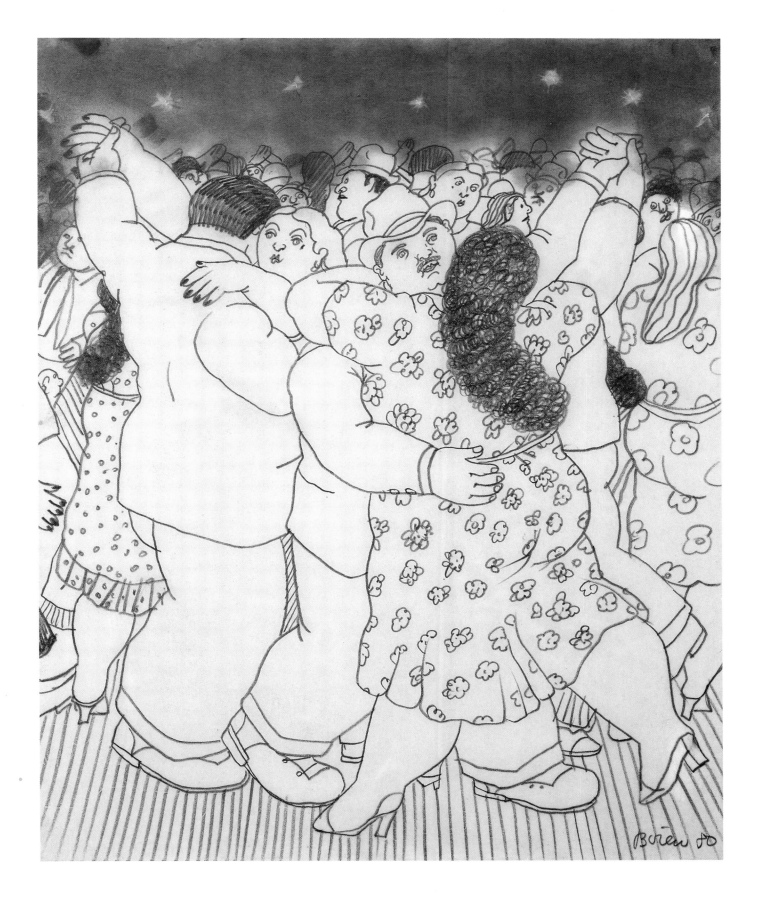

37　*The Dance*

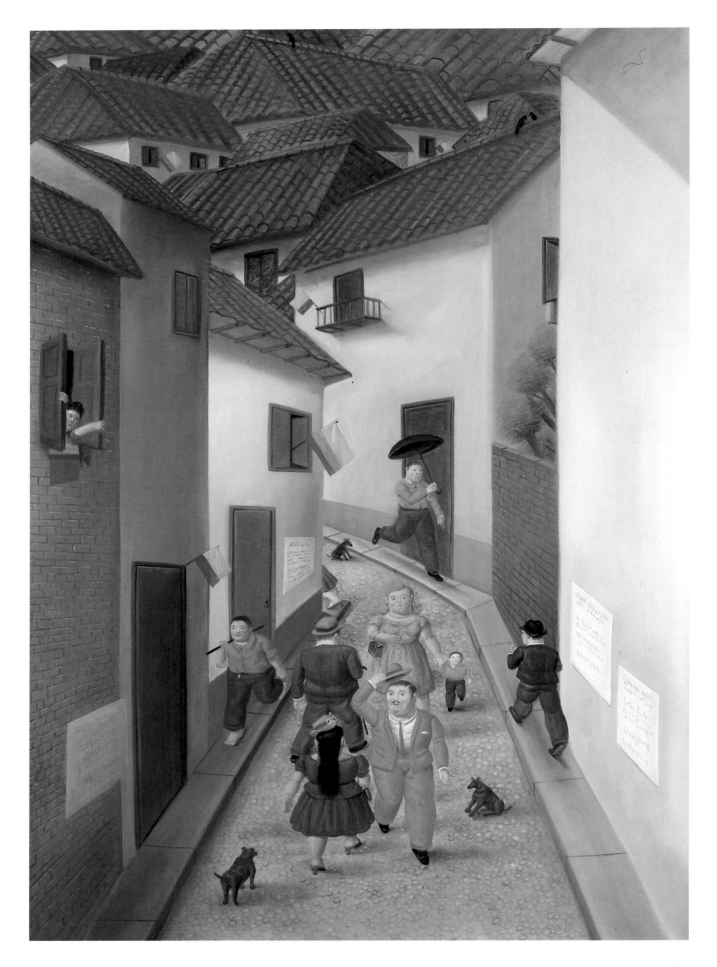

39 *The Thief*

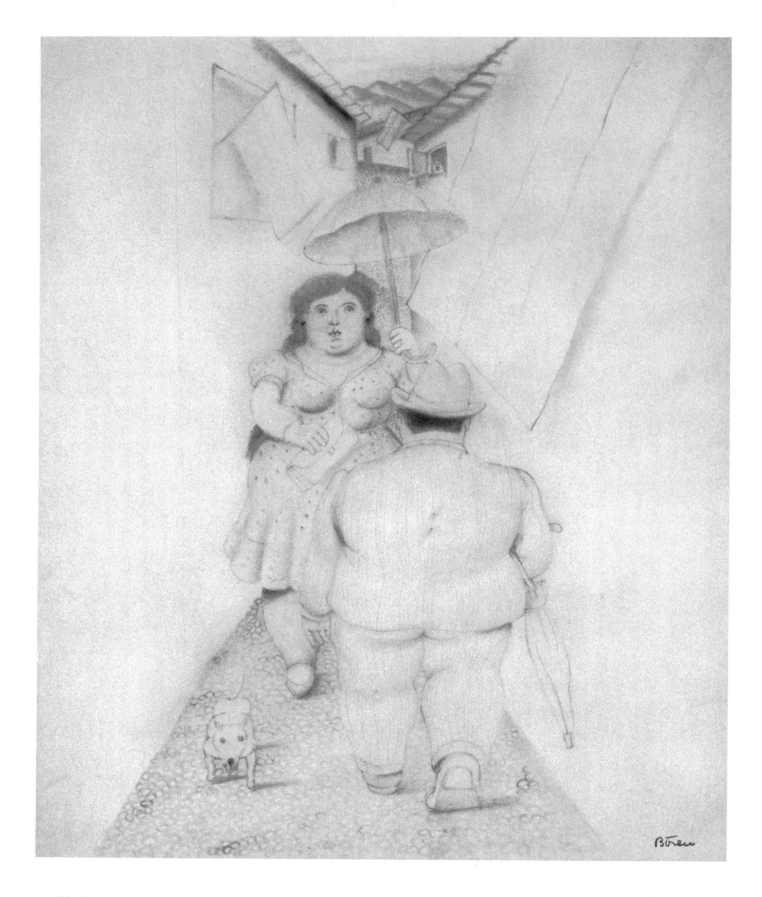

40 *The Street*

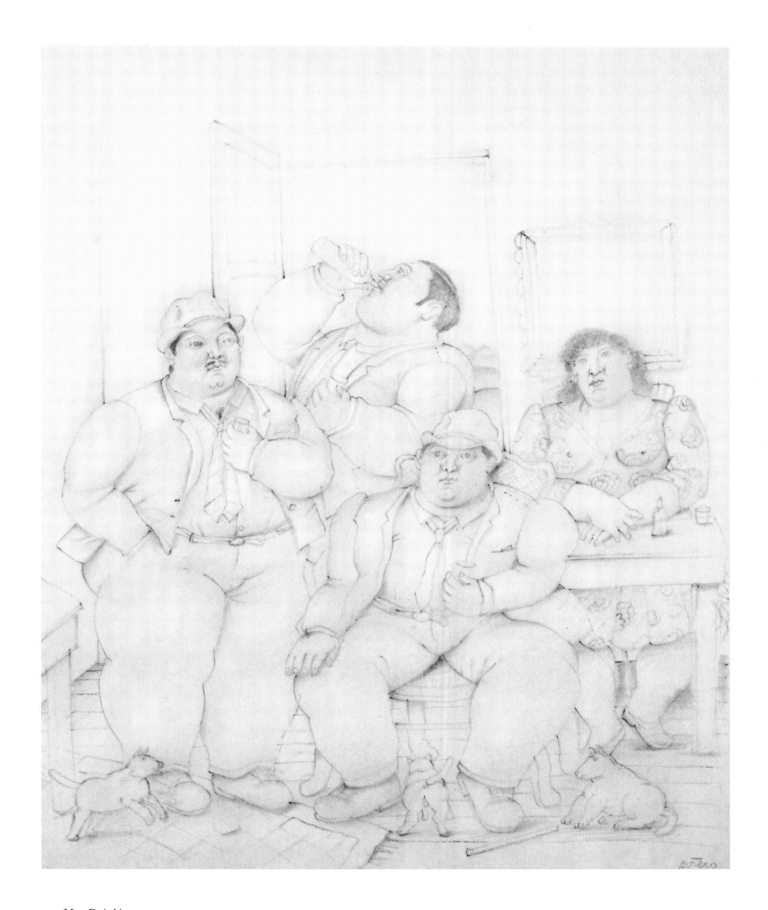

41 *Men Drinking*

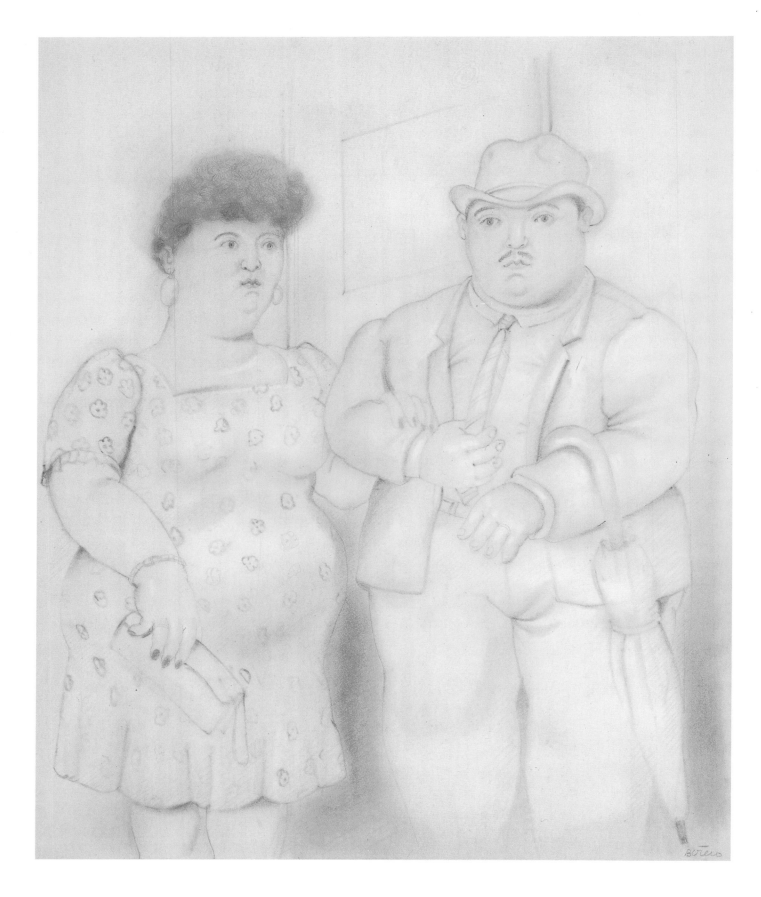

42 *Couple*

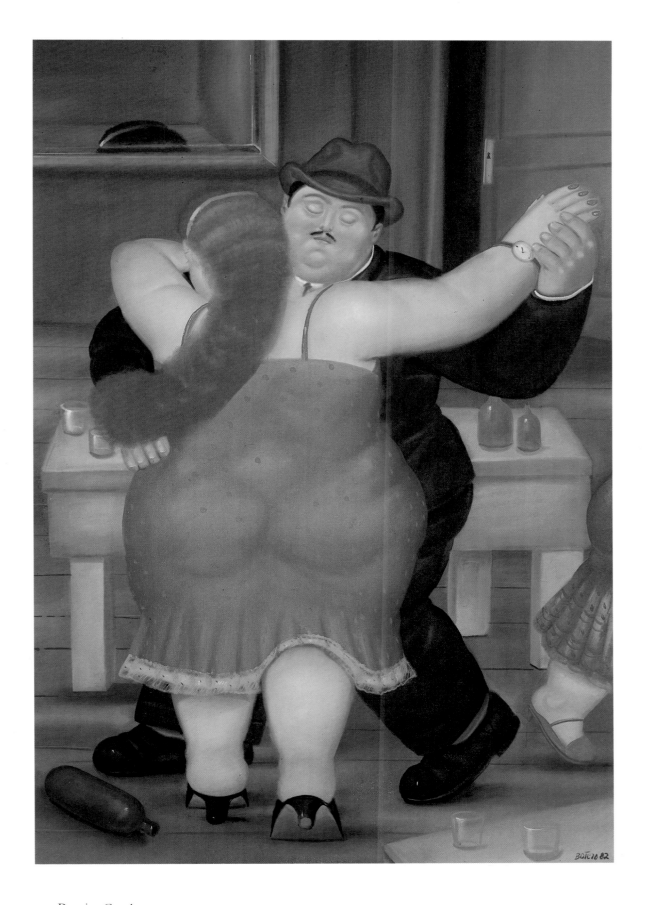

43 *Dancing Couple*

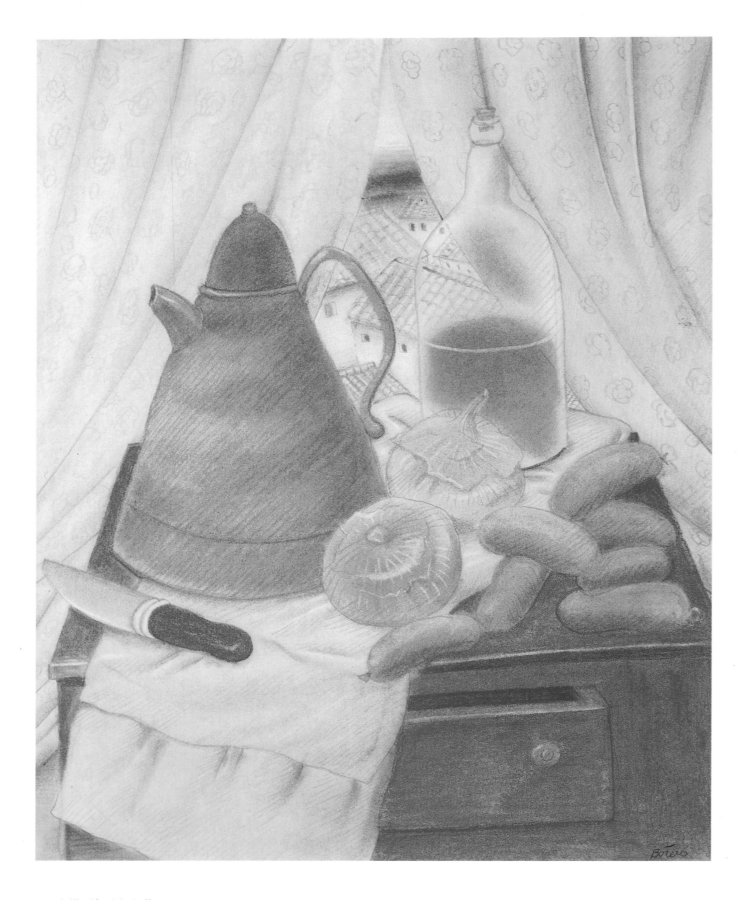

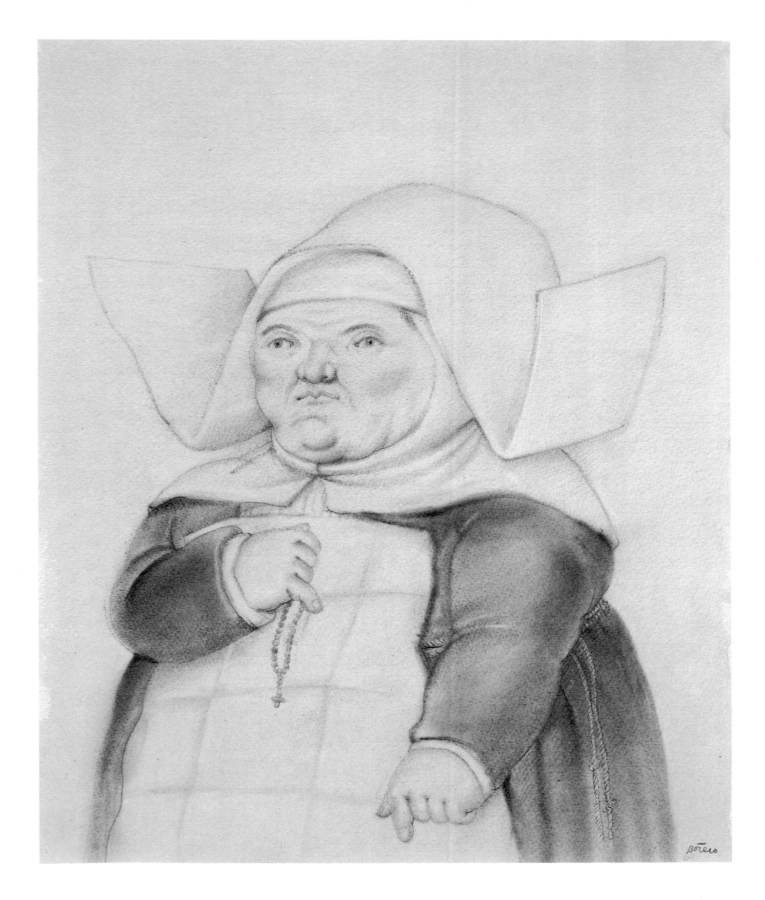

45 *Nun*

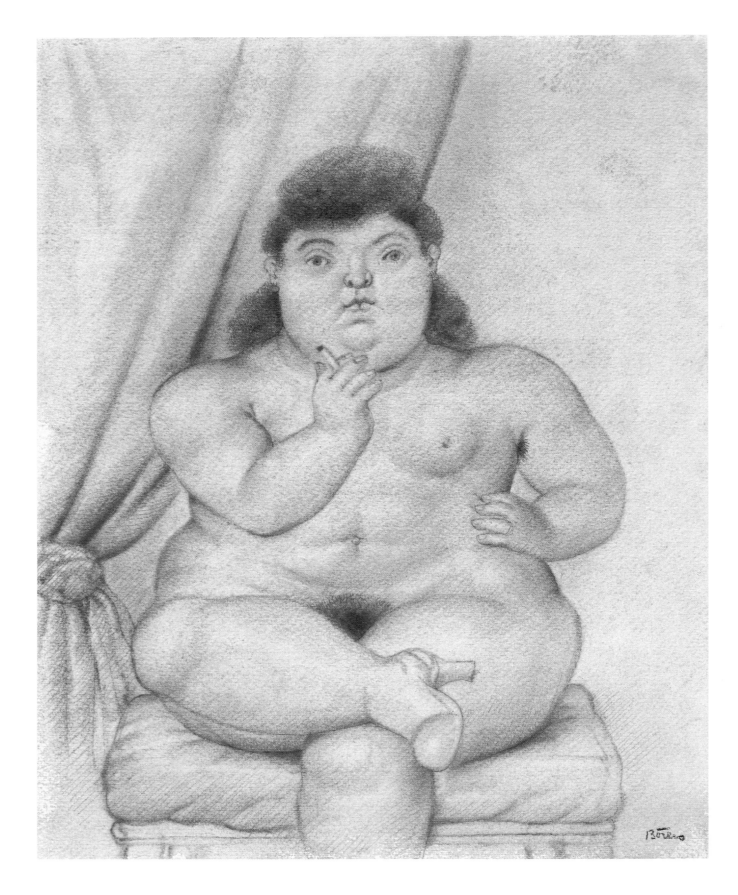

46 *Scated Woman*

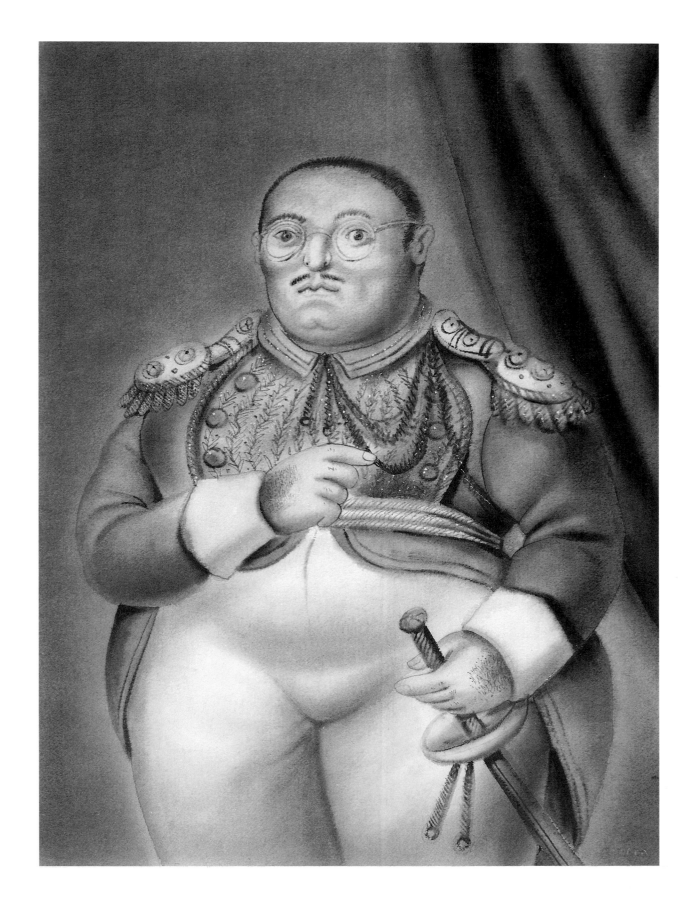

47 *The General*

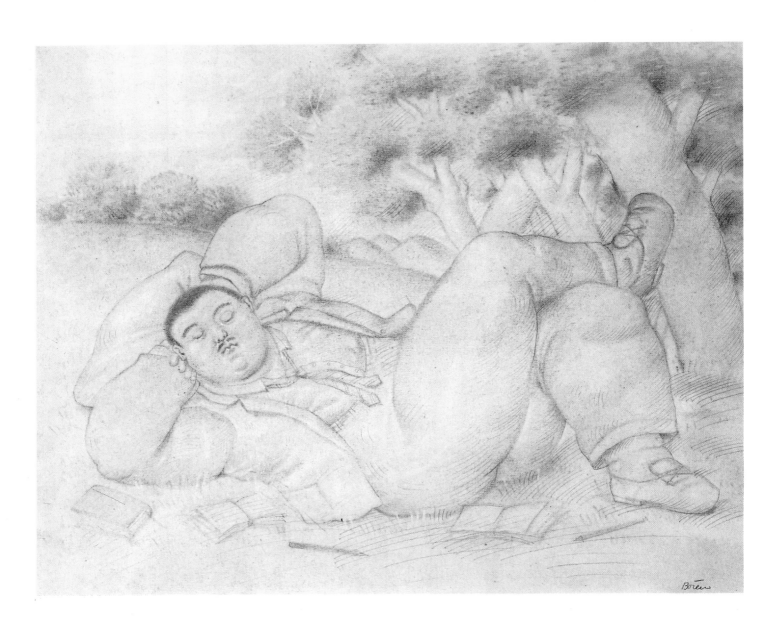

48 *The Poet*

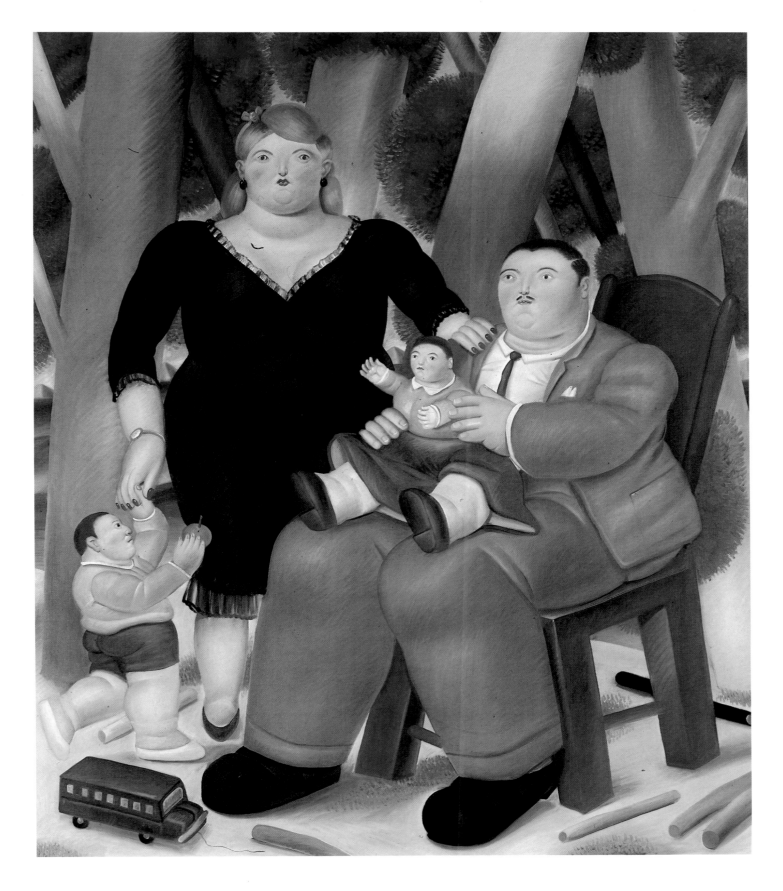

49 *Family Group*

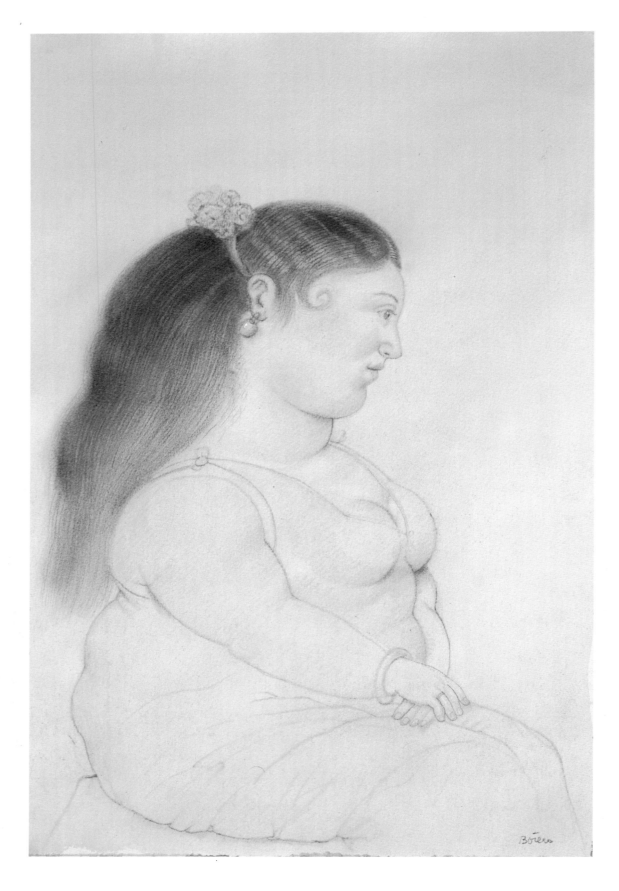

50 *Seated Woman*

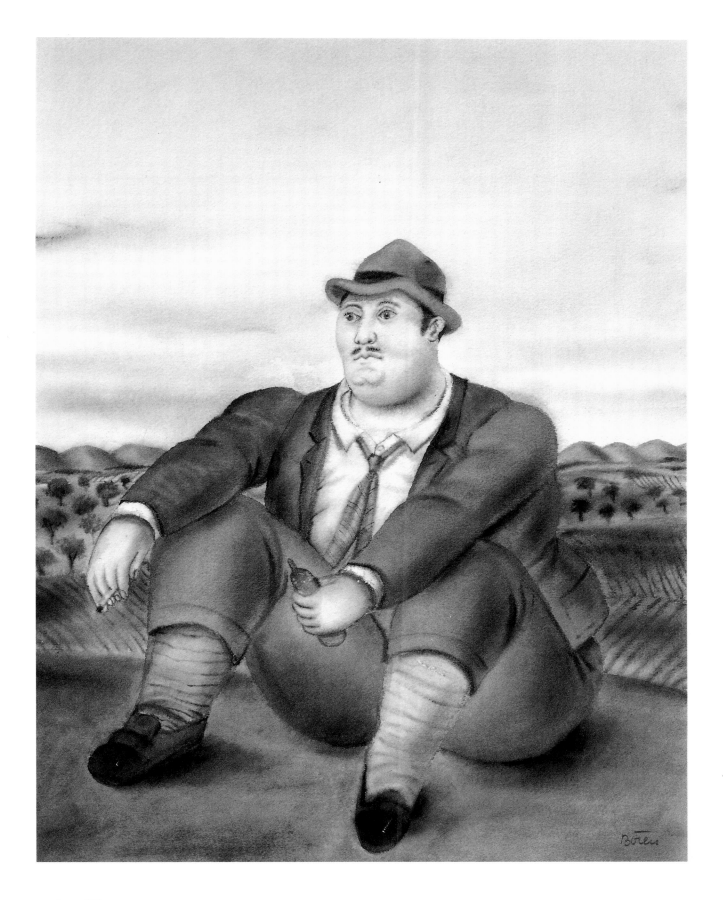

51 *Seated Man*

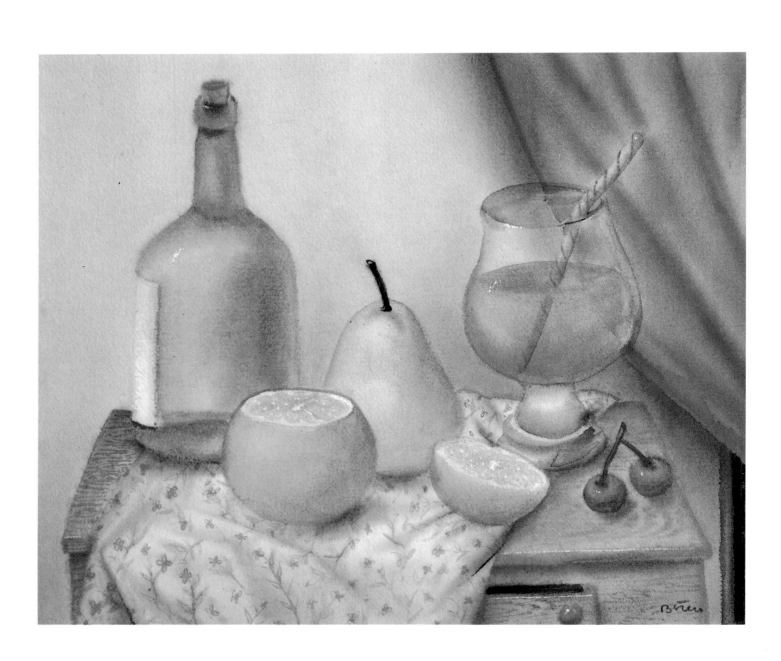

52 *Still Life with Bottle and Glass*

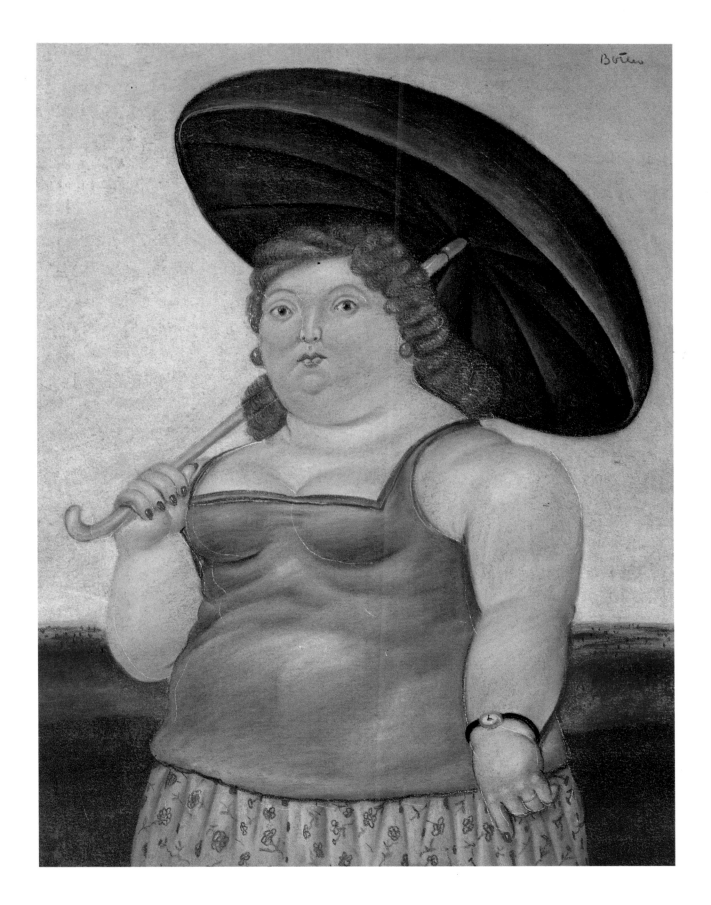

53 *Woman with Umbrella*

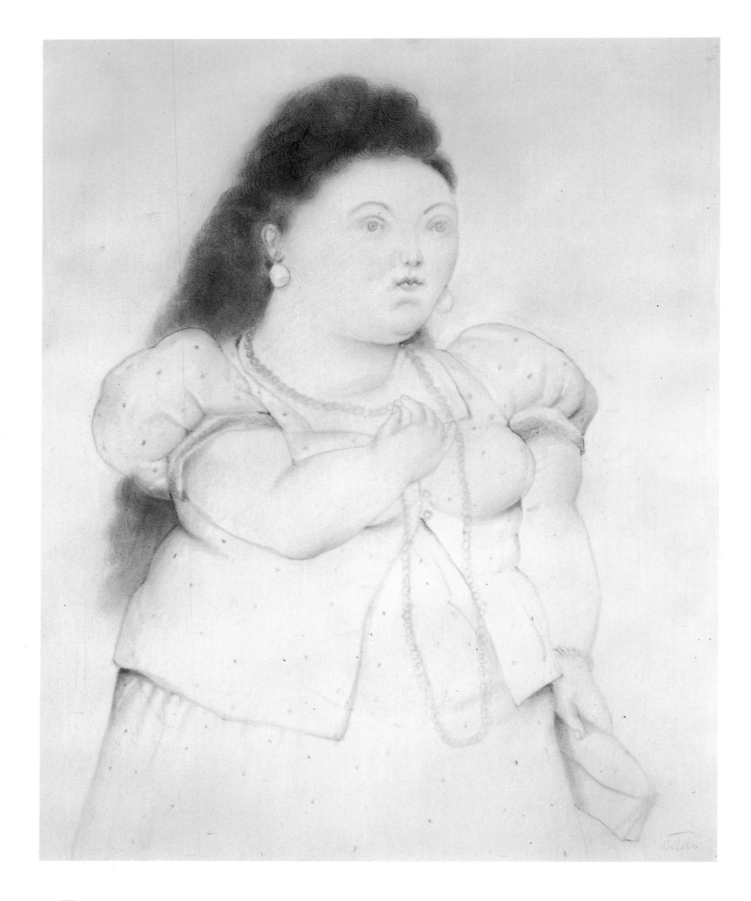

54 *Woman*

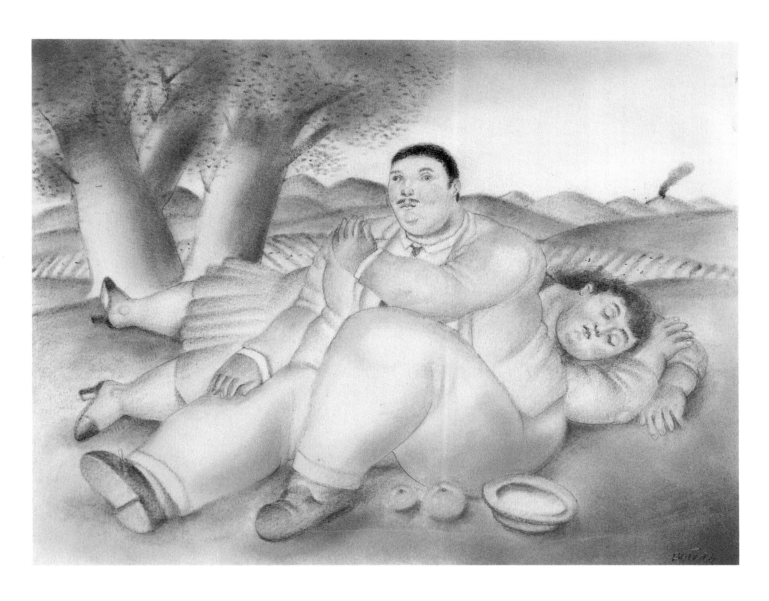

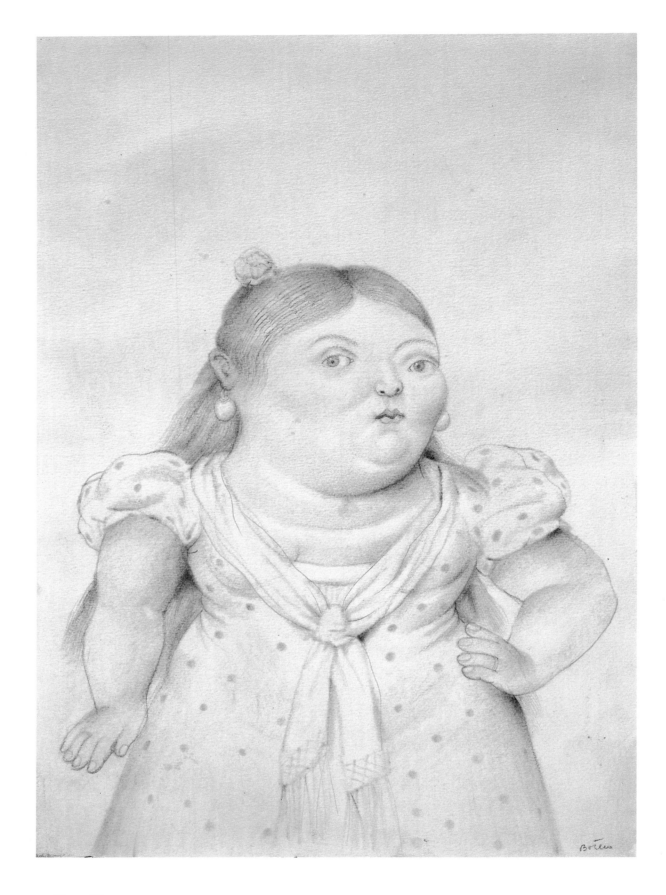

56 *Young Woman*

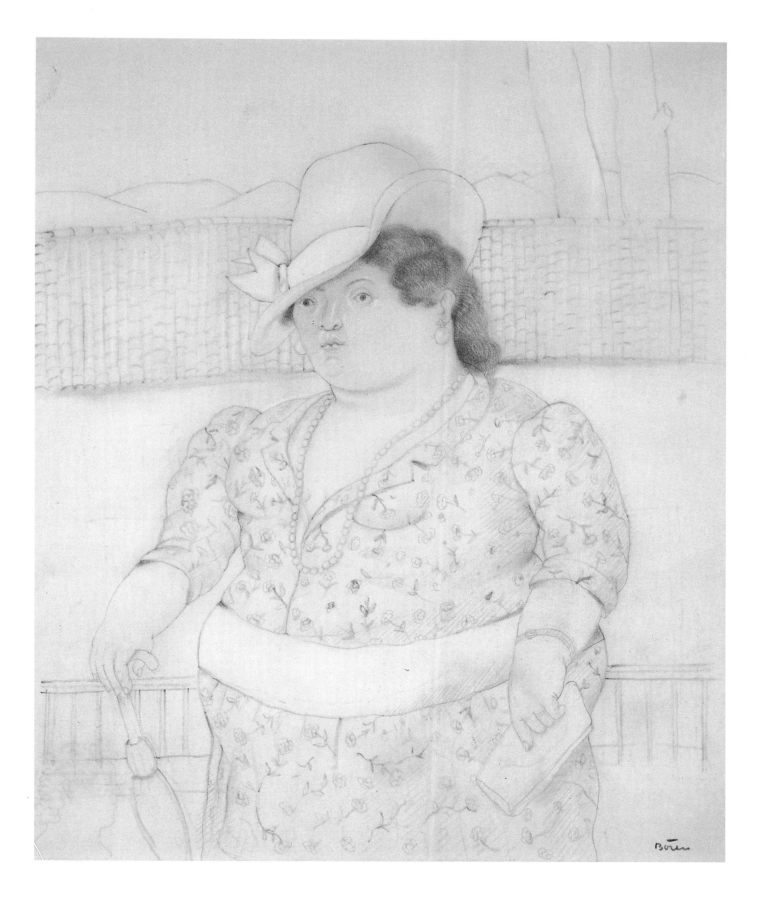

57 Woman

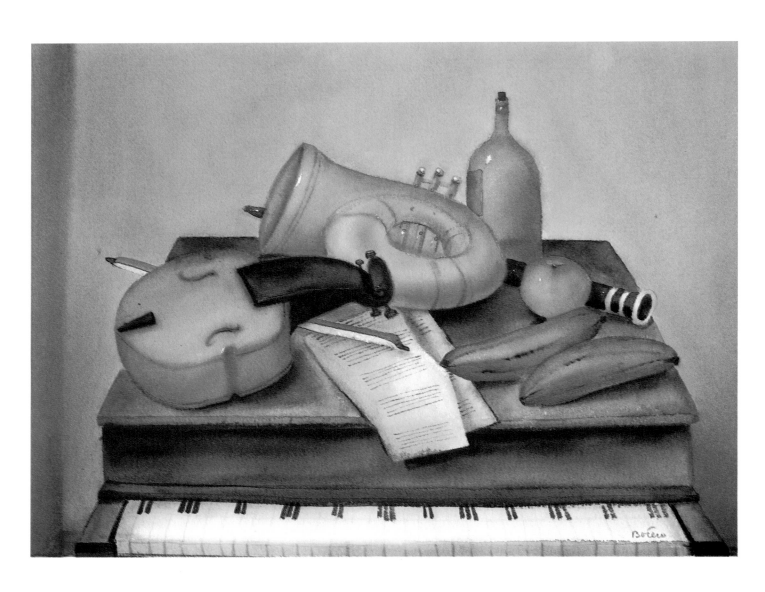

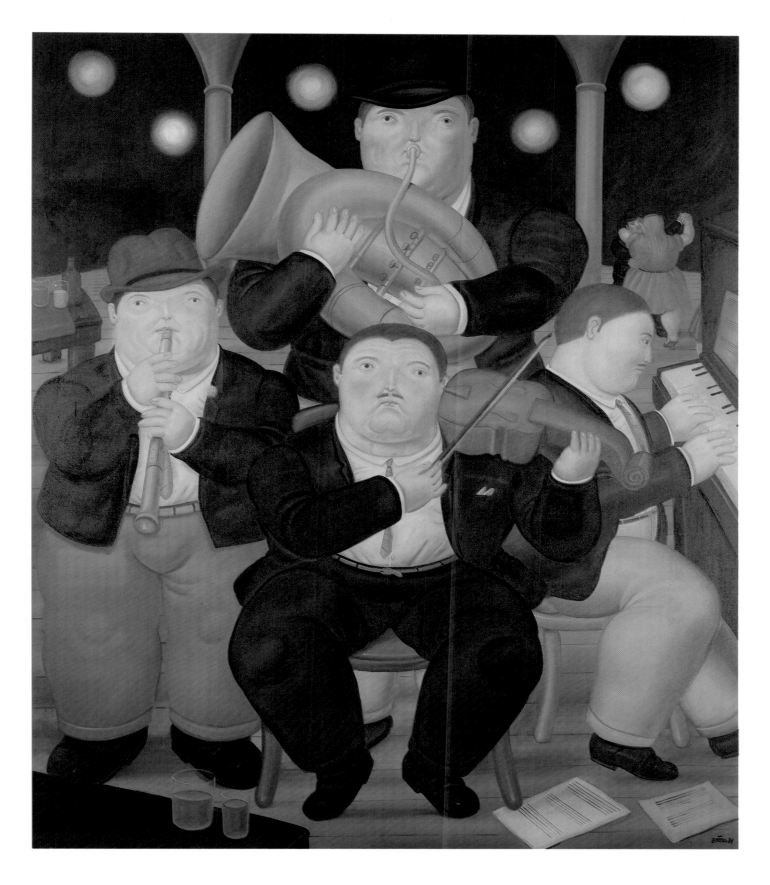

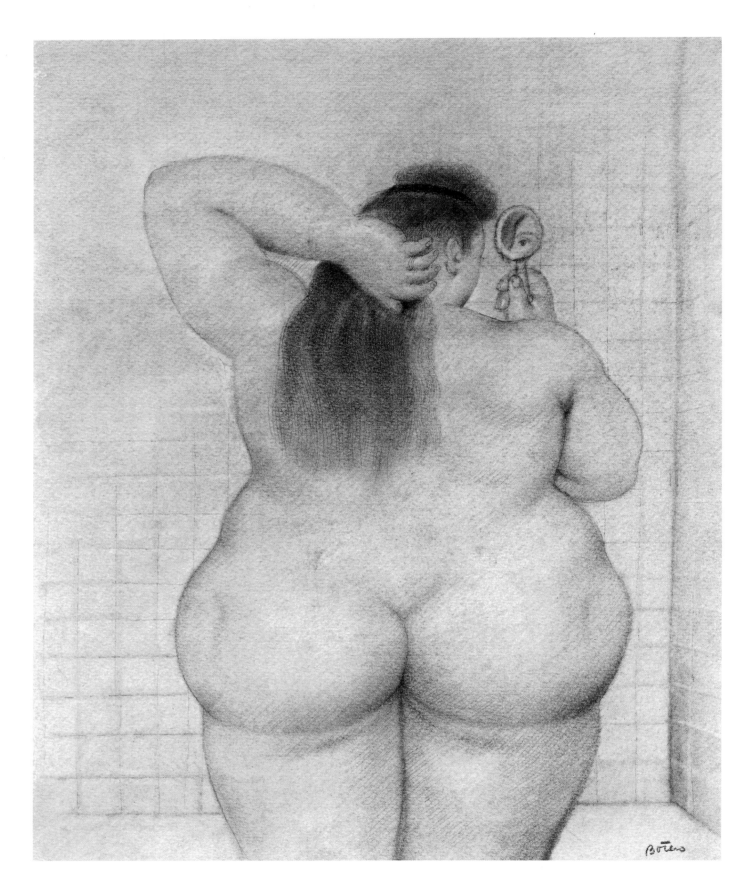

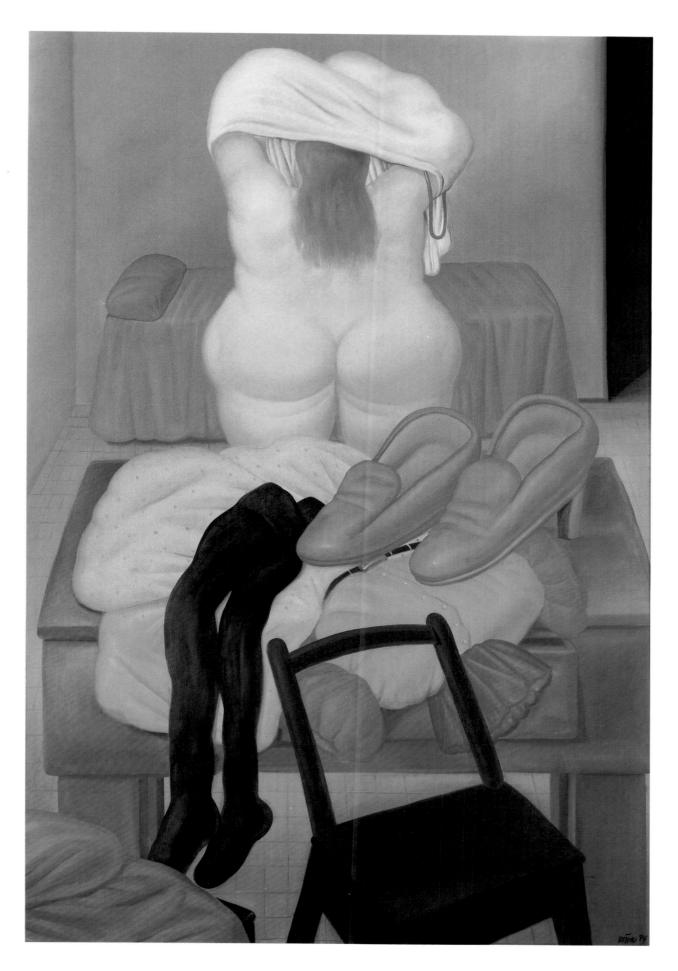

61 *Still Life with Woman Undressing*

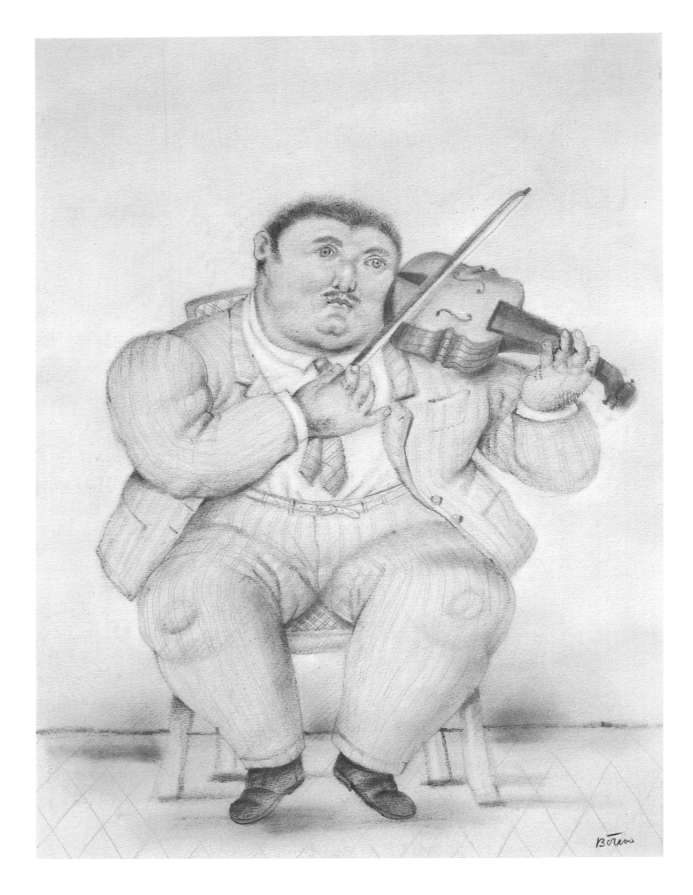

62 *Violinist*

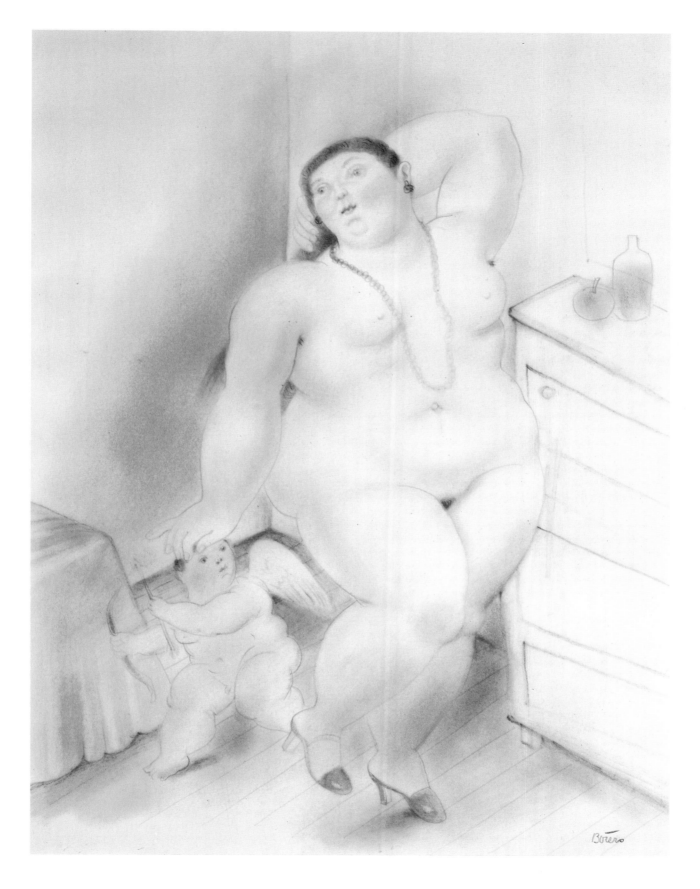

63 *Venus*

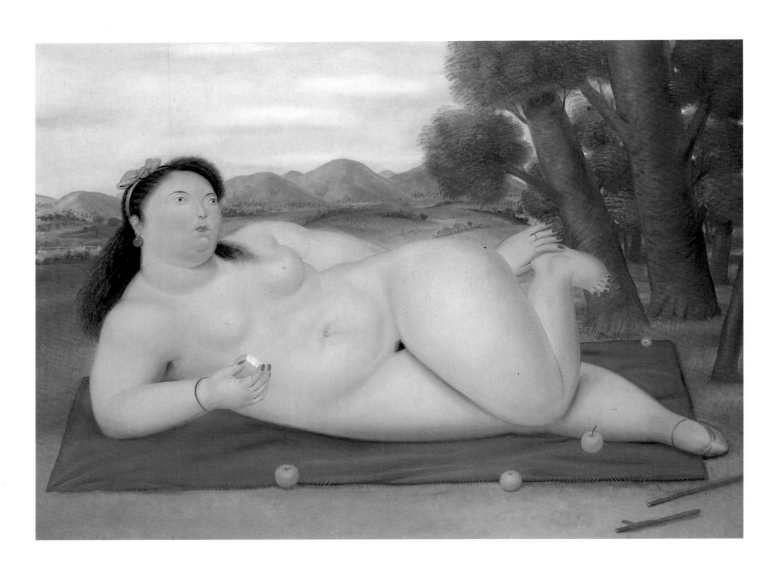

64 *Colombiana*

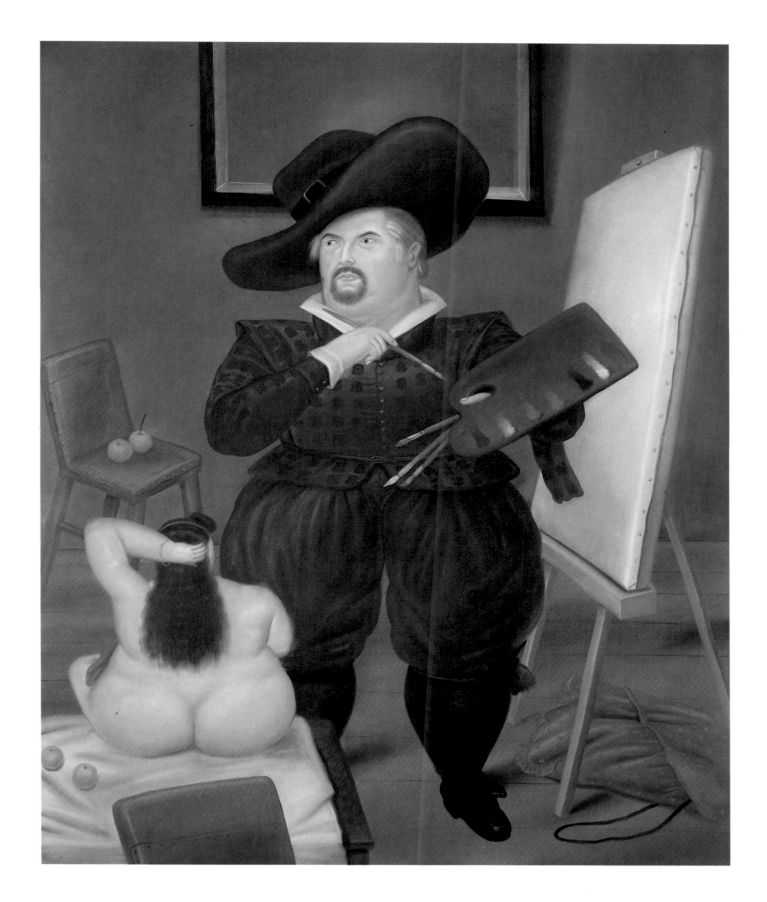

65 *Self-Portrait Dressed as Velázquez*

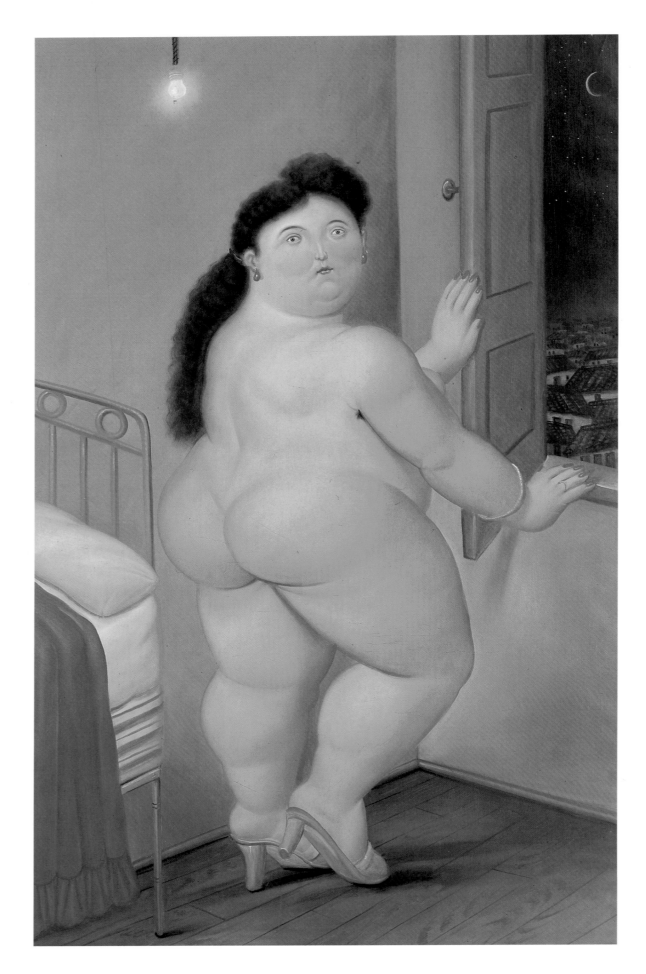

66 *Woman at the Window*

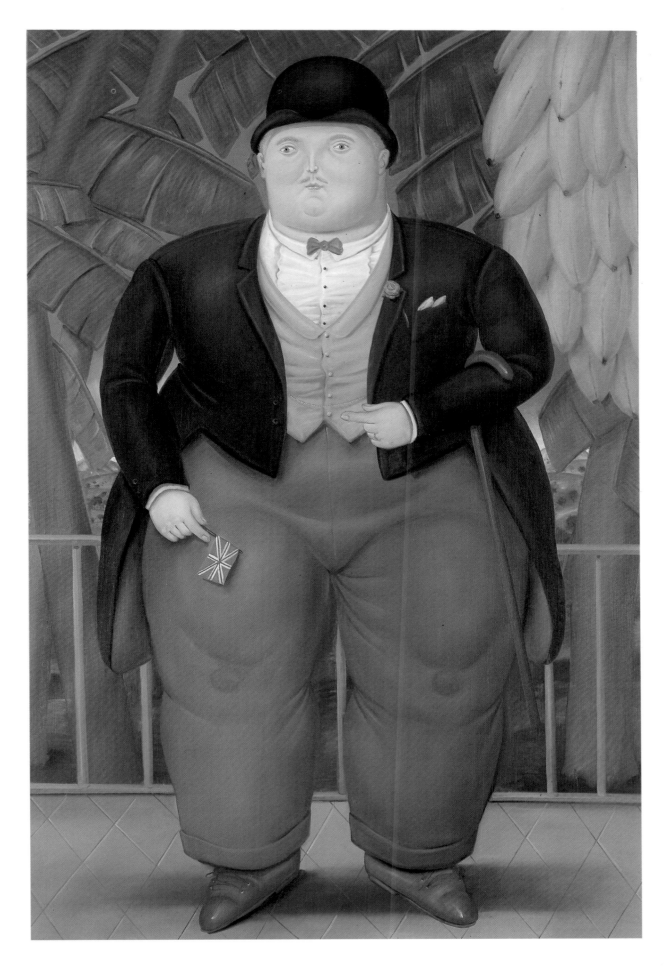

67 *The English Ambassador*

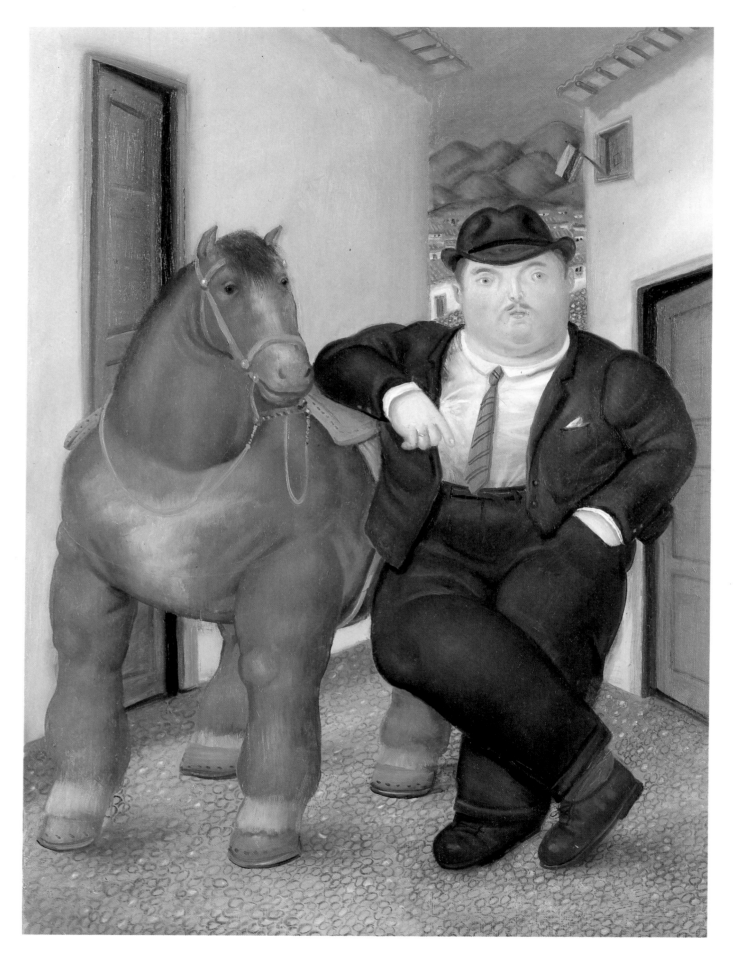

68 *Man with Horse*

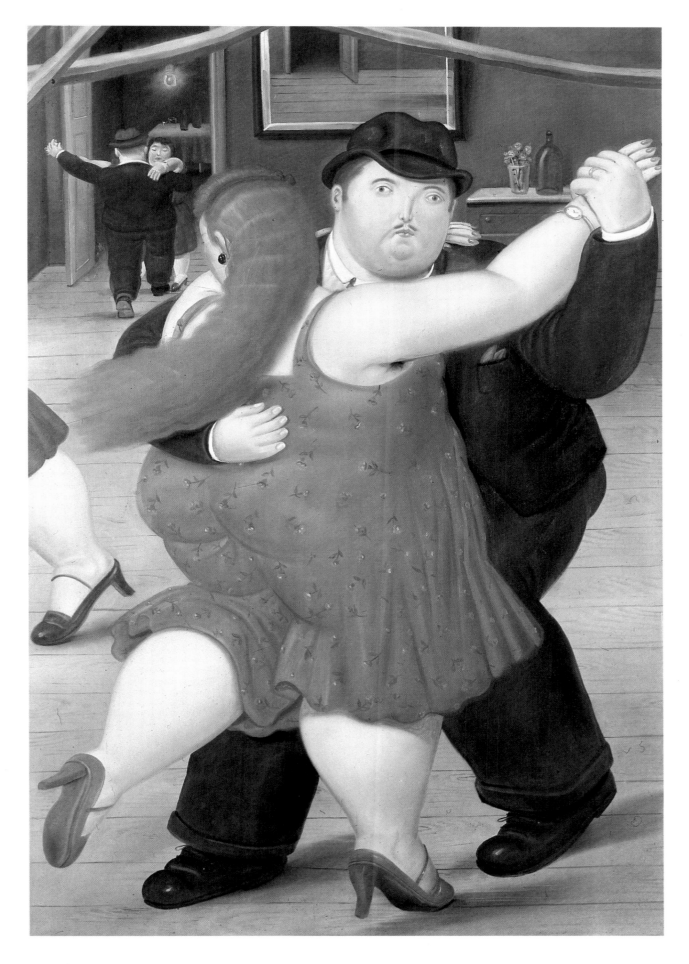

69 *Dancers*

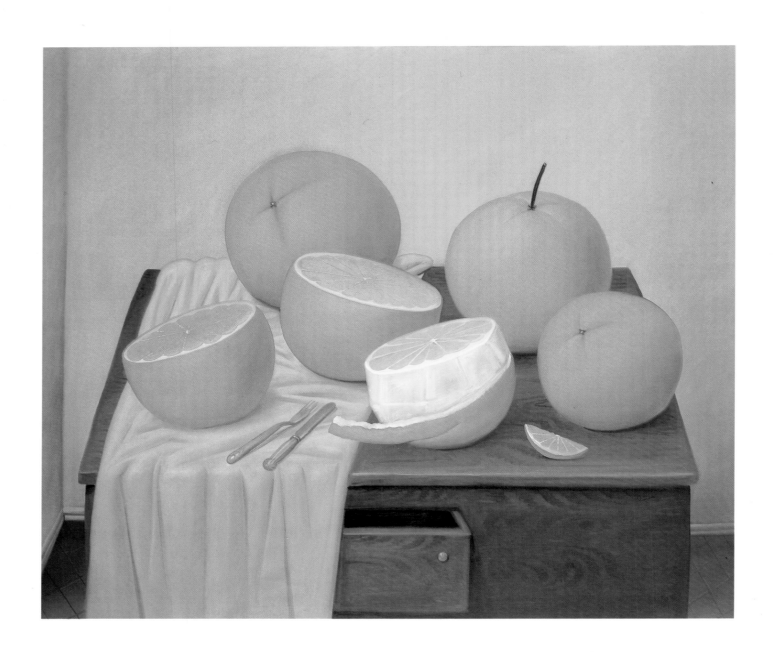

70 *Oranges*

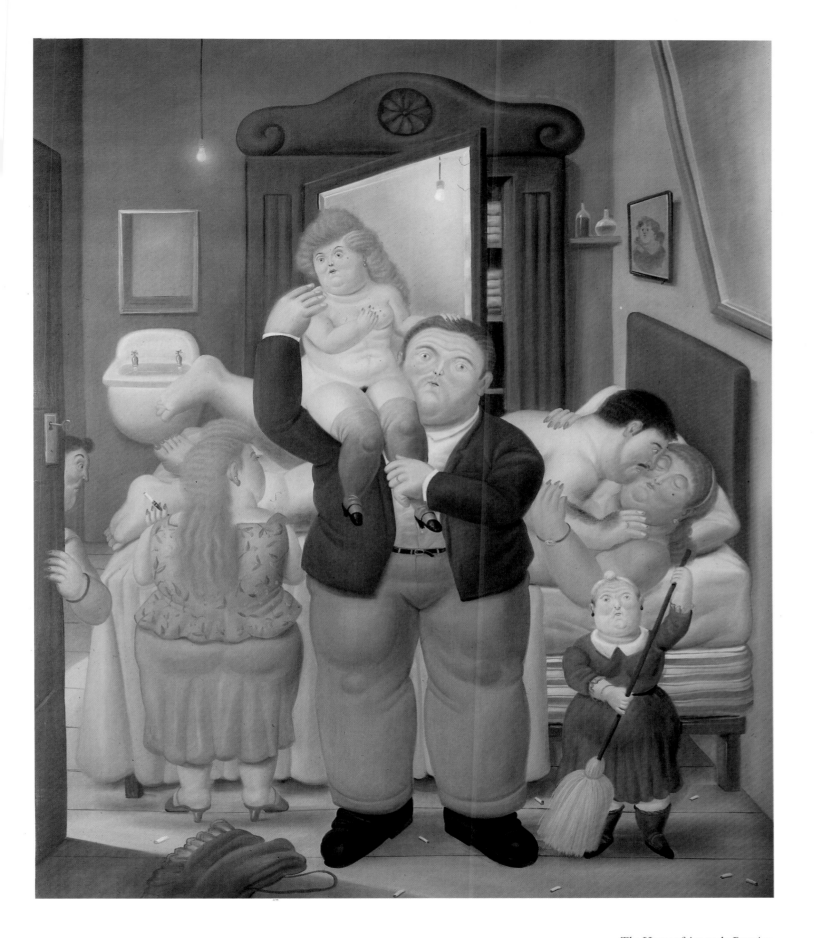

71 *The House of Amanda Ramirez*

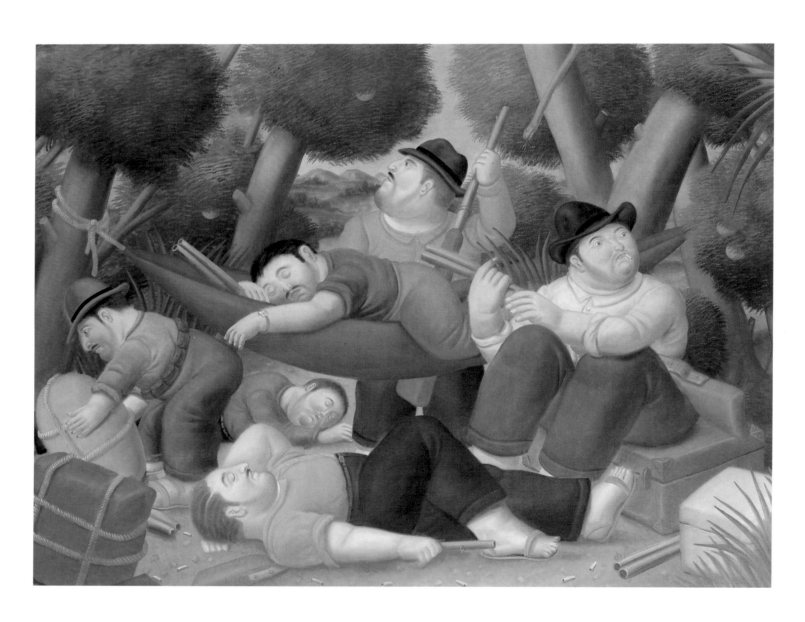

72 *Guerillas*

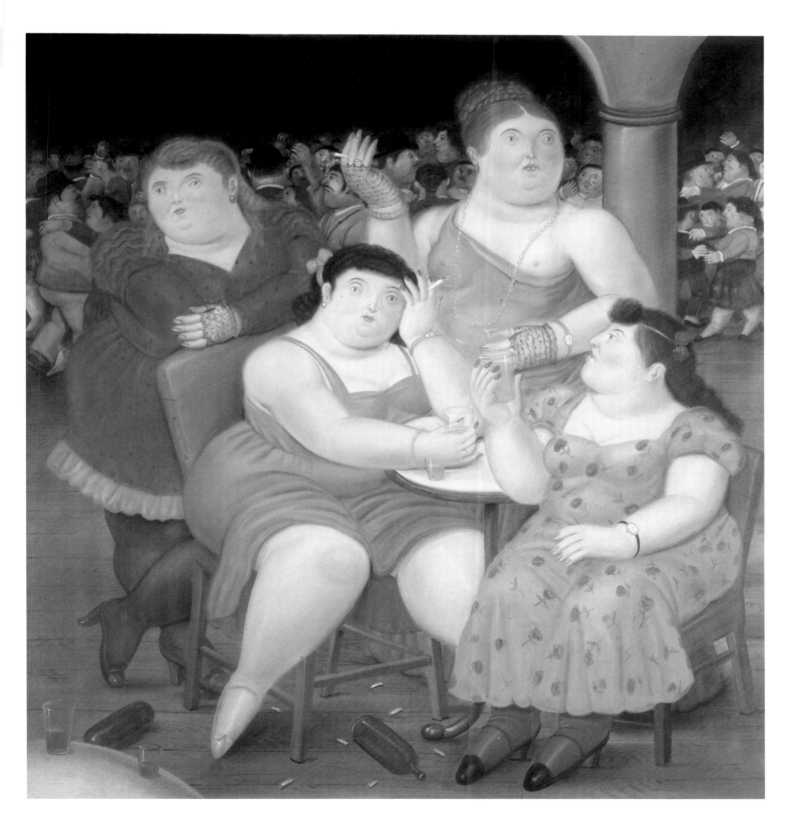

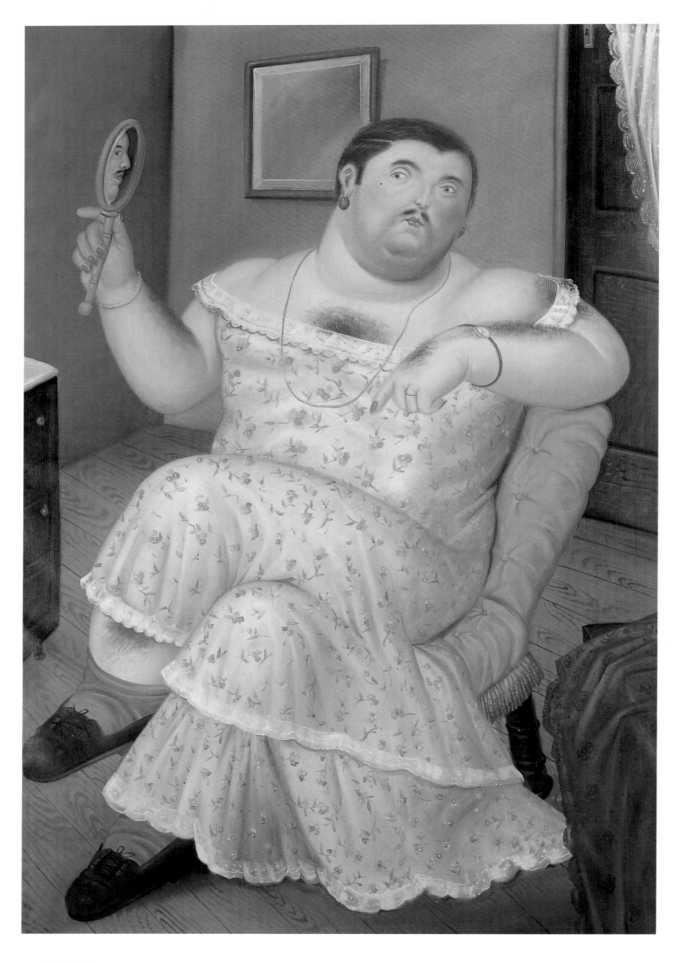

74 *Melancholy*

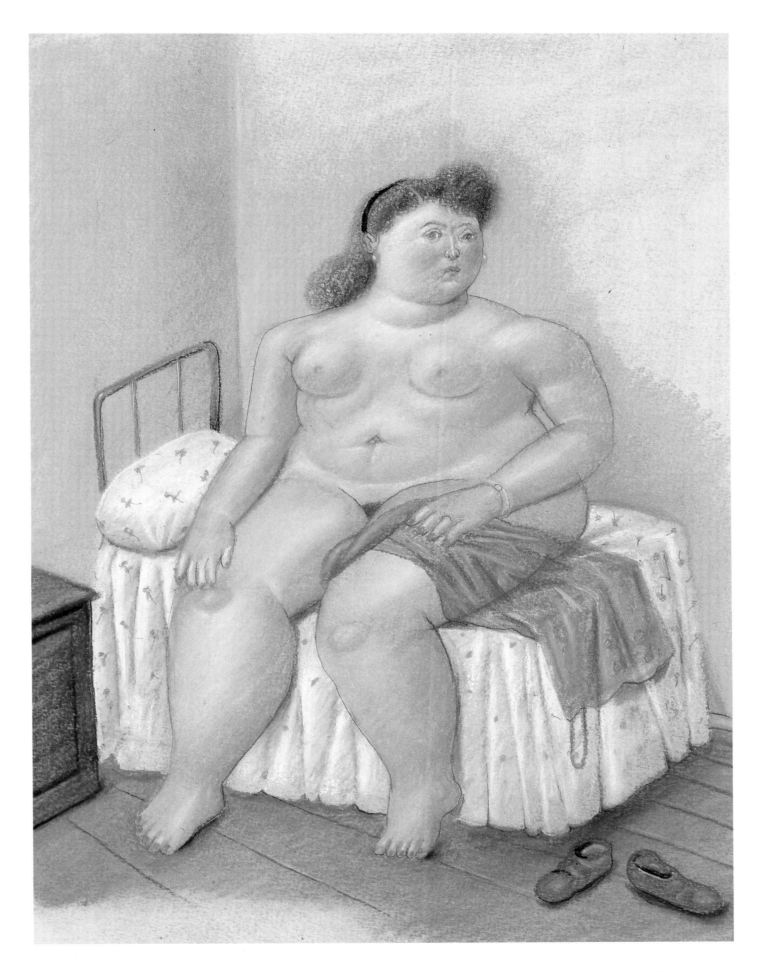

75 *Woman on a Bed*

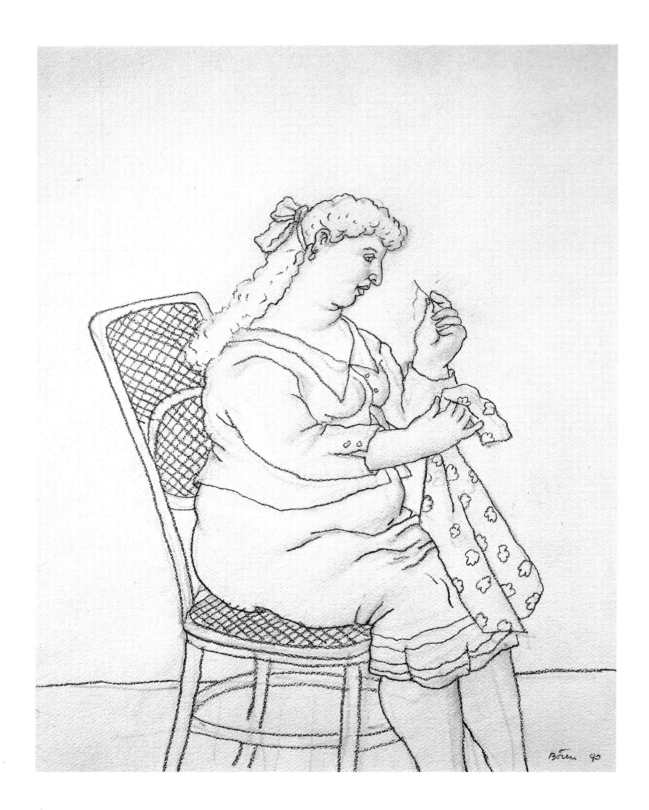

76 *Woman Sewing*

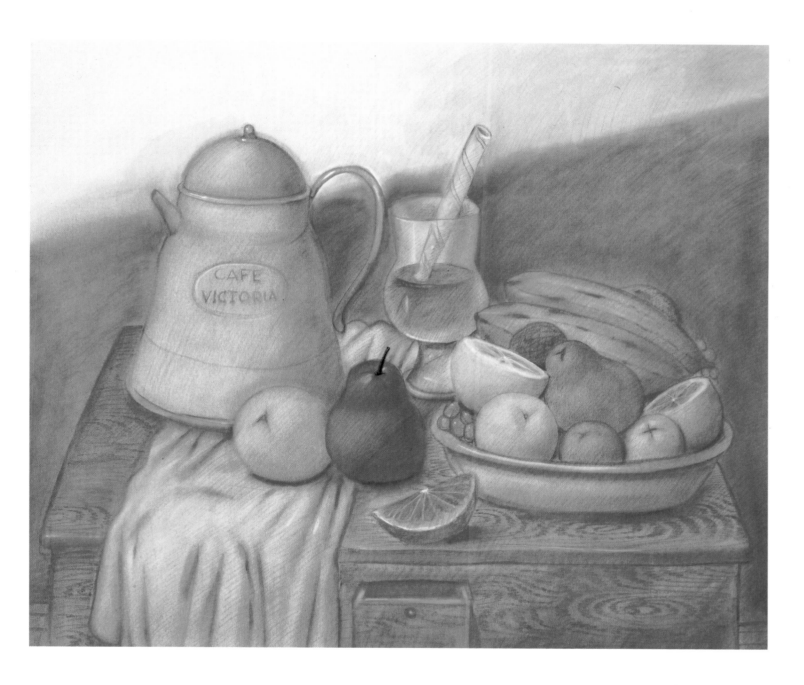

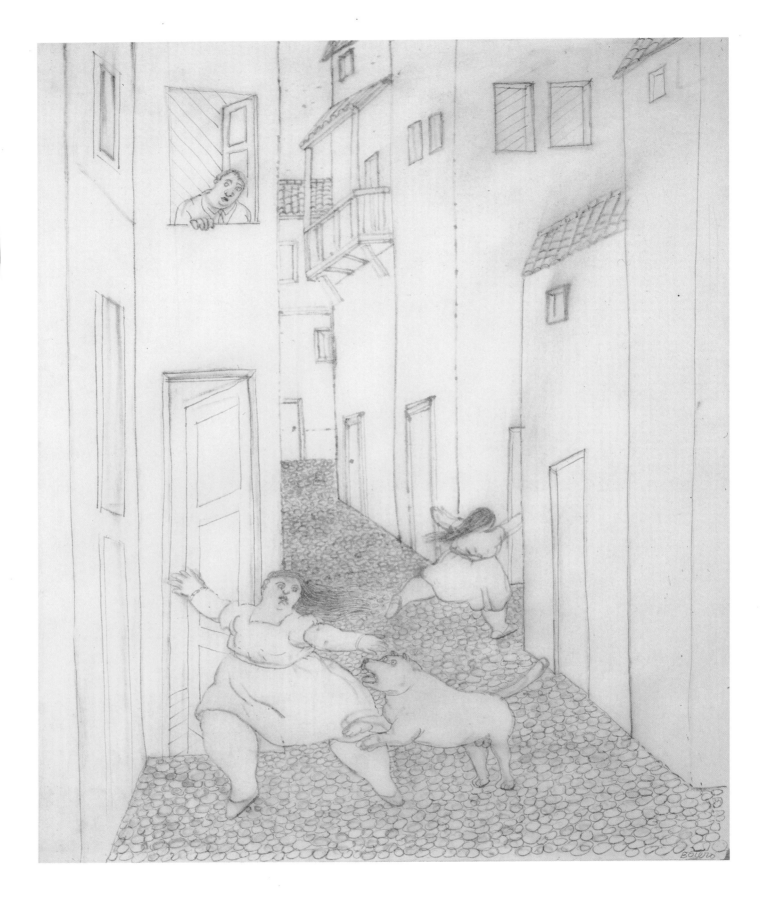

78 *Girl Attacked by a Dog*

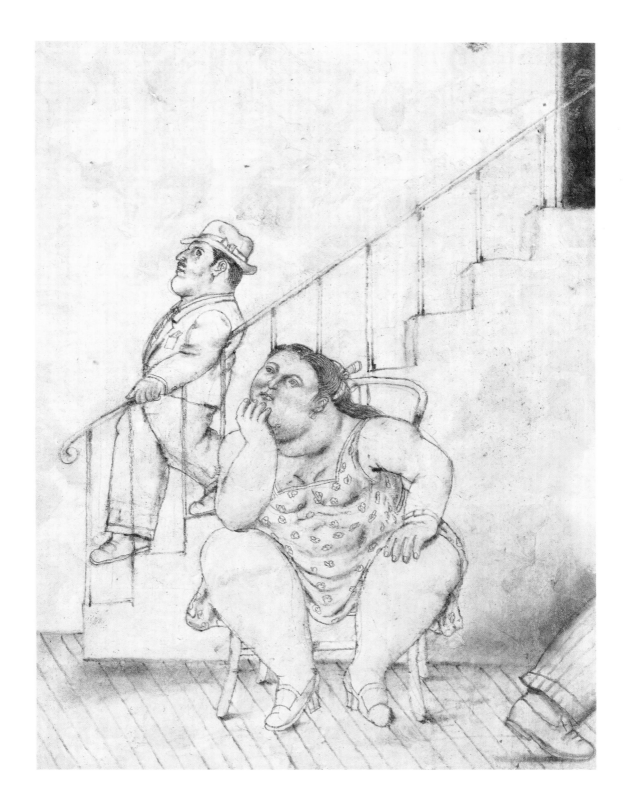

79 *Woman*

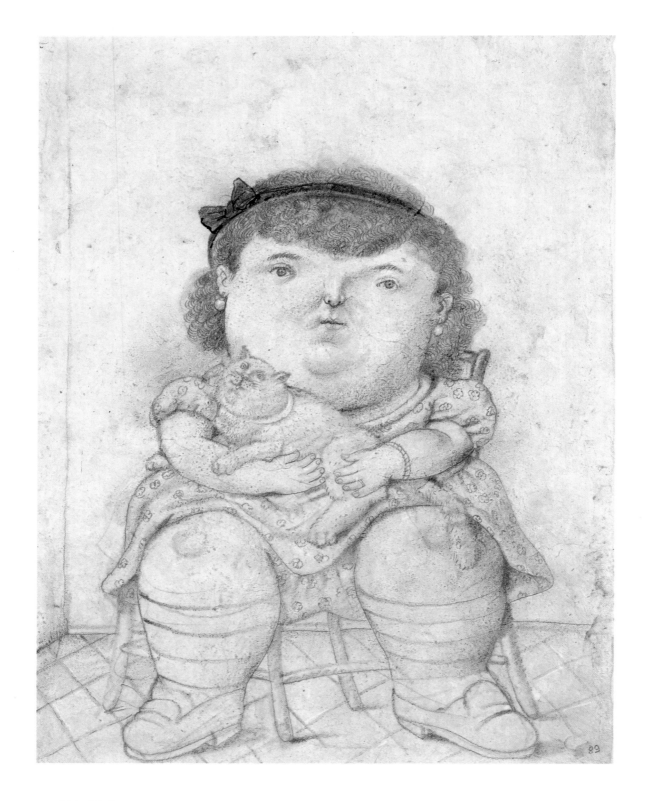

80 *Girl with Cat*

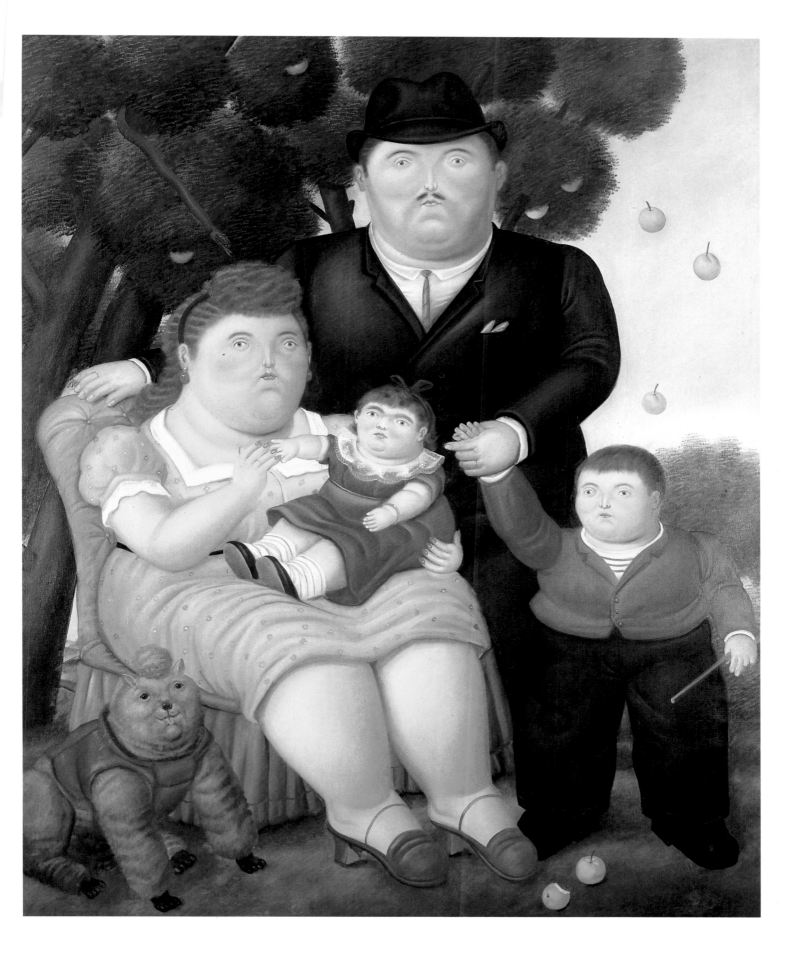

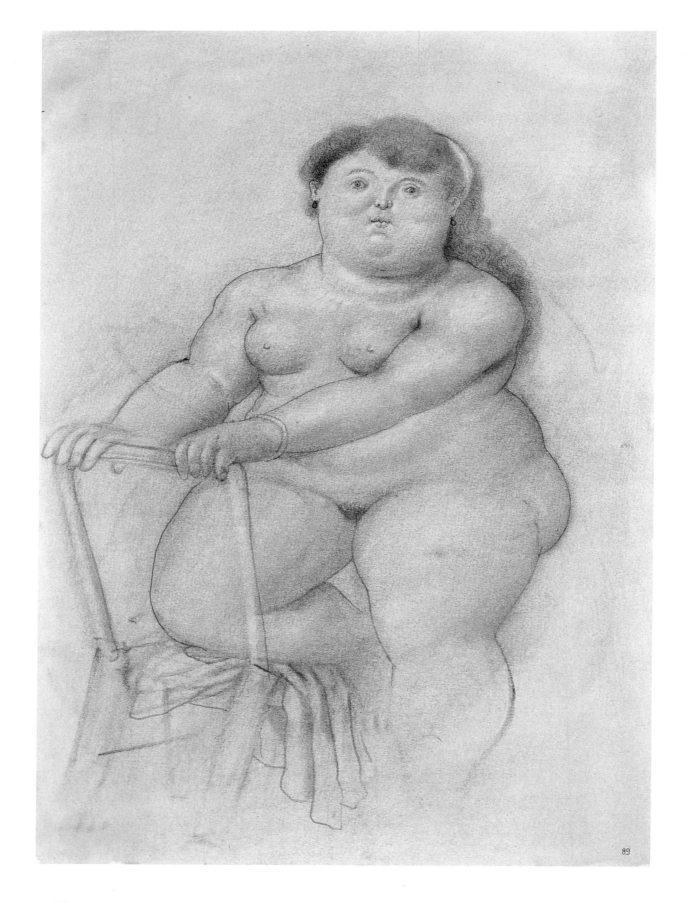

89

82 *Woman*

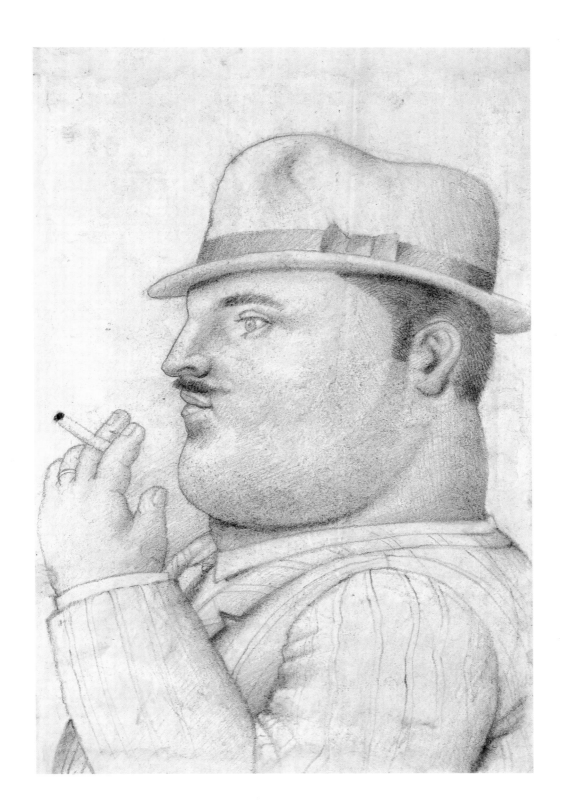

83 *Man Smoking*

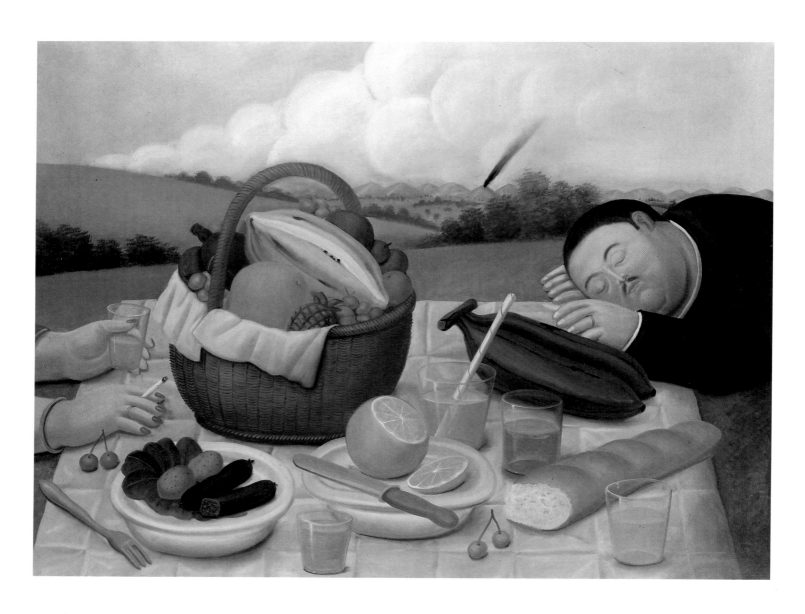

84 *The Picnic*

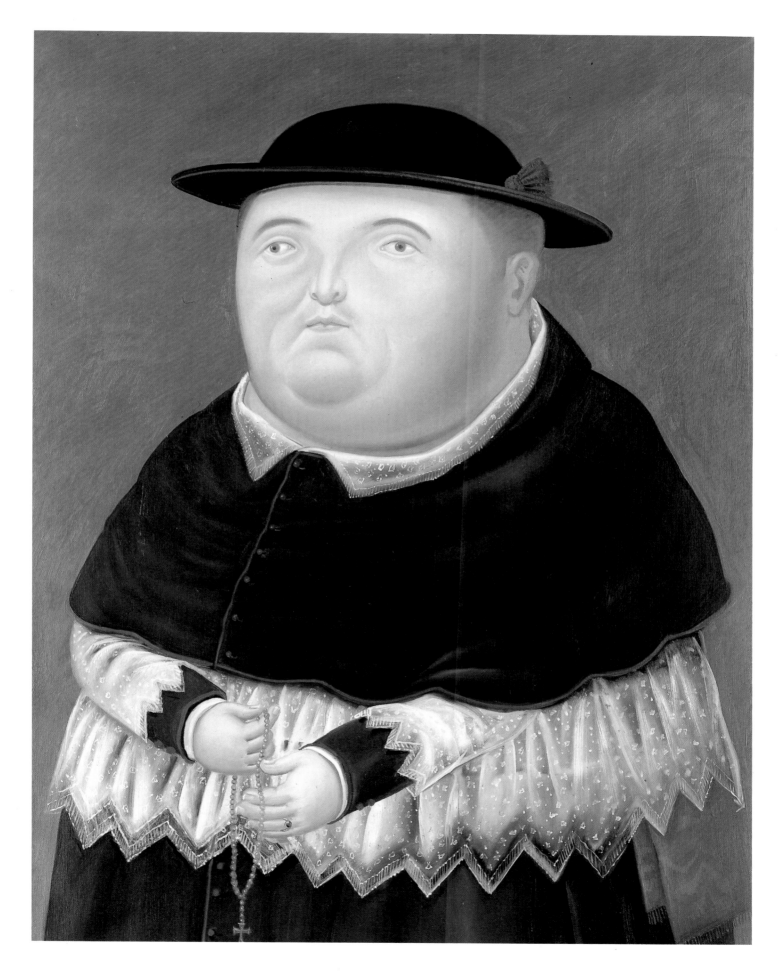

85 *Bishop*

86 *Landscape*

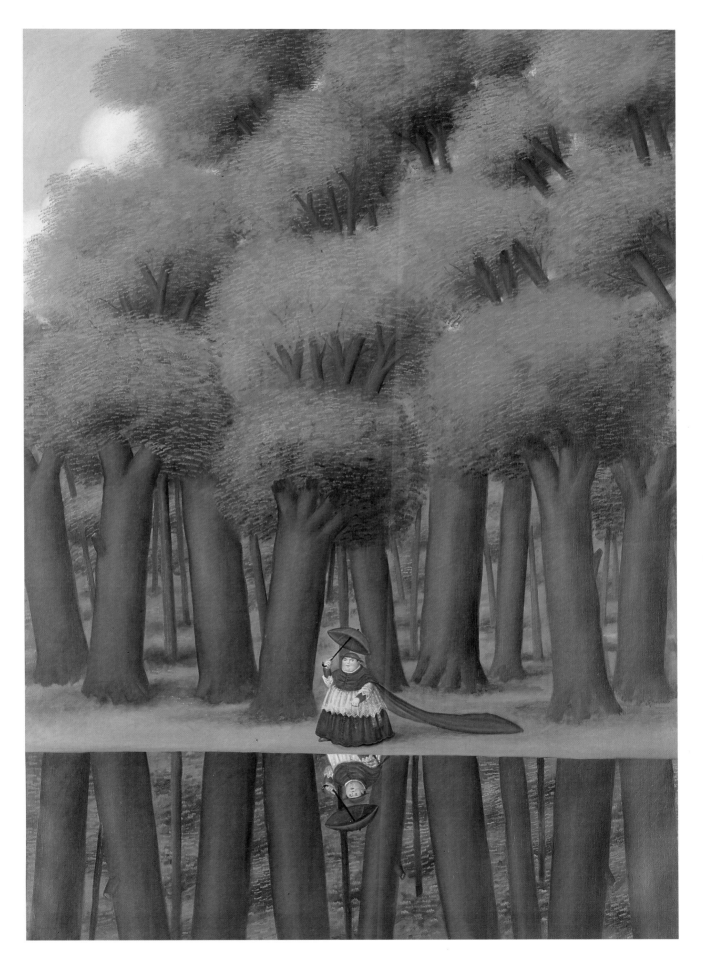

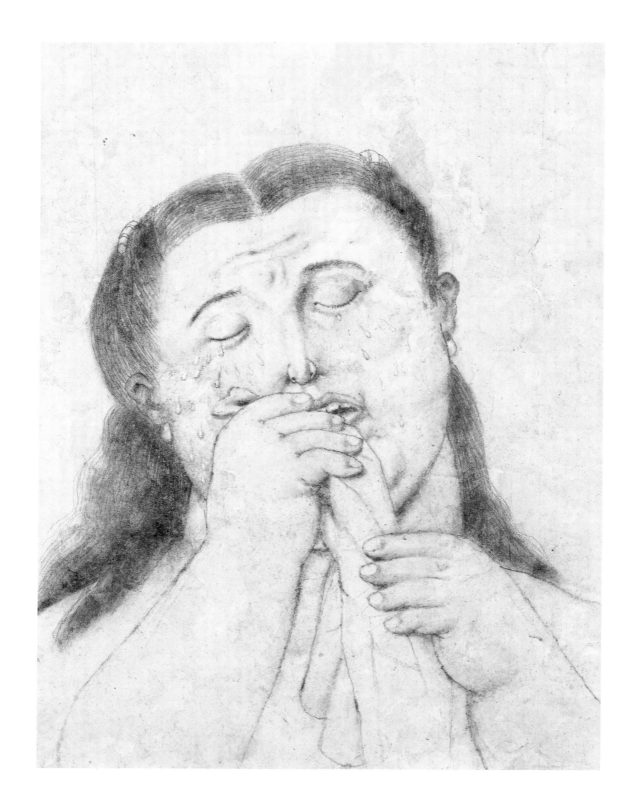

88 *Woman Crying*

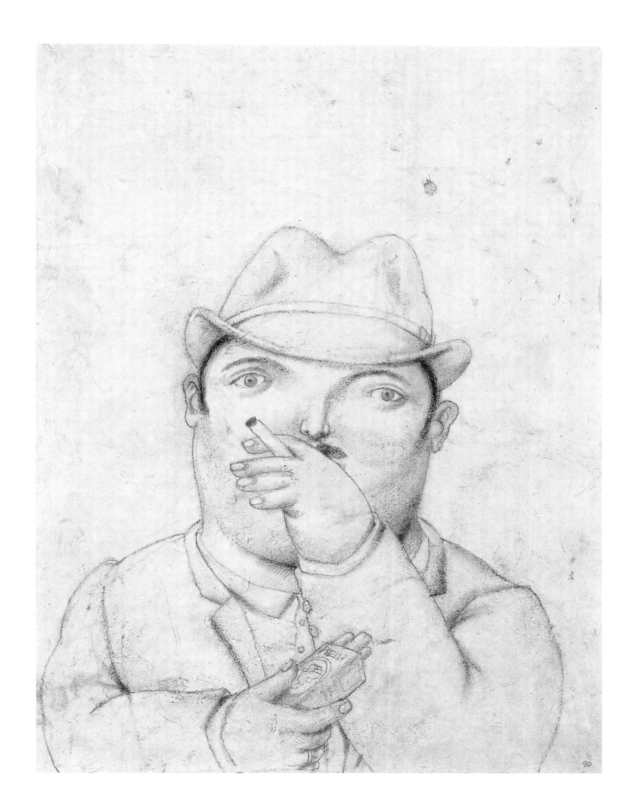

89 *Man Smoking*

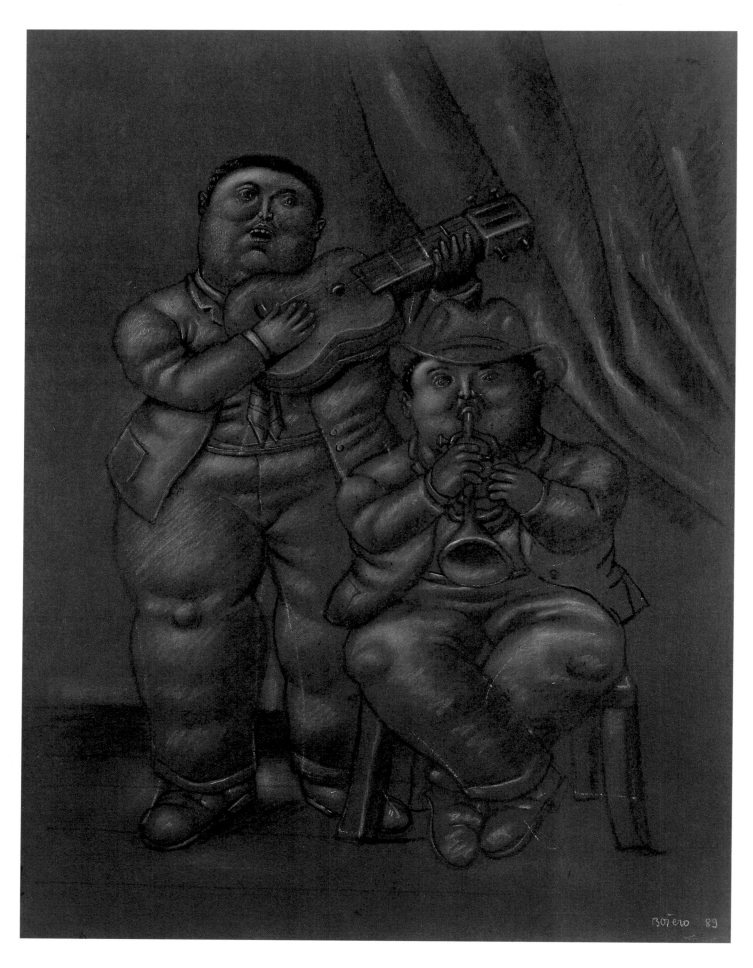

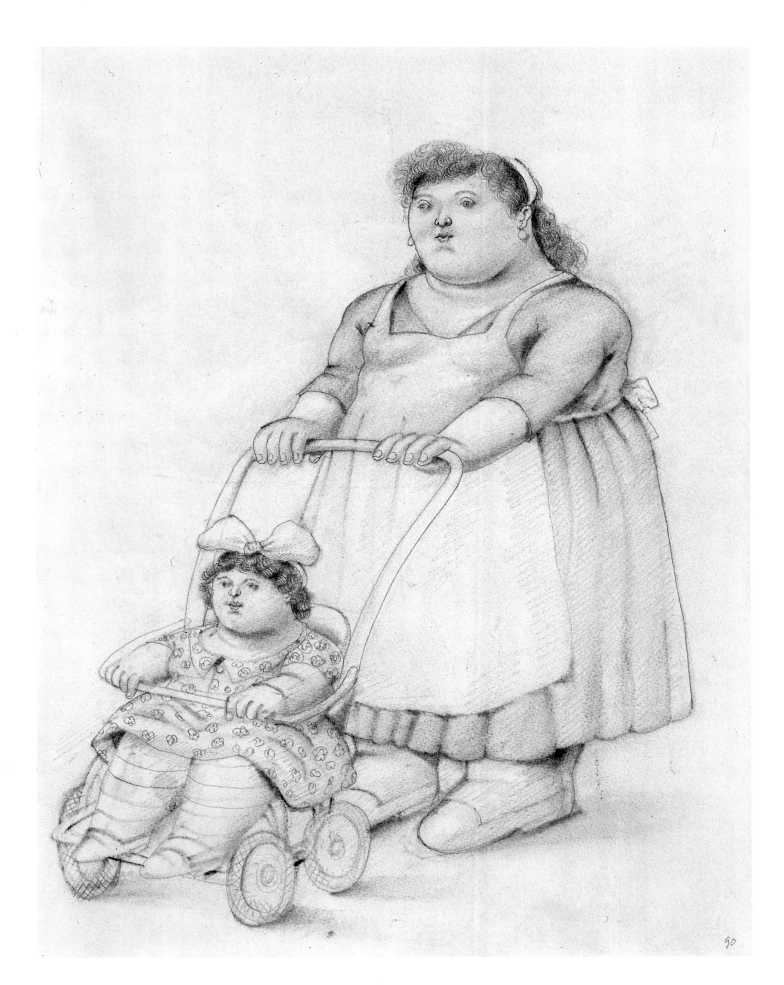

93 *The Nanny*

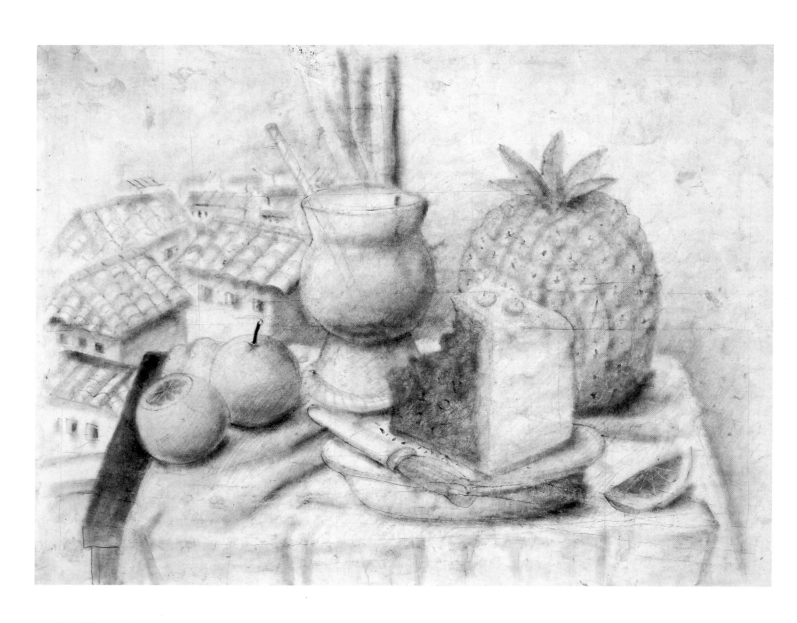

94 *Still Life with Cake*

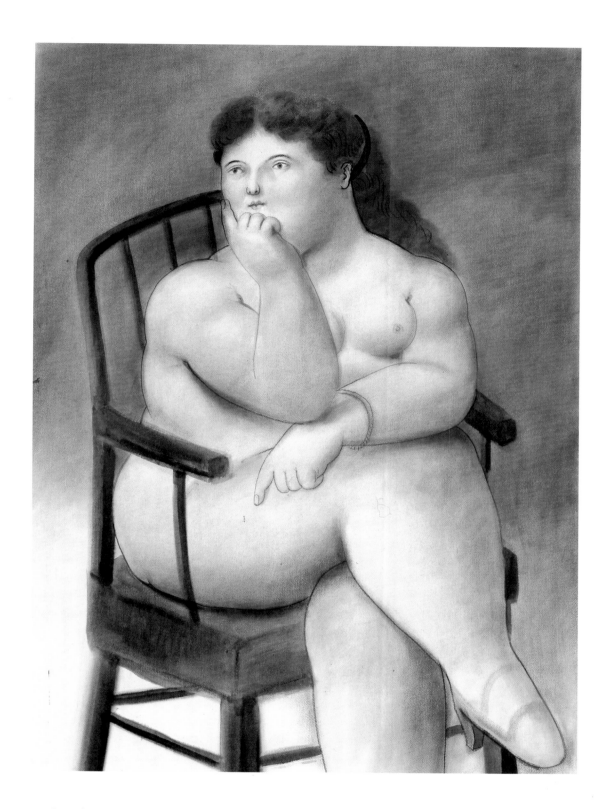

95 *Seated Woman*

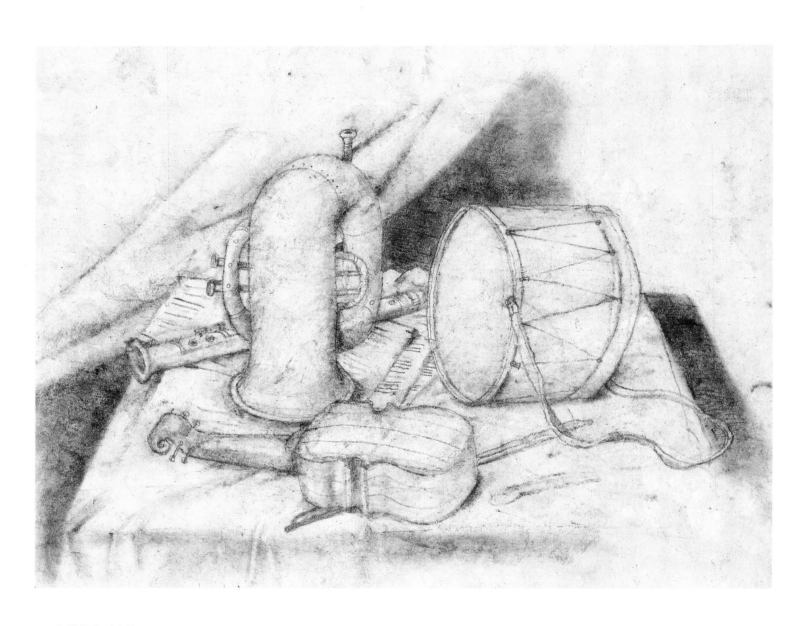

96 *Still Life with Drum*

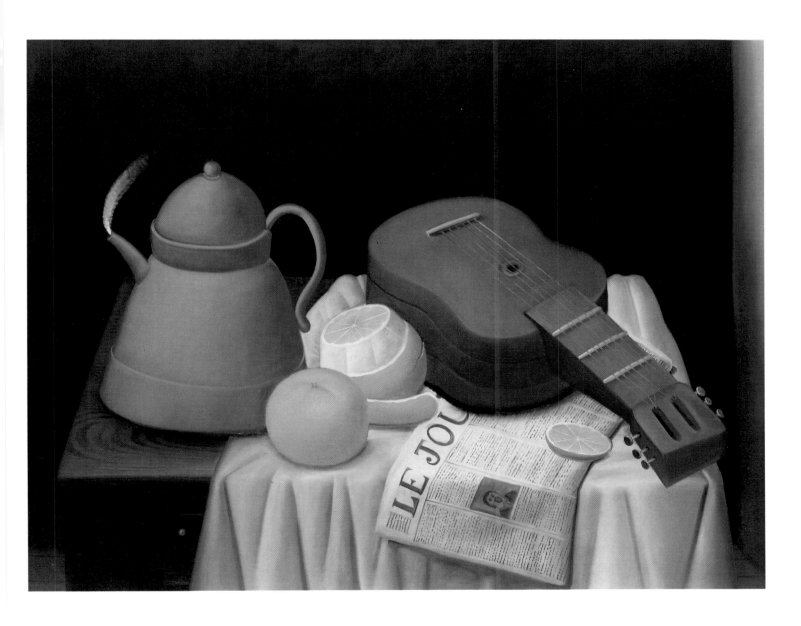

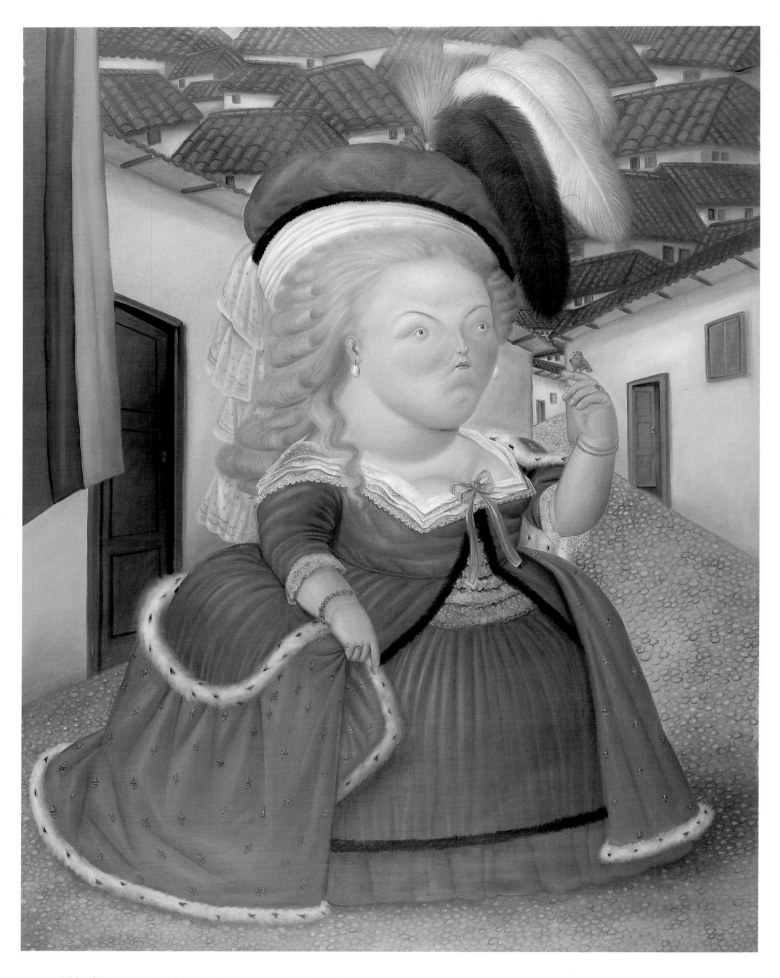

98, 99 *Visit of Louis XVI and Marie Antoinette to Medellín, Colombia*

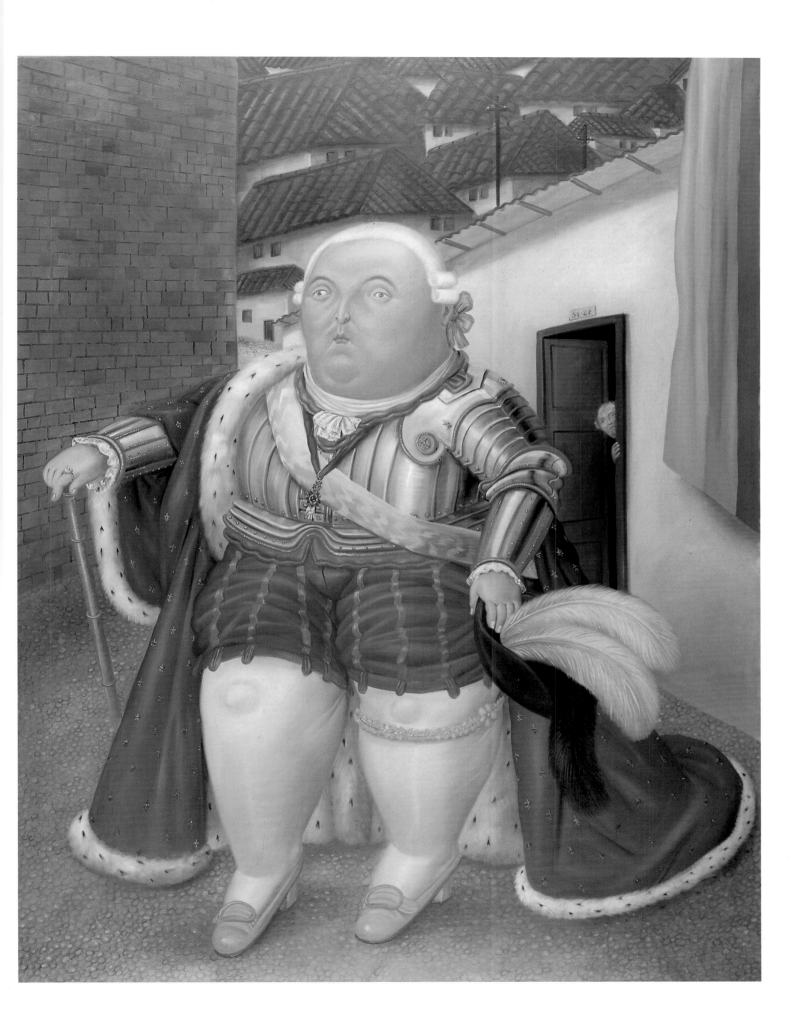

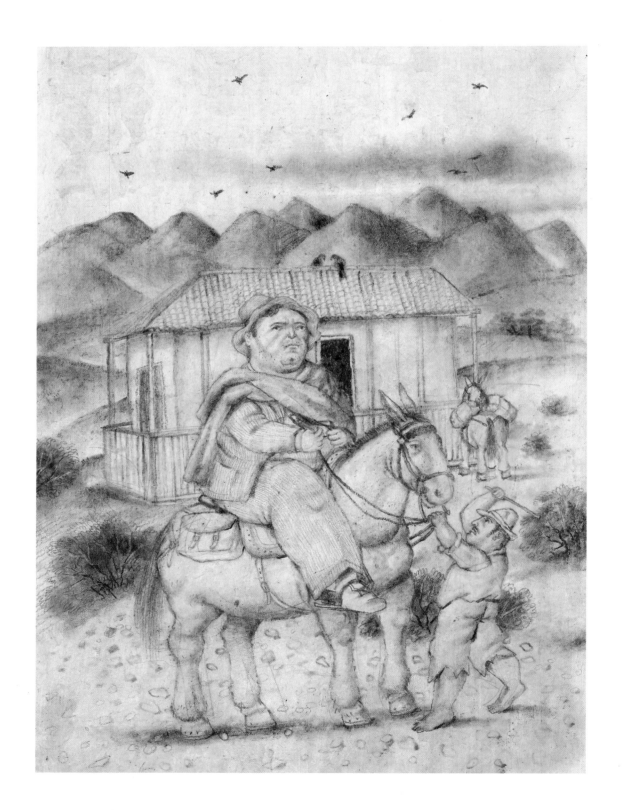

101 *Couple*

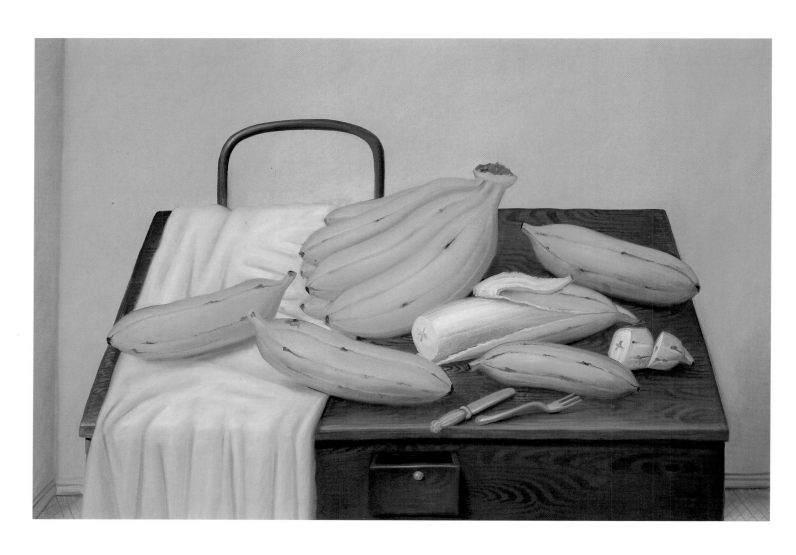

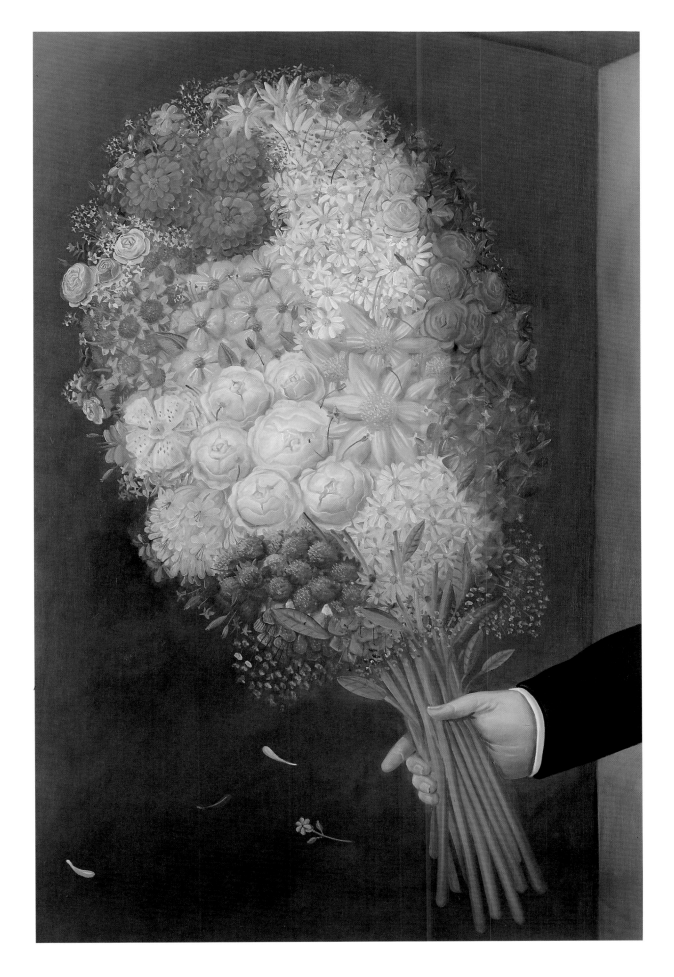

103 *Flowers*

105 *Girl on a Horse*

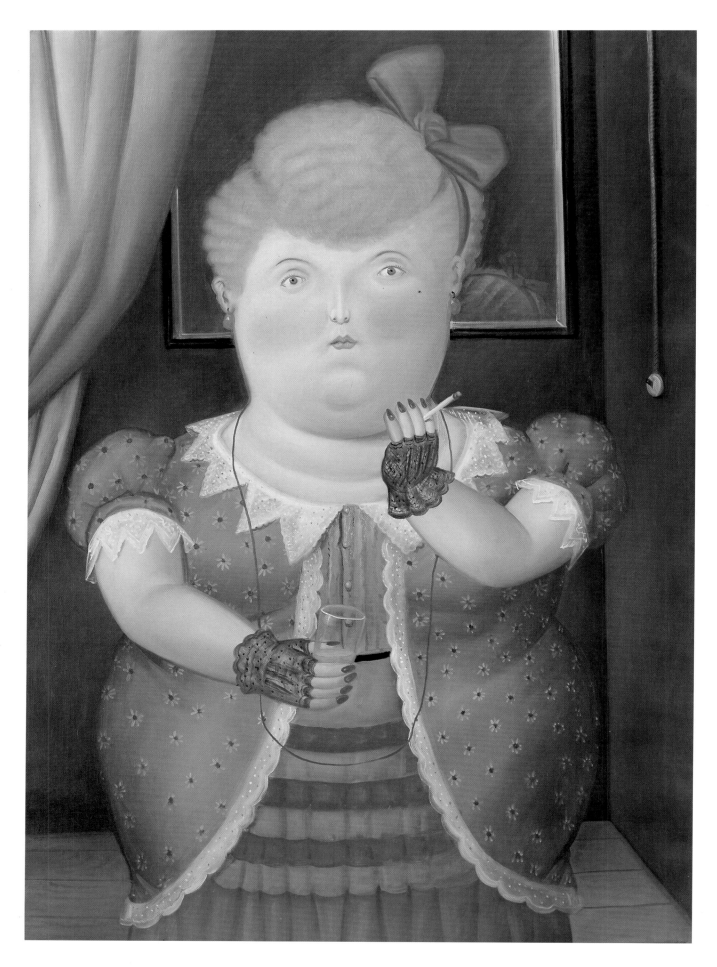

106 *Woman with Red Bow*

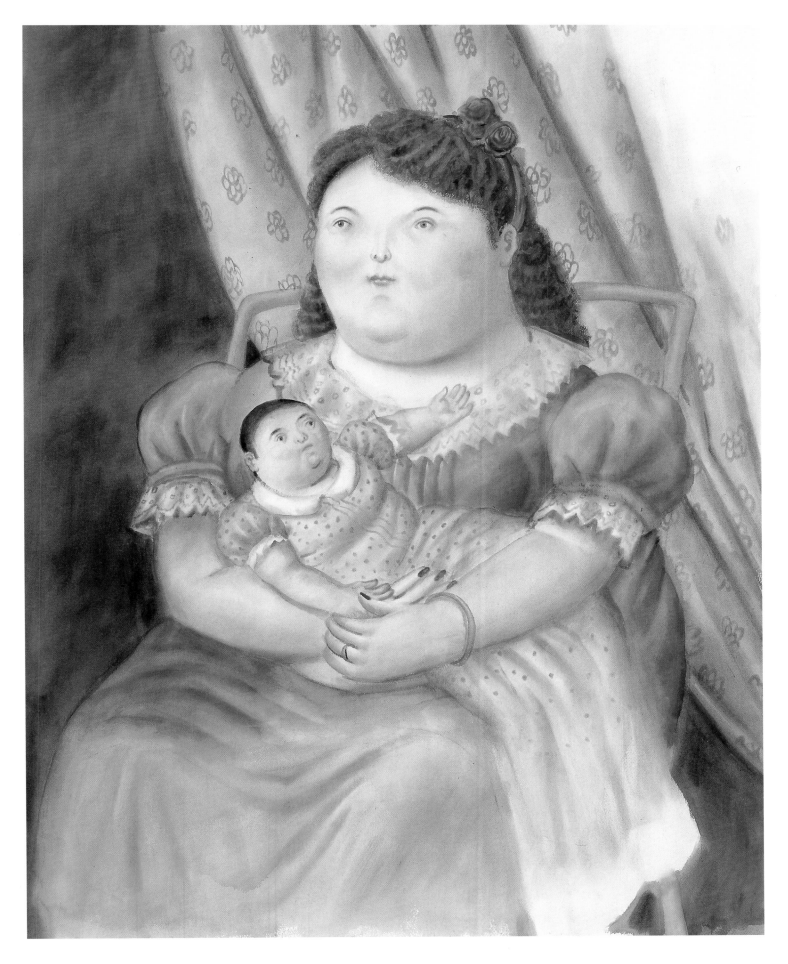

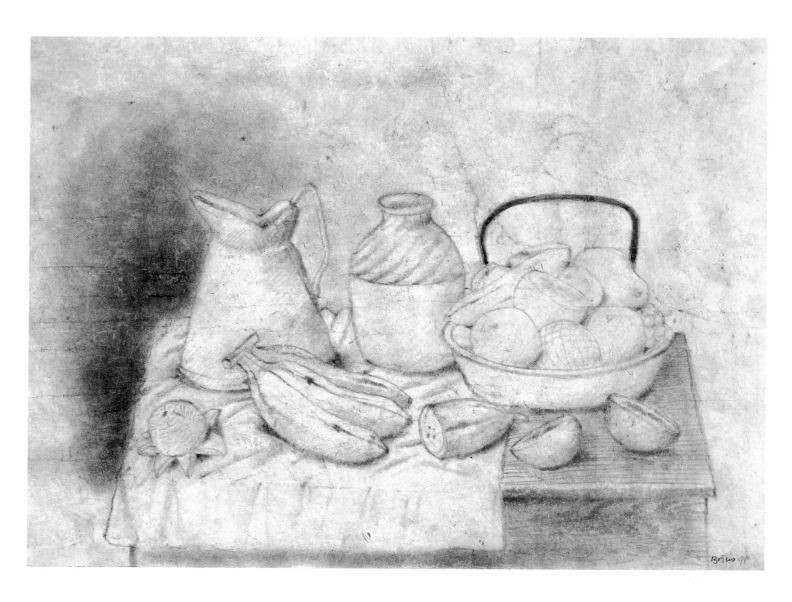

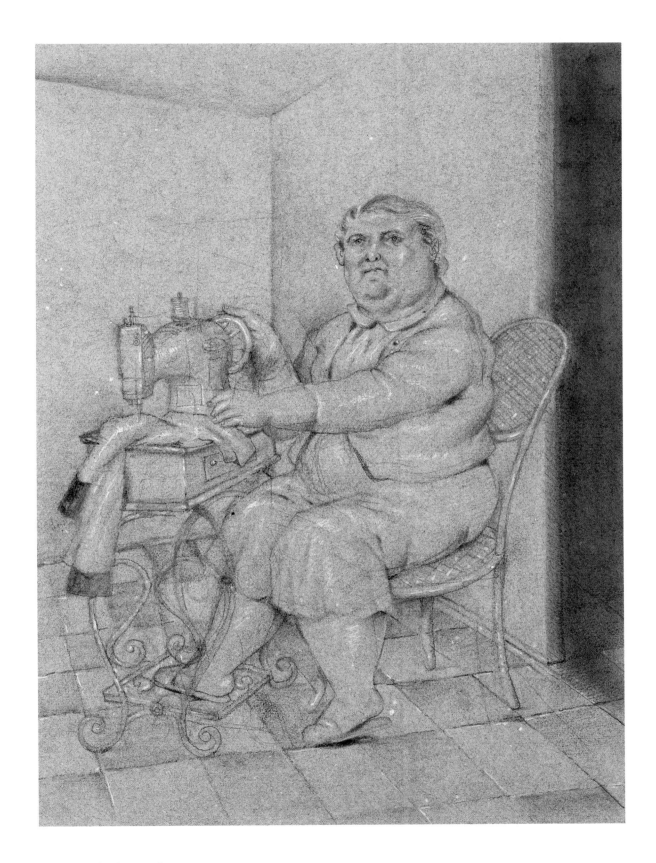

109　*Portrait of my Mother*

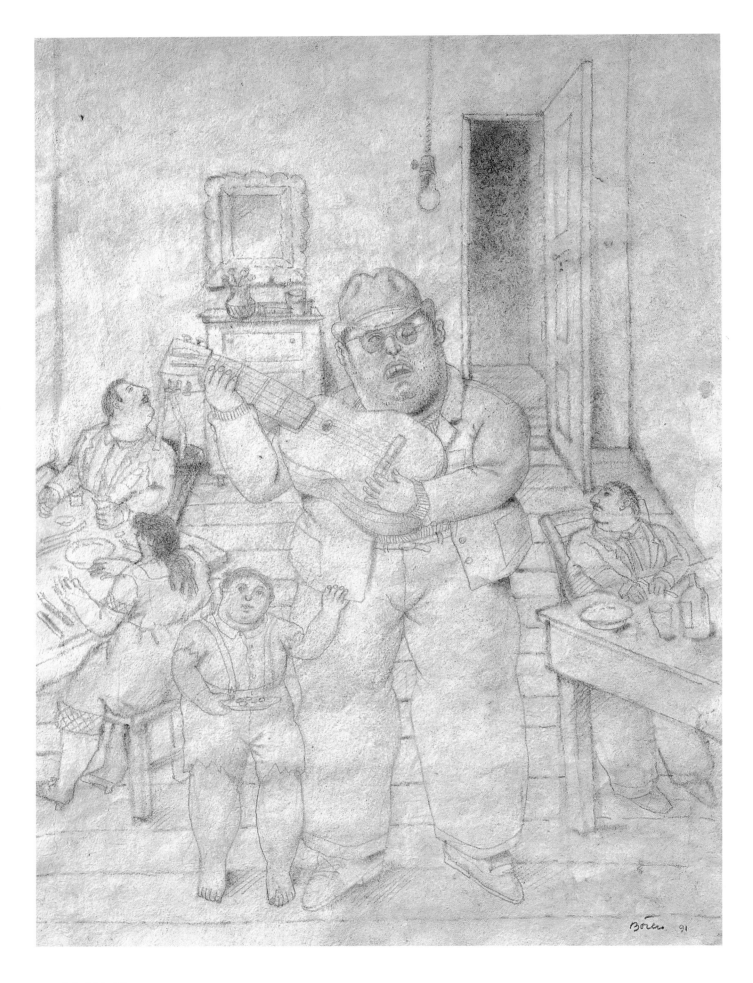

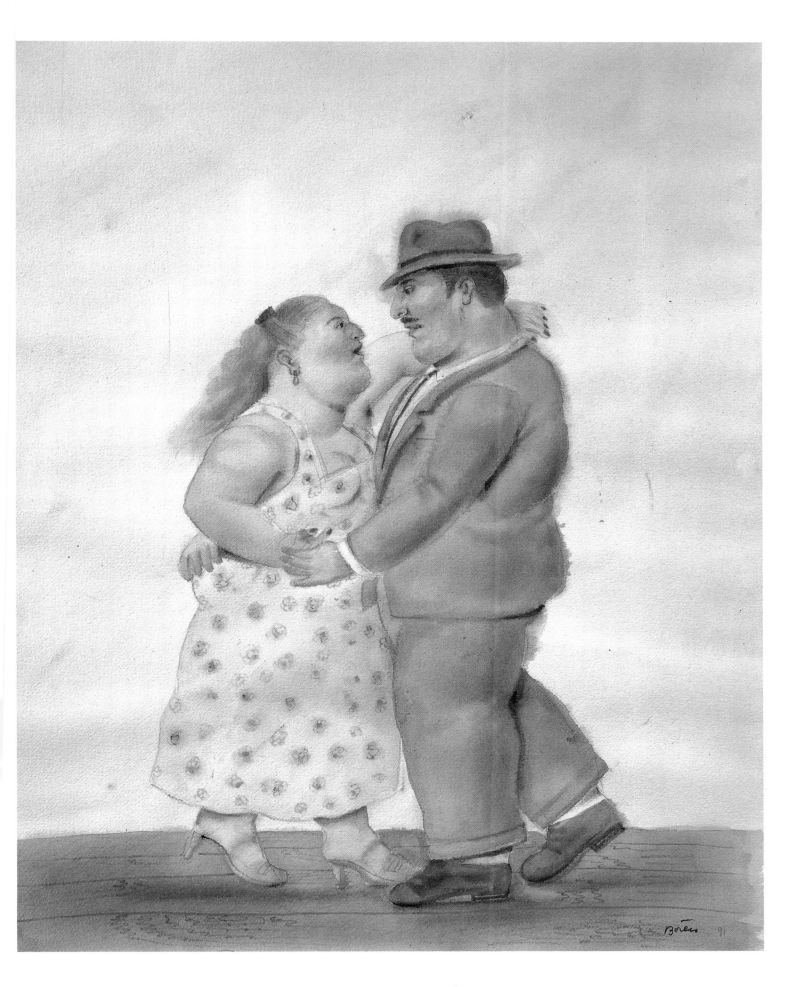

List of Plates

1

Mona Lisa, Age 12

1959
Oil and tempera on canvas
83 x 77″ (211 x 195.5 cm)
The Museum of Modern Art,
New York; Inter-American
Fund, 1961

2

Figure in Profile

1962
Charcoal on canvas
41¼ x 72½″ (105 x 184 cm)
Galerie-Verein München,
Staatsgalerie moderner Kunst,
Munich

3

*Camera degli Sposi
(Homage to Mantegna) II*

1961
Oil on canvas
91¼ x 102¼″ (231.7 x 259.8 cm)
Hirshhorn Museum and Sculpture
Garden, Smithsonian Institution,
Washington, D. C.; Gift of
Joseph H. Hirshhorn

4

Dead Bishops

1965
Oil on canvas
69 x 74¾″ (175 x 190 cm)
Galerie-Verein München,
Staatsgalerie moderner Kunst,
Munich

5

The President's Family

1967
Oil on canvas
80 x 77¼″ (203.5 x 196.2 cm)
The Museum of Modern Art,
New York; Gift of Warren
D. Benedek, 1967

6

Sunday Afternoon

1967
Oil on canvas
69 x 69″ (175.3 x 175.3 cm)
Collection Joachim Jean Aberbach,
New York

7

Picnic in the Mountains

1966
Oil on canvas
59 x 70¾″ (150 x 180 cm)
Collection Joachim Jean Aberbach,
New York

8

Oranges

1981
Red chalk on paper
9¹/₁₆ x 12⅝″ (23 x 32 cm)

9

Man

1969
Pastel on paper
59½ x 49½″ (151 x 126 cm)

10

*Official Portrait
of the Military Junta*

1971
Oil on canvas
67¼ x 85¾″ (171 x 218 cm)
Collection Joachim Jean Aberbach,
New York

11

The President

1971
Oil on canvas
83 x 64″ (210.8 x 162.6 cm)
Private collection, New York

12

Still Life with Watermelon Shake

1971
Oil on canvas
61¾ x 70½″ (157 x 179 cm)
Greer Gallery, New York

13

*Alof de Vignancourt
(after Caravaggio)*

1974
Oil on canvas
100 x 75″ (154 x 190.5 cm)
Mr. & Mrs. Carlos Haime

14

Morning Toilet

1971
Oil on canvas
75½ x 44½″ (192 x 113 cm)
Private collection

15

Homage to Bonnard

1972
Oil on canvas
92 x 70″ (234 x 178 cm)
Collection Aberbach Fine Art,
New York

16

Elspeth Tucher (after Dürer)

1968
Charcoal on canvas
77½ x 66½″ (197 x 169 cm)
Kunsthalle, Nuremberg

17

Woman

1981
Red chalk and pencil on paper
16¹⁵/₁₆ x 12⅝″ (43 x 32 cm)

18

The House of Anna Molina

1972
Red chalk on canvas
77 x 67″ (195.5 x 170.2 cm)
Collection Aberbach Fine Art,
New York

19

The House of the Arias Twins

1973
Oil on canvas
90 x 74″ (228.6 x 188 cm)
Robert E. Abrams, New York

20

Woman with Parrot

1973
Pastel on canvas
63¼ x 47¾" (161 x 121 cm)
Private collection

21

Study with Male Model

1972
Pastel on canvas
67 x 48½" (170.2 x 123.2 cm)
Mr. & Mrs. E. A. Bergman, Chicago

22

Still Life with Watermelon

1974
Oil on canvas
65¼ x 73¼" (166 x 186 cm)
Collection Mrs. Susan Lloyd

23

The Collector

1974
Oil and collage on canvas
36 x 31" (91.4 x 78.7 cm)
Collection R. Lerner, Madrid

24

The Maid

1974
Oil on canvas
76¼ x 60½" (194 x 154 cm)
Private collection

25

The Old Maid

1974
Oil on canvas
76¼ x 50¾" (194 x 129 cm)
Private collection;
courtesy Marlborough Gallery,
New York

26

Homage to Bonnard

1975
Oil on canvas
72 x 107¾" (183 x 274 cm)
Private collection

27

*The House of Raquel Vega
(Medellín, Colombia)*

1975
Oil on canvas

77 x 97" (195.5 x 246.5 cm)
Museum moderner Kunst, Vienna;
on loan from the Ludwig Collection,
Aachen

28

Seated Woman

1976
Oil on canvas
76 x 59¾" (193 x 152 cm)
Private collection

29

The Letter

1976
Oil on canvas
58¾ x 76¼" (149 x 194 cm)

30

Still Life with Fruit

1978
Oil on canvas
69¼ x 75¼" (176 x 191 cm)
Private collection

31

Reclining Priest

1977
Oil on canvas
72 x 107¾" (146 x 193 cm)
Private collection

32

Untitled

1978
Oil on canvas
35 x 43¼" (89 x 110 cm)
Private collection

33

Stroll in the Hills

1977
Oil on canvas
74¾ x 40½" (190 x 103 cm)
Private collection

34

Mona Lisa

1978
Oil on canvas
73½ x 65½" (187 x 166 cm)
Private collection

35

Woman Undressing

1980
Watercolor on paper

76 x 45" (193 x 114.3 cm)
Collection Mr. & Mrs. Pierre Levai,
New York

36

Man Falling from a Horse

1981
Pencil on paper
13¾ x 16¹⁵⁄₁₆" (35 x 43 cm)

37

The Dance

1980
Pencil on paper
16¹⁵⁄₁₆ x 13¾" (43 x 35 cm)

38

The Street

1988
Oil on canvas
74 x 52" (188 x 132 cm)

39

The Thief

1980
Oil on canvas
65 x 43¾" (165 x 111 cm)

40

The Street

1982
Pencil on paper
16¹⁵⁄₁₆ x 13¾" (43 x 35 cm)

41

Men Drinking

1982
Pencil on paper
16¹⁵⁄₁₆ x 13¾ " (43 x 35 cm)

42

Couple

1982
Red chalk on paper
16¹⁵⁄₁₆ x 13¾" (43 x 35 cm)

43

Dancing Couple

1982
Oil on canvas
41 x 28" (104.2 x 71.1 cm)
Collection Raymond and
Theodora Zakroff, Bala Cynwyd,
Pennsylvania

44

Still Life with Coffeepot

1983
Red chalk on paper
16¹⁵⁄₁₆ x 13¾" (43 x 35 cm)

45

Nun

1982
Red chalk and pencil on paper
20¹⁄₁₆ x 14³⁄₁₆" (51 x 36 cm)

46

Seated Woman

1982
Pencil on paper
17¹¹⁄₁₆ x 13⅜" (45 x 34 cm)

47

The General

1983
Pencil and wash on paper
20¹⁄₁₆ x 14³⁄₁₆" (51 x 36 cm)

48

The Poet

1983
Pencil on paper
14³⁄₁₆ x 18⅞" (36 x 48 cm)

49

Family Group

1983
Oil on canvas
63 x 53" (160 x 134.6 cm)
Private collection

50

Seated Woman

1984
Red chalk and pencil on paper
20¹⁄₁₆ x 14³⁄₁₆" (51 x 36 cm)

51

Seated Man

1983
Pencil and wash on paper
20¹⁄₁₆ x 14³⁄₁₆" (51 x 36 cm)

52

Still Life with Bottle and Glass

1983
Watercolor on paper
7⅞ x 10⅝" (20 x 27 cm)

53

Woman with Umbrella

1983
Pastel on paper
11¹³⁄₁₆ x 7⅞ " (30 x 20 cm)

54

Woman

1984
Pastel and pencil on paper
20¹⁄₁₆ x 14³⁄₁₆" (51 x 36 cm)

55

Picnic

1983
Pastel and pencil on paper
14³⁄₁₆ x 19¹¹⁄₁₆" (36 x 50 cm)

56

Young Woman

1983
Red chalk and pencil on paper
20¹⁄₁₆ x 14³⁄₁₆" (51 x 36 cm)

57

Woman

1983
Red chalk on paper
16¹⁵⁄₁₆ x 13¾" (43 x 35 cm)

58

Still Life with Musical Instruments

1983
Watercolor on paper
8¼ x 11¹³⁄₁₆" (21 x 30 cm)

59

Four Musicians

1984
Oil on canvas
88½ x 72¾" (225 x 185 cm)
Private collection

60

Morning Toilet

1983
Pencil on paper
20¹⁄₁₆ x 14³⁄₁₆" (51 x 36 cm)

61

Still Life with Woman Undressing

1984
Oil on canvas
75¼ x 50" (191 x 127 cm)
Private collection

62

Violinist

1984
Red chalk on paper
20¹⁄₁₆ x 14³⁄₁₆" (51 x 36 cm)

63

Venus

1984
Pastel and pencil on paper
20¹⁄₁₆ x 14³⁄₁₆" (51 x 36 cm)

64

Colombiana

1986
Oil on canvas
56¾ x 78¼" (144 x 199 cm)
Galerie Beyeler, Basel

65

Self-Portrait Dressed as Velázquez

1986
Oil on canvas
85¾ x 69" (218 x 175 cm)
Galerie Beyeler, Basel

66

Woman at the Window

1990
Oil on canvas
76¼ x 47¾" (194 x 121 cm)

67

The English Ambassador

1987
Oil on canvas
81½ x 53½" (207 x 136 cm)

68

Man with Horse

1989
Oil on canvas
22 x 16½" (56 x 42 cm)

69

Dancers

1987
Oil on canvas
76¾ x 51¼" (195 x 130 cm)

70

Oranges

1989
Oil on canvas
67 x 77½" (170 x 197 cm)

71

The House of Amanda Ramirez

1988
Oil on canvas
88½ x 73½" (225 x 187 cm)

72

Guerillas

1988
Oil on canvas
60½ x 79¼" (154 x 201 cm)

73

Four Women

1987
Oil on canvas
75½ x 81" (192 x 206 cm)

74

Melancholy

1989
Oil on canvas
76 x 51¼" (193 x 130 cm)

75

Woman on a Bed

1987
Pastel on paper
15 x 11" (38 x 28 cm)

76

Woman Sewing

1990
Pencil on paper
18½ x 14¼" (47 x 36 cm)

77

Still Life

1990
Red chalk on paper
50 x 59" (127 x 150 cm)

78

Girl Attacked by a Dog

1981
Pen and ink on paper
16¹⁵⁄₁₆ x 13¾" (43 x 35 cm)

79

Woman

1990
Pencil on paper
20 x 14¼" (51 x 36 cm

80

Girl with Cat

1989
Pencil on paper
19¾ x 15" (50 x 38 cm)

81

Family

1989
Oil on canvas
95 x 76¾" (241 x 195 cm)

82

Woman

1990
Bister on paper
20¾ x 15¾" (53 x 40 cm)

83

Man Smoking

1989
Pencil on paper
23½ x 14¼" (60 x 36 cm)

84

The Picnic

1989
Oil on canvas
52 x 69" (132 x 175 cm)

85

Bishop

1989
Oil on canvas
65 x 50" (165 x 127 cm)

86

Landscape

1989
Pencil on paper
14¼ x 20" (36 x 51 cm)

87

Stroll by the Lake

1989
Oil on canvas
82 x 56¾" (208 x 144 cm)

88

Woman Crying

1990
Bister on paper
20¾ x 15¼" (53 x 39 cm)

89

Man Smoking

1990
Bister on paper
19¾ x 15¼" (50 x 39 cm)

90

The President

1989
Oil on canvas
80 x 65" (203 x 165 cm)

91

The First Lady

1989
Oil on canvas
80 x 65" (203 x 165 cm)

92

Two Musicians

1990
Chalk on paper
19 x 14¼" (48 x 36 cm)

93

The Nanny

1990
Pencil on paper
19 x 14¼" (48 x 36 cm)

94

Still Life with Cake

1990
Pencil on paper
31 x 40½" (79 x 103 cm)

95

Seated Woman

1990
Pencil and wash on paper
56 x 41" (142 x 104 cm)

96

Still Life with Drum

1990
Bister on paper
15¼ x 20" (40 x 51 cm)

97

Still Life with "Le Journal"

1989
Oil on canvas
51¼ x 66¼" (130 x 168 cm)

98, 99

*Visit of Louis XVI and
Marie Antoinette to Medellín,
Colombia*

1990
Oil on canvas
107 x 45¾" (272 x 116 cm) (each)

100

Portrait of my Father

1990
Bister on paper
20¾ x 15¼" (53 x 39 cm)

101

Couple

1990
Bister on paper
15¼ x 20¾" (39 x 53 cm)

102

Bananas

1990
Oil on canvas
51¼ x 75¼" (130 x 191 cm)

103

Flowers

1988
Oil on canvas
78¾ x 51¼" (200 x 130 cm)

104

The Street

1991
Pencil on paper
22 x 15¾" (56 x 40 cm)

105

Girl on a Horse

1991
Pencil on paper
15¾ x 21¾" (40 x 55 cm)

106

Woman with Red Bow

1990
Oil on canvas
67 x 46¾" (170 x 119 cm)

107

Mother and Child

1990
Watercolor on paper
53½ x 41¾" (136 x 106 cm)

108

Still Life

1991
Pencil on paper
20¾ x 20½" (39 x 52 cm)

109

Portrait of my Mother

1990
Pencil on paper
17¾ x 12½" (45 x 32 cm)

110

Blind Musician

1991
Pencil on paper
21¾ x 15¾" (55 x 40 cm)

111

Dancers

1991
Watercolor on paper
20¾ x 16½" (53 x 42 cm)

"I'm the most Colombian of Colombian artists"

A Conversation with Fernando Botero

Could you define the message behind your work?

Actually, there is no message. For me, painting means creating a poetic work from a particular stylistic standpoint. That's the way it's always been done. All the great artists of the past were able to create the illusion of something that exists, from a quite specific stylistic standpoint.

But the results are not purely aesthetic; they have resonances, they convey something.

Well, yes, but my chief concern is with the so-called decorative aspects of painting. Of course, expressive elements enter my work, but they result from the decision to do a good painting—and my main intention is to adopt a clear stylistic position and do just that. My work is not a commentary on reality.

So you regard yourself purely as a painter; you're not a philosopher making statements about the world. Does that mean you view painting exclusively as handicraft?

No, it's more than that, because subconscious things enter one's work in a completely natural way. When you start with the intention of painting an aesthetically, a stylistically clear work, everything follows naturally because it's all there in yourself. But I am not trying to comment on reality. Most people think my aims are satirical, but that's not true.

Taking "message" in a broader sense to include the subconscious elements you mentioned, what do you think emerges at the end of your wrestling with formal problems? What is the final effect?

I'm the last person to answer that, because to me everything I do is so natural that I can't see

Fig. 1 *Louis XVI and his Family in Prison*, 1968. Charcoal on canvas, 74 x 73″ (188 x 185 cm). Collection Aberbach Fine Art, New York

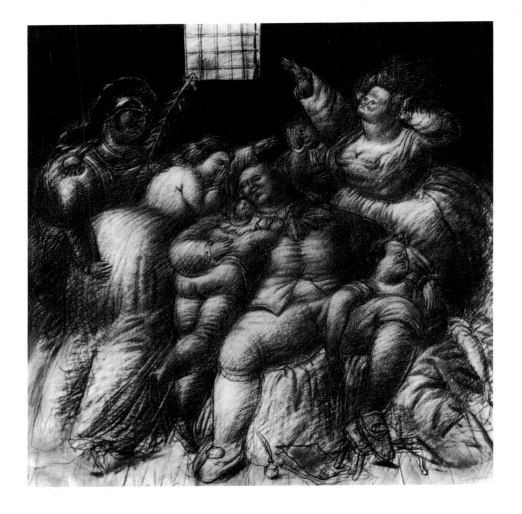

the results from the beholder's point of view. Sometimes people ask me to explain a particular feature in a painting, but it's impossible for me to analyze the results of my work.

Do you think your work could be described as a latter-day, South American development of the Baroque style?

No, not really. "Baroque" is not the right word to describe my paintings. I think the Baroque is centrifugal—look at the forces at play in sixteenth- and seventeenth-century sculpture. My work is the opposite. It is centripetal: its forces are quiet, looking for the centers of things in order to stay close to them. It's not baroque, it's abundant. Many things go into my paintings, but their relationship to one another is quiet—not baroque.

What do you mean when you say that your work is "abundant"?

A lot is going on in my paintings. Of course, you can do a painting with little or no subject matter, but there's nothing wrong with doing one that has a lot. If detailed subject matter occurs to me, I carry out everything that comes into my mind. That's the only way to work in art. You have to do everything, take chances, make mistakes. Picasso is a good example of that. No one did so many bad paintings in a lifetime—it's difficult to create such brilliant works as he did without making a lot of mistakes. If it comes to a battle between yourself and abundant subject matter, then you must give in to it and depict it. At other times, though, you'll paint nothing more than an apple.

You have been one of the most consistent exponents of figurative painting, and were so at a time when it was the last thing in demand. Do you have a sense of continuity with the past, a sense of developing, perhaps perfecting, the centuries-old tradition of figurative art? Or is your work governed by a conscious return to figuration after the periods of abstraction in our century?

The kind of figurative work I do derives in a way from the experience of abstraction: it's not the same kind of figurative art as that practiced before abstraction. My compositions are based on the requirements of color and form, so I often have to turn a painting upside down in order to view it as an abstract work. Abstraction has taught us to arrange colors and forms in a self-sufficient manner, so I need complete freedom in matters of proportion and, up to a point, in color as well. For example, if I need a small form somewhere in a

painting, I can reduce the size of a figure. In doing so, I'm proceeding rather like an abstract painter. If I had to respect proportion and color I'd be robbed of this freedom, which is the most important thing for a figurative painter today.

"An artist is able to let people experience the past with the feeling of the present"

Do you think the experience of abstraction gives you an advantage over earlier artists? Have you progressed beyond the stage represented by, say, Mantegna or Velázquez?

An artist is always a critic of earlier artists. It is a very strange mixture of admiration and criticism. You think you must, and can, improve on earlier ages. Of course, you don't, but the belief that you can is what keeps you working—it's the curiosity to see if your idea works. And you naturally fail all the time—that's what makes it so exciting. So you start all over again. Each day you think you've got it right—and you continue to fail. You just keep on trying. Sometimes you're better, sometimes worse—but you're never actually right. You must have this critical attitude to art of the past, because you're not here just to do nice paintings, but to attempt to arrive at absolute painting, using every means at your disposal to find optimum solutions to, say, the problem of plasticity.

Then there's the matter of sensibility. Our sensibility is different from that of earlier times. Most people are more susceptible to the art of today than to that of the past because it belongs to the present-day world. An artist is able to let people experience the past with the feeling of the present. In a way, you're saying: "I'll do it better; I'll do the art of today." Of course, it's not the art of the past. You can't escape from your own time, so you're creating something that belongs to the present moment—because once art has gone through an experience it never returns to its previous position. That's why it's impossible to fake Quattrocento or nineteenth-century paintings—they'll always be twentieth-century paintings.

Is the use of earlier paintings in your work an expression of nostalgia?

When I do this it's for two reasons. Firstly, I want to learn something about the pictures in question: it's one thing to look at a painting, but another to find out what makes it work. Secondly, I want to prove that it's not the sub-

ject matter of the painting, but its style that's the most important thing. These pictures of mine sometimes start as a joke. Once, I did a painting of a woman in a shower [plate 15] and didn't know what title to give it. Then I thought of *Homage to Bonnard*, because pictures of bathing women are so closely associated with him. Naturally, there's nothing of Bonnard in the painting. Later, I painted a picture of a woman in a bathtub [plate 26] that was closer to Bonnard. But there's nothing less like Bonnard than this painting, because he was an Impressionist, interested in the vibrations of color, not in form. My picture is just the opposite: it has space, atmosphere, form, volume, and compact, not vibrating, color. In effect, I was saying: "Look, subject matter's not important—this painting is a Botero." You can take the same subject and create a totally different painting. That's where real originality lies, in taking something that's already been done by someone and doing it differently. Of course, you don't consciously try to be original, but because you are original, quite naturally and spontaneously, something different emerges. For instance, every artist has painted an apple at some time, but each image is different and its creator immediately recognizable. That's originality. Painting a creature from outer space isn't original.

"Woman in a Bathtub" is a general theme, but your variations on Velázquez or your Mona Lisa *(plate 34) are based on specific prototypes, ones instantly recognizable to anyone who has even the most superficial acquaintance with the history of art.*

The important thing for me is to take images that are so well known that they've almost become part of popular culture, and then do something different with them. Sometimes, it's simply that I'm deeply interested in understanding a painting, its technique and the spirit behind it. That was the case with the Velázquez pictures. I once read a letter from Ingres to a friend in which he said he'd finally come to understand the technique of the Venetians and of Velázquez because English painters had told him, among other things, that they were painted on unprimed canvas. I thought I'd see if that was correct, so I took an unprimed canvas and did one of Velázquez's paintings. This first version was very close to the original. Then I did another eleven versions, and by the end I was painting highly geometrical pictures. So I developed from virtual copies of Velázquez to paintings that were free variations, which proves that it's the style that counts.

On the other hand, it's not a good thing to become too obsessed with style, because you must express something that goes beyond it—the style should really be there already. You fight a continual battle with yourself in deciding which is more important, style or what is said by means of it. So you approach things from the one angle, then from the other. You keep on trying. If you don't have doubts every day you're lost.

Do you think that Velázquez and the other artists who have provided you with points of departure shared your notion of painting as a formal adventure?

Undoubtedly.

But surely they were more closely bound to content, circumscribed by their dependence on commissions for pictures with religious or other subjects? Weren't formal problems secondary to them?

I don't think so. If they hadn't felt this restlessness there would have been no development in art. Look at Goya, Rembrandt, or Titian. Titian, for example, started off in one way and ended up painting impressionist paintings. Why? Because he questioned, because he was unbending in his efforts to arrive at the ideal of absolute plasticity. He was trying to move us by painting alone—that's why his art developed so dramatically. An artist never does the same thing twice. You do something and then you question it.

"ART IS BEAUTY"

Aside from technical matters, do you feel an affinity with the painters of earlier centuries in terms of the culture and spirit of their times?

I should make it clear that the background of a European or an American artist is completely different from that of a Latin American one. There were no museums in Colombia when I was young. The only paintings I saw where those by Colombian Baroque artists in the churches. I never saw a Goya, Velázquez, or Titian, let alone a Picasso. The first time I saw a real painting was in Barcelona when I got off the boat coming from Colombia. I headed straight for the museum.

When Colombian children go to church they see all these Madonnas, so clean and perfect. In South America chinalike perfection is very much a part of the ideal of beauty. More so even than the polychrome wood sculptures in Spain, Latin American sculptures look like porcelain. Indians were continually employed in their making. So, in contrast to Europe or

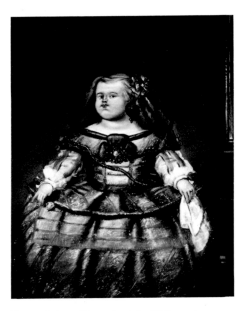

Fig. 2 *Princess Margarita (after Velázquez)*, 1977. Oil on canvas, 72½ x 61" (184 x 155 cm). Collection Joachim Jean Aberbach, New York

North America, you connect the notions of art and beauty at a very early age. I grew up with the idea that art is beauty. All my life I've been trying to produce art that's beautiful, to discover all the elements that go to make up visual perfection. When you come from my background you can't be spoilt by beauty, because you've never really seen it. If you're born in Paris, say, you can see art everywhere, so by the time you come to create art yourself you're spoilt—you're tired of beauty as such and want to do something else. With me it was quite different. I wasn't tired of beauty; I was hungering for it.

Does that mean that your imperviousness to pure abstraction when you came to Europe was connected with the fact that Colombia is about one hundred years behind Europe in its artistic development?

It's more like five hundred years! If I'd been born in Paris, in Germany, or in Spain I'm sure I wouldn't paint the way I do. On the other hand, we're at an advantage because, not possessing anything ourselves, we have a panoramic view of all cultures. If you come from a country with a strong culture you are so dominated by that culture that you can't view the cultures of other countries with anything like objectivity. But if your native country has no cultural tradition then, in a way, the culture of the entire world belongs to you. It's good to be able to pick and choose from cultures at will.

But Colombia does have a cultural tradition—the colonial and folk art known as pre-Columbian.

It's a very weak tradition and, although we make tremendous efforts to do so, there's really very little to be extracted from it. I've always been keenly interested in our culture, and a genuine Indian cultural heritage does exist. Take colonial art. In colonial times the Church brought engravings of paintings by Zurbarán and many other Spanish artists to Latin America and gave them to the Indian painters, the Creoles. They copied the engravings, but not exactly, and the considerable deviations from the originals constitute the South American component. The Indians have continued this tradition down to the present day. I love the colonial and folk art of Latin America and try to incorporate elements from it in my work. This art was part of my childhood, but I'm well aware that ours is an extremely poor artistic tradition. We are desperately trying to escape from this poverty, and one way of doing so is to adopt things from elsewhere. Nevertheless, the fact that I

was born in South America has quite naturally stamped itself on my work.

The proportion of clerics in the population of Colombia is greater than anywhere else in the world. In no other country are there so many bishops, nuns, monks...

Colombia is the most Spanish country in Latin America. Spanish traditions have been preserved there longer than elsewhere, for geographical reasons. Whereas most capital cities in South America are ports, Bogotá, the capital of Colombia, is in the interior. Until thirty or forty years ago it took eight days to reach by boat from the coast. My home town, Medellín, lies in a mountain valley, very isolated. I didn't see the sea until I was thirteen years old, and it took me eight days in a boat to get to it. With such bad communications it's easy to understand why Spanish traditions have been so long-lived in the Colombian valleys. One of the most beautiful towns in the country is Villa de Leva. It's unlike any present-day Spanish town because time seems to have stood still there since the eighteenth century. It, too, lies in a mountain valley, and the first road to it wasn't opened until about twenty-five years ago. It's incomparably beautiful, and more purely Spanish than anything in Spain.

"HOW CAN YOU PAINT ABSTRACT PICTURES IF YOU HAVE TO RIDE A HORSE ALL THE TIME?"

When it's said that you turn to the past for inspiration, then in a sense that's not true, for, to you, the past was for a long time the present. Having grown up in the Baroque, as it were, your position is not really that of a twentieth-century painter referring back to seventeenth-century motifs and techniques because, for a Colombian artist, the two are much closer than that.

In a way, yes. We were very backward. Our mentality was completely different. We lived in isolation. Of course, I'm not saying that we didn't have any books—we did! But geographical factors are immensely important. The Andes are one long chain of mountains, running from Patagonia to Colombia. Between the Andes and the sea lie the valleys of Chile and Peru. These countries are open to the world; they're not separated from it by mountains. When the Andes reach Colombia they divide into three, creating valleys and plateaus. And that's where the towns are—isolated. For instance, going from Bogotá to Medellín takes twenty minutes by plane, but if

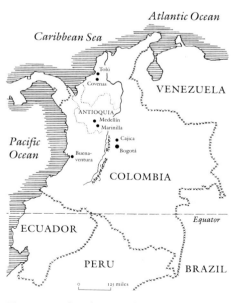

Fig. 3 Map of northern South America

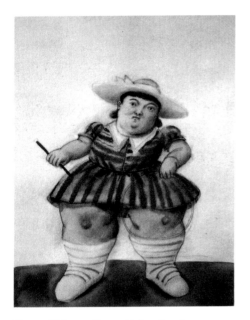

Fig. 4 *Girl*, 1990. Pen and ink and wash on paper, 19 x 14¼" (48 x 36 cm)

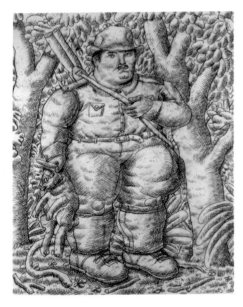

Fig. 5 *The Hunter*, 1987.
Black chalk on paper, 23½ x 18" (60 x 46 cm)

you go by car it takes twelve hours because you have to cross the Andes. They make communications very difficult. And roads were expensive to build. When I was a child, the roads went about twenty miles out of town and then you had to get on a horse. I'll always remember seeing the horses at these points. How can you paint abstract pictures if you have to ride a horse all the time?

Traveling from Colombia to New York, Paris, and Tuscany—places where you have studios—must have been like journeying from the Middle Ages into the twentieth century.

I left Colombia when I was nineteen. At that age, you're already the way you are and don't really change later. The first twenty years of your life mark you in a very special way. You have to be honest with yourself; you cannot pretend to be "one of the boys," like some artists I know who moved to New York from Colombia or other South American countries. They forgot—or tried to forget—who they were, and acted like Americans. It's not a good thing to ape what other people are doing, to deny your identity. Art, too, must have roots, has to be honest. It's better to be a peasant in Colombia than a fake American.

Another important point in this regard is that Latin Americans are extremely wary of cultural imperialism. We are most anxious to retain our identity. We need that identity. Latin America doesn't want to belong to either the USA or Europe, to be a cultural colony. It's up to our writers and artists to create images that mean something to the people of Latin America, that they recognize as theirs and theirs alone. It is most gratifying to me to find my work appreciated at all levels of Colombian society. It's incredible—even the peasants know about my work. Some years ago a large paper manufacturer produced a calendar with reproductions of my work, and people framed the pictures and hung them in their homes. That was a source of immense satisfaction to me. They don't frame Picassos. His pictures may be a thousand times better than mine, but Colombians don't *feel* them. My paintings they understand. You have a responsibility toward your country, too.

Artists of all kinds have to say things that everybody would like to say but cannot express. I have the capacity to paint pictures, so it's up to me to say those things, and not to copy the Americans or the French to produce fake American or French paintings. I must paint Colombian pictures. And the strange thing is that these impress people in France, Germany, Japan, and elsewhere. In a sense, the more parochial you are, the more universal you can become. Art has always been paro-

chial in origin. Think of the Impressionist movement. It didn't even emerge from a whole town; it emerged from a neighborhood, from the tiny, insignificant district of Montmartre. But it achieved universality. Of course, it's easier to have a sense of universality in a culture that encompasses many countries, but I think the Third World should take advantage of the opportunity of being universal within its own culture. Many artists fancy that universal art is produced by copying universally. I don't believe that. You must be true to your roots; only then can you reach people all over the world.

So you think that your painting can help the people of Colombia to acquire a cultural identity?

I hope so. I'm the most Colombian of Colombian artists, even though I've been out of the country for such a long time. I've remained more Colombian than the painters who actually live in Colombia, because many of these try to follow international fashions in art. If you want to create things that really mean something to your people, you must first be honest with the medium of paint and then with yourself.

If your paintings are so inherently Colombian, what sense do you think they make to a New Yorker or a Parisian?

That's impossible for me to say, but the fact that my work is collected all over the world—in South Africa, in Tokyo, in Germany, France, and the USA—means that people in these countries must sense truth in my paintings without actually knowing Colombia.

But I must emphasize that this has nothing to do with picturesqueness: I never do "typical" things suitable for tourists. If you go to Colombia with my paintings you'll see that they differ from the country. They're not illustrations. There was once a Colombian artist whom people thought wonderful; in his pictures he'd really captured the colors of the landscape, they said, but it would never have occurred to them to compare the two! I paint Colombia the way I want it to be. It's an imaginary Colombia—like Colombia but, at the same time, not like it. I give expression to my desire for things that are there but hidden, obscured in part by the highways, skyscrapers, and so forth to be seen in the country today. It's a kind of nostalgia, but if you look closely you can see the things I'm talking about. That's the case with all art. You do things the way you'd like them to be: you write the book you'd want to read, you paint the picture you'd like to look at.

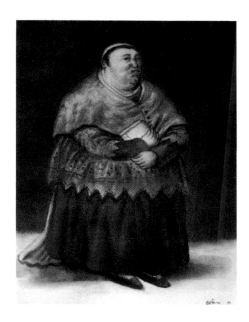

Fig. 6 *Bishop*, 1990.
Pencil, pen and
ink, and wash on paper,
16¼ x 11¾"
(41 x 30 cm)

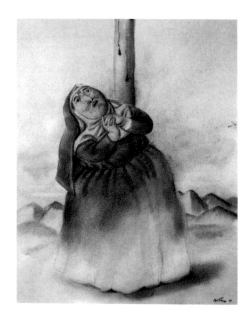

Fig. 7 *Mater Dolorosa*, 1990.
Pencil, pen and ink, and wash
on paper, 19 x 14¼" (48 x 36 cm)

"A BISHOP . . . A WONDERFUL SIGHT!"

Looking at all the clerics in your paintings—bishops as a still life, bishops bathing in the river, bishops on the way to Councils—one gets the impression that your intentions are satirical. Is Dead Bishops *[plate 4], for example, a political image?*

I started painting bishops because they provide an artist with wonderful coloristic and formal opportunities. There's nothing less attractive to paint than contemporary dress. In the Quattrocento, say, things were quite different: people had one leg red, one green. There was a wealth of bold color which virtually painted itself: you just took your brush and reproduced the colors. Nowadays, everything is gray and monotonous. To then see a bishop in his red vestments—that's a wonderful sight! That's abundance! So I became interested in bishops because they gave me a chance to use red. That allowed me greater freedom in the deployment of color—but I didn't want to become a Fauvist painter, since that had been done already. The various extravagant vestments of bishops and priests offer marvelous coloristic possibilities. All these vestments were introduced in the Renaissance but, because it would be false to depict Renaissance people today, you paint a bishop and have a Renaissance figure in the world of today. That's why I turned to the clergy as subject matter.

Of course, there's an element of satire as well, because the Church has always been very powerful in Colombia and has done a lot of harm. As a result, in recent years there's been widespread criticism of the Church in Colombia, especially among artists, writers, and the like. Nowadays, the Church is less important than it was in my childhood. At that time it was overpowering, occupying not only the churches but the streets as well. I remember the funeral procession of one of our most important bishops, his body dressed in red on the catafalque and accompanied by hundreds of priests on its progress through the town. Today, when a bishop dies, the ceremony takes place in the church and that's the end of it. It's barely noticed.

And then there was the partisan role of the Church in the political violence in Colombia in the Forties and Fifties, when it supported the conservatives and preached against the liberals. It gave the peasants the feeling that they could do anything in God's name, even kill His enemies—and they were reckoned to be everyone except the conservatives. The liberals were not even left-wing; they were a party of the center. Some 300,000 people—mostly liberals—lost their lives in the course of those disturbances. This open intervention of the Church in politics caused it to lose much of its influence. The peasants realized that something dreadful had happened.

More recently, the priests have adopted the opposite political stance. Some cabinet ministers have been clergymen. One of Colombia's most famous guerillas, Camillo Torres, was a priest who taught at the university and also fought in the hills, where he was shot. Several other priests have fought alongside the guerillas. So the situation has changed completely. Earlier there was civil war with no ideological basis; now the guerillas are Marxists. Well, that's their problem. Anyway, the satirical element in my paintings stemmed from a feeling of revulsion toward the attitude of the Church at that time.

"THERE'S LOVE IN EVERY BRUSHSTROKE"

In this particular case, then, your paintings do convey a specific message, are not concerned solely with formal problems?

Well, I can't deny that, in some of them, I started out from an idea. When I painted *Official Portrait of the Military Junta* [plate 10] ten dictators were in power in South America, which almost amounted to an invitation to do a painting of that kind. Also, when I was young I was far more politically motivated than I am now. Today, I tend to be skeptical, more aloof in such matters. But twenty-five to

thirty years ago I was more involved. Even when living in New York, I was highly involved, and the paintings I did give expression to my feelings at the time.

Does Dead Bishops *express hatred?*

No. There's never real hate in my work. Of course, my intention was satirical. Ideas pass through your mind and you grab them, but when you're painting you virtually forget them. I didn't say to myself, brush in hand: "I'm going to put paid to these guys."

So you don't see your paintings as propaganda?

Quite the opposite. When you paint, you have to caress, be gentle with the colors. It's somehow an act of love. Painting turns hatred into love, so when I paint a dictator, I finish up almost loving him! It's quite unlike Orozco, the Mexican painter who painted political pictures: in every brushstroke of his there was hate. With me, it's the other way round: there's love in every brushstroke.

Fig. 8 *Still Life with Watermelon*, 1976-77.
Bronze, 60 x 74 x 43″ (152 x 188 x 109 cm).
Private collection

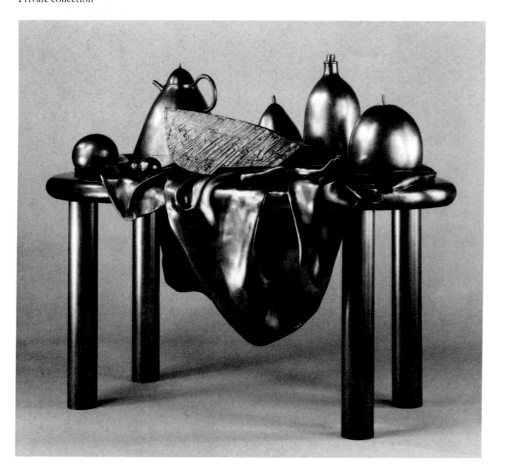

Are all the figures you paint imbued with this love?

Yes. The first idea for a picture is usually satirical, but that soon disappears—it becomes love, becomes a painting. From the moment I start painting it, a picture becomes a still life for me. To me, every painting is a still life.

Even figure paintings?

Yes, because a face becomes like an apple. I've no metaphysical message to convey. I simply want to be a painter, and I see my subjects as a painter, not as a commentator or philosopher or psychoanalyst. I've no desire to express profound thoughts about the world or about life in general. I want to paint as though I were always painting fruit. You know, Cézanne used to say to his wife when she was sitting for him: "Just sit there as though you were an apple." That's the way. And when you look at a Cézanne you don't wonder about what he was thinking at the time; you see fruit, you see a painting. That's the correct approach. I don't trust painters who emphasize expression so much that you see only expression and not the painting. In their work a facial expression is sometimes so exaggerated that you don't see the actual painting. In a painting you must be able to see everything, not just a facial expression.

What's your attitude to abstract painting— Abstract Expressionism, for example?

Abstract Expressionism was a very important movement. I admire very much its handling of paint, the brushstrokes. I liked it so much at the time that, in some of the paintings I did in New York, I tried to employ similarly free brushstrokes. In a way, that was wrong, because it contradicted what I was trying to say. But these things happen—you don't alter your basic ideas, but the "skin" of your work changes as a result of influences. Abstract Expressionist paintings were most important at the time; now they seem less so. For instance, I was very disappointed when I saw the de Kooning exhibition some years ago at the Whitney Museum in New York. I was in New York during the heyday of Abstract Expressionism and, in fact, knew de Kooning well. He was something of a god to me: I was so deeply impressed by his work. Then I saw the exhibition, and it was so poor. Spiritual expression was lacking—you saw only the act of painting. A painting should be a mixture of spiritual expression and the act of painting. If you don't have both, your work will become stale within a few years. I was really disappointed with that exhibition.

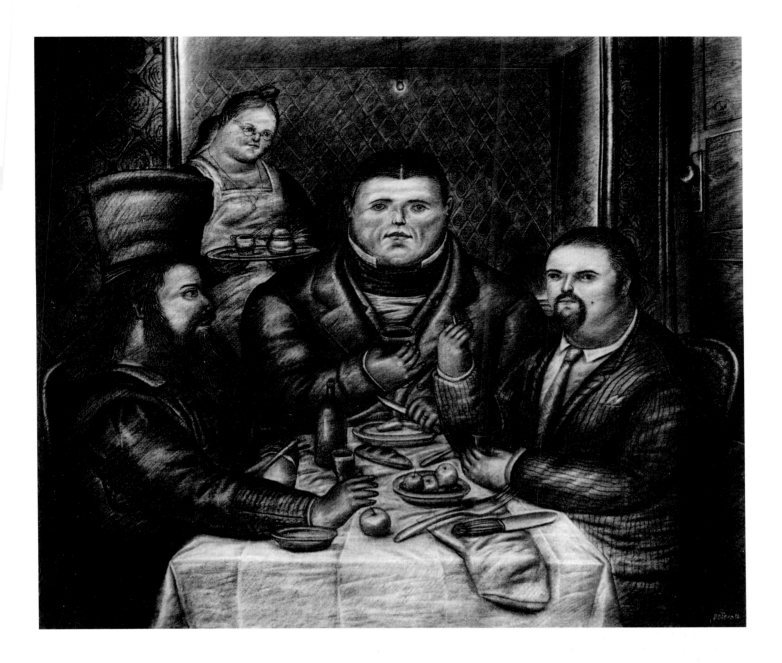

Fig. 9 *Supper with Ingres and Piero della Francesca*, 1972. Charcoal on canvas, 65½ x 76″ (166.5 x 193 cm). Collection Aberbach Fine Art, New York

"THE FEELING OF PLASTICITY IS AWAKENED IN THE BEHOLDER"

You've given many interviews, and in all of them have been asked about the voluminosity of the figures in your pictures. Does this corpulence express the mental or spiritual state of the people depicted? I'm convinced you'll tell me that it's a formal problem!

Every interviewer has to ask that question. It can't be avoided because it touches on something absolutely central. An artist is attracted to certain kinds of form without knowing why. You adopt a position intuitively; only later do you attempt to rationalize, or even justify, it. I'm attracted to painters of the Trecento and Quattrocento—Giotto, Masaccio, Uccello, Piero della Francesca—and to such later artists as Rubens and Ingres. They all depict figures of a certain fullness; they paint what is referred to as "fat people." You're attracted instinctively to a certain kind of art and your work takes a similar direction. Then you start reading books. Bernard Berenson's *Italian Painters of the Renaissance*, for instance, helped me a lot, because he proposes a scale of values in art based on the capacity to produce what he calls "tactile values." He's right when he says, for example, that composition and color had existed for centuries, but that it was Giotto who lent them three-dimensionality.

Fig. 10 *Homage to Canova*, 1989. Bronze, 23¼ x 15¾ x 20" (59 x 40 x 51 cm)

Giotto gave the viewer the feeling that he or she could touch the things in his paintings. He created a genuine sense of space in his images and thus, in a way, initiated what we now call the Italian Renaissance. If you look at the mosaics in the Baptistery in Florence you see that Berenson was right: the compositions are those used by Giotto, but he imbued them with tactile values.

Berenson attached great importance to the ability to create volume and space. Reading his book confirmed in rational terms the things I'd felt instinctively. I realized the importance of plastic values. The book came as a revelation to me, but it described in words something that had already existed inside me.

That's surely one reason why the whole notion of "influence," so beloved of art-historical writing, is questionable. It tends to relegate the artist to a passive role, underestimating the strength of his or her individual creative impulses.

Exactly. Berenson said—and he's right—that volume is important and that it stands for voluptuousness and sensuality. And this stirs something inside the viewer: the feeling of plasticity is awakened in the beholder. Of course, there are other aspects too—the spiritual dimension, for example—but from the point of view of painting the most important thing is to create volumes that are tactile.

Giotto's three-dimensionality is, however, a long way from your plastic voluminosity.

Maybe, but the fact is that "fat" art has always been the most important art. Look at Greek art—it's at its greatest in the fifth century,

Fig. 11 *Torso*, 1981. Bronze, 43 x 31½ x 19½" (109 x 80 x 49.5 cm). Private collection

when its figures are most voluminous. Art always reaches a certain point and then becomes elegant, stylized, and repetitious. With Phidias, Greek art entered its "fattest" phase.

Why Phidias? Surely he's the prime representative of the classical canon of proportion? Greek figures tend to possess greater fullness in the fourth century.

Yes, but Phidias' forms are very round. In the fourth or fifth century Greek art was more stylized; thereafter it became increasingly elegant. It's the same in all the various phases of Egyptian art. The classical phase, the moment of full maturity, always has greater fullness.

Does fullness of body correspond, for you, to richness of mind and spirit?

I can only explain why I think this kind of art is effective, but not what it was that attracted me to it in the first place. That's intuition. I can't say why I chose this particular art, why I work differently from Giacometti.

"I WANT TO PAINT PEOPLE AS STILL LIFES"

To me, the people in your pictures look rather foolish. They gawk . . .

That's right.

Here, you certainly ignore classical ideals of beauty.

It's the same as Cézanne wanting his wife to sit for him like an apple. I don't want the people in my paintings to look particularly intelligent. Neither do I want them to look at the viewer—they gaze into empty space. If you look at a person you never really see the person, just the eyes. If you want to view the whole person you have to ask him or her to close their eyes, because the attraction of the eyes is so strong that you see nothing else. The first thing I do when I paint a portrait is to say: "Close your eyes. I'll tell you when I'm finished." Only then can I perceive the figure, the mass of forms, the volumes. Otherwise, I see only the mind of the sitter and many other nonpictorial things. That's why I try to give the impression that the people in my pictures are looking into empty space—just as they do in Egyptian art, by the way. Egyptian figures don't look at the viewer; they don't look at anything, which I find wonderful.

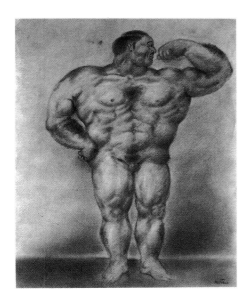

Fig. 12 *Man*, 1982. Red chalk on paper, 17¾ x 13" (45 x 33 cm)

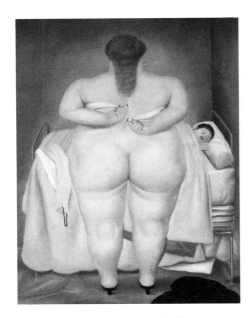

Fig. 13 *Woman Unfastening her Brassière*, 1976. Oil on canvas, 97¼ x 76¾" (247 x 195 cm). Museo Nacional, Caracas

They look into eternity.

Into eternity or into nothingness. It depends. If it's Egyptian art you say they look into eternity; if it's mine you say they look foolish!

In museums the guides often say: "Look, it's marvelous; the eyes in this painting follow you about." I don't like pictures that look at me all the time! I want figures to gaze into emptiness. I want to paint people as still lifes, not to give them an intellectual dimension. In painting I find figures that don't think more interesting than ones that do. Incidentally, the people in Giotto's pictures don't look that intelligent either.

Most painters have a face that they paint all the time. All Giotto's women have the same kind of face, and his men have a woman's face with a beard. Why? Because for him people were just elements in a composition. It's the same with me—I need forms, not people, in my pictures. I don't want to distract attention from the painting. If a picture requires a small form I put in a small person—or a chair. That's where the experience of abstraction comes in: I add a form that can be anything in terms of content—which can lead to disturbing results, I know. Or take Rubens. The women in his paintings are always the same woman, the men always the same man. Most painters do that. Brueghel, Rubens, Giotto—they all did the same thing.

This leads me to something that I particularly wanted to ask you about: the relationship between man and woman in your paintings. In one picture [Fig. 13] a woman, filling almost the entire picture plane, is undressing, while in the background a tiny man lies fast asleep in bed. Can you tell me why he doesn't even acknowledge the woman's presence?

Things like that come at the last moment. You don't have them in your mind when you start a composition. In the painting you mention, I wanted to paint a nude figure seen from behind and undressing. That's all I knew when I began. While I was painting the figure, I realized I had to balance it with something else. In a landscape you can take a river, but in a room . . . Problems like this crop up during the act of painting. Then, the colors I'm applying to the canvas demand further colors. Painting green gave me the idea of a bed cover, but it wasn't until the last minute that I decided to put a little man in the bed.

But that doesn't explain why he's asleep, impervious to the woman.

Dubuffet used to say that in every painting a small miracle occurs at the end which makes it

work. And that's so true. You start painting and have to be prepared for surprises—and you can't be if you've got the painting complete in your mind from the outset. You put in a color, a figure, or another element, or you remove one—and deciding not to put something in is tantamount to removing it.

Do you start painting by drawing the motifs on the canvas?

My point of departure is naturally a sketch, which I transfer to the canvas. And then I begin to paint, knowing very little about the picture. I'm usually clear in my mind about the central part, but not about the colors. I have to decide on the colors, and it's they that direct the course of painting. I just follow the colors. I apply them to the canvas and they suggest motifs to me; I interpret them in terms of reality. If I need green in a painting, I can put in a mountain or a bed with a green cover or a table—it depends. I simply follow the suggestions made by the colors. If you're an abstract painter you can add, say, red wherever you wish. It's the same for a figurative painter initially, but then you have to find an object appropriate to the color. That's why I require freedom in matters of proportion: I must be able to put in small or large forms in order to follow the colors the way an abstract painter does. I can add the same red as an abstractionist, but I have to find an object that fits it.

Do you have a standard object that you use when faced with a seemingly insoluble compositional dilemma?

Snakes. Snakes are lovely creatures! . . . Having to find something that fits in representational terms forces you to discover surprising things. People sometimes ask me how I got a particular idea. Well, I was forced to get it. It's like having a gun pointed at your head: "Think of something to put there!" The procedure is the same as in abstract painting. Once you've started, you have to continue. It's like being in a subway: you can't get out; you have to carry on to the end.

Does it ever happen that a painting turns out so completely differently from your initial concept that you're forced to relinquish that concept?

No, never. When you start, you're clear in your mind about perhaps twenty percent of the painting. In a way you know everything about it without knowing anything, because you know what you're going to paint but not where it's going to lead you. You just get on

Fig. 14 *Pedro*, 1980.
Pen and ink and wash
on paper, 17 x 12½" (43 x 32 cm)

the train and let it take you. The rules, or logic, of painting oblige you to do certain things. You have to follow without preconceived ideas.

Let me give you an example of what I mean. A few years ago I went to a Picasso exhibition and saw this wonderful blue – deep ultramarine blue with just a touch of white. Now, I'd banished ultramarine from my palette twenty-five years before. I'd always used cobalt blue because it's cooler. By mixing it with a little red you can arrive at a color similar to ultramarine. From red you can't go to green, but you can go from green to red: if you add red to green it becomes red. But you cannot take the red out of ultramarine. That's why I like cobalt blue. Anyway, I was so in love with Picasso's blue that I wanted to use ultramarine again; I couldn't wait to put it in my pictures. I did so, and the results were catastrophic. I had to remove all the blue. Everything became so complicated; I had to change this, I had to change that, and so on.

And all because I didn't follow my natural path, but had this preconceived idea of using ultramarine. It's far better not to know anything about the colors you're going to use.

Your pictures show an intact world: families, children, toys – snakes! – all coexist in the kind of perfect harmony that one associates with naive art.

There's a difference between naive painting and mine. The naive painter works in the way he does because his knowledge is limited. His world of images consists exclusively of what he sees, and his technique is so elementary that the results are genuinely naive. In other kinds of painting the artist knows exactly what he's doing. The fact that he or she happens to do figurative pictures doesn't mean that these are naive. My subject matter is naive – that kind of paradisiac reality is naive – but my approach to it is governed by a high degree of consciousness.

FERNANDO BOTERO

Six
Short Stories

"The Painter and his Delicious Model" was pub-
lished in the Colombian newspaper *El Tiempo* in
1980. That year the newspaper's Sunday supple-
ment, *Lecturas Dominicales,* printed "The Seduction
by the Guardian Angel," "Snake," "Life is a Dream,"
and "The Death of the Holy Ghost." "Baby" was
first published, in German translation, in the
catalogue of the Botero exhibition held in Munich
in 1986.

Baby

From the beginning everything seemed to indicate that this baby would not be like the rest. To start with, his mother never noticed that she was pregnant, since her figure seemed to diminish rather than expand as the months went by. Only, one fine day she woke up to find the tiniest baby imaginable lying between the sheets. They called him León María, though in no way did the name correspond to the tiny creature's real size.

The unexpected birth caused great commotion in the Rada family—and natural concern, since the baby hardly grew at all during his first months. The parents tried every conceivable means of stimulating his development, including the care of a well-known wet nurse, who had nursed all the children born in Maranilla over the past thirty years and many of the adults; but nothing seemed to be able to cure the fierce anemia and underdevelopment from which the child suffered.

Given the extremity of the situation, the Radas decided that the mother, Doña Amelia, should take León María, who was now a year old, to Medellín to see Doctor Mejía Escobar, the famous pediatrician of Antioquía, who had completed his medical studies in Hamburg. The instructions for the salve that the pediatrician prescribed were written in German, and the mother, in an understandable mistake, gave the child the medicine with a spoon, sweetening it with the sugar syrup that León María was given every night.

At three in the morning they heard the first noises, when the railings on Leoncito's crib broke. This was followed by a louder blow, as the crib itself collapsed on the floor. The anxious parents rushed to the baby's room and found the child sitting on the floor growing at an extraordinary rate and occupying almost all the space in his little room. Mr. and Mrs. Rada, distraught and powerless, watched in amazement as the child grew and grew, all the while crying inconsolably as a result of the intense hunger that his sudden growth had produced.

By dawn his parents could stand the anguish no longer. Seeing that the baby was unable to move and that he could scarcely breathe, since each time he inhaled he seemed to swallow all the air in the house, they decided to call the firemen, who arrived shortly

after amidst a great blast of sirens. They immediately proceeded to tear down the wall between the living room and the baby's room so that he could move his numb arms. But León María only increased in size the more space he had. So, one after another, all the walls were torn down until the whole house was just one big room, which the baby filled entirely—he even had to keep his head bent over his shoulder so as not to hit the beams of the ceiling.

At eleven in the morning, when he tried to change the position of his legs, his little foot broke a hole through one of the side walls and his whole leg stretched out into the yard, ruining the rose garden that Doña Amelia had so lovingly planted. The house now took on a strange appearance. An enormous leg stuck out from one of its sides and grew before the gaze of a crowd of onlookers who had gathered there since the morning: they watched incredulously as the strange phenomenon developed before their very eyes.

At noon the firemen gave the order to evacuate the area because dangerous cracks had formed in the structure of the house, which with each hour became less capable of containing the enormous body inside. The police took their clubs to the crowd, which refused to disperse. A minute later, the house fell down with an enormous crash. The child's head and shoulders emerged from a veritable shower of rooftiles and beams, which the pressure inside caused to split like matches. People ran in all directions, while the extraordinary baby, howling in the midst of the rubble, finally found space to stretch his stiff limbs.

On hearing the news, the Egred Brothers, owners of the circus that was in town at the time, ran to the scene and offered to buy the baby from its grief-stricken parents who, lost in the crowd, watched León María from a distance as he grew and grew relentlessly. Mr. and Mrs. Rada accepted the proposition right away, happy to have found a more suitable home for their little son. With a feeling of great relief, they handed over the responsibility for their child to the circus owners, who seemed to have more experience in situations like this.

Leoncito's move with the circus to the port from which they were to embark on their yearly tour through the West Indies was extremely difficult, not least because of the great crowds that amassed to get a look at the child in each town he passed through and because he did not stop growing. A diet limited to great quantities of bananas and oranges, which were carried in several trucks, seemed to be the only thing that could stop his miserable cries.

The ship set off from Turbo, but it never reached its destination. Some travelers later recounted that they had seemed to see an enormous child in the middle of the ocean, playing with a little boat. But they took it for one of those visions induced by the strong tropical sun.

The Seduction by the Guardian Angel

It can generally be said that angels have bad taste. They dress in pink nightshirts, wear yellow stockings and little black boots, read Father Astete's catechism, and do not remove their scapular even to take a bath. Only a being this odd could have fallen madly in love with Doloritas Trujillo, ugly as she was. Short and chubby, the poor little woman lived with her parents in an old house by the San Benito Church in the village of Candelaria. Her days occupied in household chores and in the delicate embroideries that her small hands plied, her only joy in life was looking after a family of cats—her one great love.

Her shiny black hair fell across her shoulders in a cascade of curls. A big violet bow stood out sharply against the ashen tone of her skin and the indefinite blue of her eyes. Her mouth, which punctuated her face like a little round dot, was fiery carmine. In her slow passage from room to room, her body swayed between soft crepes and fine laces, which rustled to the cadence of her small feet.

The delicacy of her lacework, the meticulousness with which she stitched, gradually gave Doloritas a constant squint, and this affected her sight, multiplying the inventory of the thousand things that surrounded her in daily life. At first, her world was doubled. She saw two fathers and two mothers, two houses and two sets of cats following her eagerly all over the place. But as time went on, her problem got worse, so that she ended up seeing three of everything. It was then that she understood the third dimension in space and the rule of three; and it was then that she discovered the guardian angel, that imperceptible shadow which only certain very subtle, cross-eyed people can fix in their glance.

Her guardian angel was enormous, and quite a well-formed young man. With his large wings always outspread, he chased her from room to room, through courtyards and down corridors, spilling vases, breaking dishes, and out into the garden, scattering pollen from the roses and carnations. At night, since his divine mission was to keep her company and the bed was small, the angel got into the habit of taking off his wings before he turned off the light, folding them carefully over the clothes rack in the corner. The room then filled with the soft strains of organ music. It is not surprising, then, that little by little Doloritas came to look on him more as a man than as an angel. She called him Joaquín.

And so they spent their days and marvelous nights playing with that genius for games which only celestial beings possess. Pillow fights, hide-and-seek between quilts and coverlets, and playing doctor—that was Joaquín's favorite—continued long into the morning. And nobody could figure out what had happened to Doloritas, who now lived in a sleepy daze, absorbed in thought as though in the haze of a dream, possessed by such great happiness.

The consequences were as to be expected, and soon Doloritas was getting all sorts of headaches and dizzy spells, especially with Joaquín's wings flapping all around her and the hum of organ chords constantly ringing in her ears. Months later her parents, disgraced in the neighborhood and not suspecting that the origins of the creature could have anything to do with angels and cherubs, sadly asked their daughter to leave the modest home where she had lived for so many years. Joaquín eagerly set himself to carrying suitcases, with all the grace and ease angels have for any kind of movement. Together in the taxi, they headed for Envigado, to live in the blue house behind the theater around from the square. It was there that, soon afterward, Jesus María was born, who later became Bishop and then Pope, the first Colombian Pope, the same whom posterity would venerate as Jairo I.

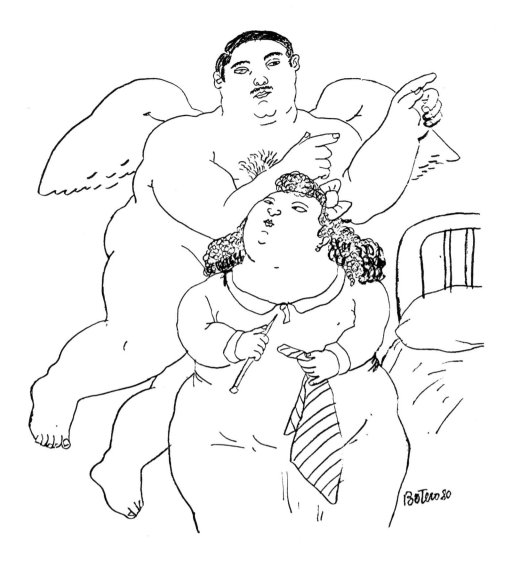

Time has passed and Doloritas still lives in Envigado. She is very old now and has even had to stop her embroidery work. Joaquín, on the other hand, has not changed a bit. He continues in the old house, every day becoming more dissipated and careless. He does not even bother to put on his wings. His taste has improved. He has forgotten all about Doloritas, the pink nightshirt, the yellow stockings, and the little black boots. Now he is the new maid's guardian angel, and every day the house is filled with the music of his bewitching organ.

Snake

As he was about to chop down a leafy tree near his home in the region of Turbo, the peasant Isidro Pinilla was attacked by a gigantic snake that had been hiding in the foliage. With a single bite, the ravenous animal gulped down the lower extremities of the unfortunate Pinilla, who shouted in terror and fought desperately against the horrible animal, striking it with his machete without succeeding in freeing himself from its deadly embrace. When he had just about disappeared altogether into the ferocious beast's mouth, his wife, Alcira, hearing his anguished screams, ran to his aid, beating the animal on its head and body with a broom that she had just been sweeping the house with. The enraged snake coiled itself around her body, which changed from one color to another before the terrified eyes of her three little children. It gulped her down slowly until all that remained of her were two long black braids tied with green and red bows. The three children were devoured next by the hateful animal, beginning with the oldest, Carmen, seven years old, followed by the boy, Fernando, three years old, and finishing off with the little one, Ana María Pinilla, seven months old, who put up no resistance.

The reptile, having satisfied its voracious appetite, proceeded to take a long nap to digest its meal. It lay for some weeks in Mr. and Mrs. Pinilla Arango's bed. The police officers who found it there, still asleep, figured out what had happened right away, since the animal still bore the clear outlines of all the members of the family on its body. By the time reinforcements from the nearest police station arrived on the scene, the merciless reptile had disappeared, but not without having devoured the house as well, of which only the foundations remained.

These events have provoked great fear and consternation among the people of the region.

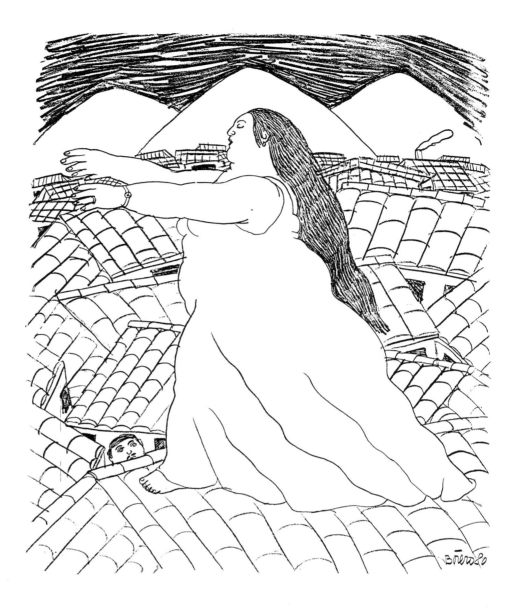

Life is a Dream

Merceditas Castrillón, like all sleepwalkers, had limp and very long hair, and all her life wore the same white, semitransparent gown she had been born in—for Merceditas was a sleepwalker from birth, and everything she did during her life she did in her sleep. The doctors who attended her mother during the difficult birth believed at first that she was blind, since she refused to open her eyes. Later they figured out what her real condition was, because of her attire and of the position of her arms, permanently held straight out in front of her. This last detail had complicated the birth considerably.

Her childhood unfolded almost as pleasantly as that of her brothers and sisters, if one excepts her long night-time excursions over rooftops and, in moments of deepest sleep, her strolls up walls and across ceilings.

Sometimes, when she was in the grip of violent nightmares, her parents would have liked to have woken her, but the doctors had warned them about the consequences of such a sudden awakening. In these moments she dreamed that she was dreaming, and reality in her dreams possessed a kind of blurred precision. On these occasions she

screamed. Then, between dreams, she calmed down, imagining that she was not dreaming but had only dreamt she was.

Once she had reached puberty, she spent long hours brushing her long hair, happily indulging her vanity and her passion for mirrors, which she never looked into but which she collected avidly.

Love came to her in her youth. What attracted her to the man who married her and later filled her with children was his manly, hoarse voice, that of a worker from Antioquía. He was a responsible and methodical man, and in their forty-three years of life together never failed in his conjugal duties and never came home without the morning paper *El Colombiano* under his arm and an avocado for lunch.

Merceditas was very religious, and in the little free time that her numerous family left her she learned to paint by ear so that she could decorate the poor missionaries' habits with pictures of the Holy Ghost. She had never seen the Holy Ghost, but she did not need to know what it looked like to paint a good likeness of it. In her old age, cataracts that had never been operated on finally left her totally blind, so that now visions were all that she saw.

Her life did not change in the least; in fact, her interest in art grew even stronger, now that her children were married and she had more free time. So she painted feverishly, imaginary landscapes of rooftops, walls, and ceilings.

One can say that she had a very happy life. Turning to her faithful husband, who was with her during her last moments, she said just before she died: "My life has really been a dream." And her arms dropped to her side.

The Death of the Holy Ghost

The hunter woke up in the dark, at the call of the first roosters. Little did he imagine that, because of him, from that day on divine wrath would be unleashed over the country. He sat up in his cot to light the candle on the bedside table and, on getting up, felt the chill of the cold floor against his feet. He looked forward to the day of hunting ahead of him. He got dressed quickly, picked up his shotgun, and went out into the countryside. The fresh dawn air awakened him. A ribbon of red earth led him toward the deep green of woods that lay in the distance. He walked a long time before he saw the first tall trees.

Now he was in the heart of the woods. Suddenly, in the midst of the silence and among the leaves, he sensed the beating of great wings and saw an enormous bird with a shining beak and wings of a special whiteness. With a single shot, whose report thundered to the ends of the earth, the hunter fired at the precious animal, hitting it in the center of its breast. As the magnificent bird fell to the ground, the earth shuddered to its core.

The sky reeled, thick dark clouds crossed the horizon, and a violent hailstorm covered the fields in white. The hunter, startled, heard bursting forth all around him the music he had heard in the Te Deums at Sonson Cathedral.

Ezequiel Correa picked up the marvelous bird, which seemed excessively heavy for its size, threw it over his shoulder, and returned home. He plucked it, seasoned it, and then, with a few potatoes and yuccas that he found in the pantry, cooked it carefully. When he ate it some hours later, he had the distinct sensation of swallowing a wax candle.

NOTE

The story alludes to political events in Colombia in the 1940s and 1950s. The liberals had come to power in the 1930s and carried out a number of reforms. In the late 1940s civil war broke out, costing over 200,000 people their lives, many of them killed by guerillas known as *pájaros* (birds). The conservatives, who won the subsequent elections, were ousted from government in 1953 by a military putsch. Further violence ensued, and ended only with the agreements reached between the liberals and the conservatives in 1957 and 1959. These foresaw a division of power, with each party taking it in turn to form a government. The color of the liberals is red, that of the conservatives blue.

Sangre Negra (Black Blood), Tiro Fijo (Sure Shot), and Tijeras (Scissors) are the names of three notorious Colombian *pájaros*.

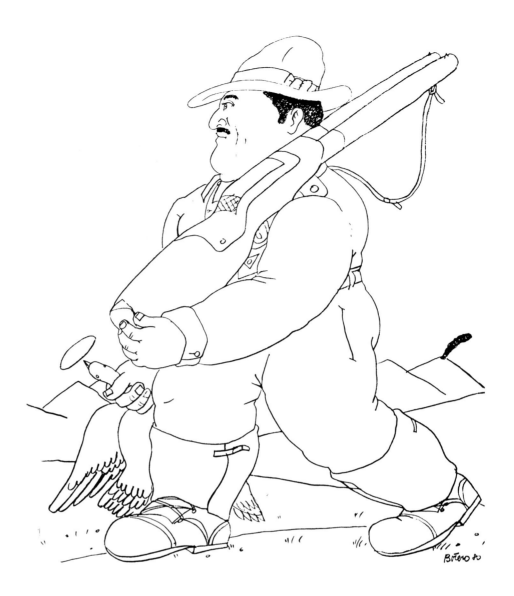

The consequences of this impromptu stew have been incommensurate and devastating. Correa died a few minutes later, belching incense and reciting the Dies Irae in a loud voice. Amparo, his wife, in the middle of the strictest mourning started to throw herself at every man she saw, and finally, dressed in red, ran off with the contortionist from the circus that happened to be in town at the time. All sorts of plagues, frosts, and tremors were unleashed over the country. Sangre Negra, Tiro Fijo, and Tijeras were born that day, when the stars in the national firmament suddenly changed position. The birds left the countryside and settled in the cities. Torrential rainstorms destroyed the orange groves and pasture grounds. The rivers overflowed, their waters rising up to the coffee plantations and even to the mountaintops. The country neglected everything but business, and calves of gold multipled throughout the villages and cities. All things lost their color and, with their color, their form. Finally, the Conservative Party won the elections. The red roads were painted blue, and the rivers dyed red.

Thirty-five years have gone by since then, and Divine Providence does not yet seem to have been appeased. Uncontrollable forces continue mercilessly to devastate this forsaken corner of the earth. The unfortunate mistake of a poor hunter changed the history of our nation.

The Painter and his Delicious Model

Luis Vélez Posada was born in Abejorral, and from an early age his sensitive soul revealed an inclination for art and the beauty of landscapes. People who knew him as a child say that in this period he painted the renowned sunsets of the region, capturing in watercolor all the subtleties of the twilight's luminous red and yellow clouds. Later he achieved remarkable results in still life. Fruits in rich, warm colors, pitchers, enormous knives and other kitchen utensils took over his imagination and became the center of his artistic concerns. Now all that remained for him to tackle was the human figure.

He often saw walking in front of his house a young woman with appetizing thighs and firm, round breasts. He thought Amparo—for that was her name—looked good enough to eat. What a great model she would be! Finally, overcoming his shyness, he managed to make friends with her and convince her, little by little, of the great service that she would be doing to art by posing for him. What a fine morsel she was!

The atmosphere of the studio could not have been more favorable. She took off her clothes slowly, while Vélez Posada's eyes literally popped out as each piece of clothing fell softly to the floor.

He made her lie down on the bed that he had in front of his easel. He took his revolver out of its case and, with steady aim, fired a shot through her heart. Then, taking out the enormous knives that he kept carefully stored away, he started cutting slices from every part of her, and, as he ate with relish, he thought that he would never find another model as delicious as Amparo.

Selected One-Man Exhibitions

1951

Bogotá, Galerías de Arte Foto-Estudio Leo Matiz. *Fernando Botero.* June 15–July 3. Twenty-five works. Catalogue.

1952

Bogotá, Galería Leo Matiz. *Botero.* May. Twenty-three works. Catalogue.

1955

Bogotá, Biblioteca Nacional de Colombia, Sala Gregorio Vásquez. *Exposición de pintura de Fernando Botero.* May 12–26. Forty works. Checklist.

1957

Mexico City, Galería Antonio Souza. *Fernando Botero of Colombia.*

Washington, D. C., Pan-American Union. *Fernando Botero of Colombia.* April 17–May 15. Thirty-one works. Catalogue.

1958

Mexico City, Galería Antonio Souza. *Fernando Botero: Oleos.* February. Twenty works. Checklist.

Washington, D. C., Gres Gallery. *Fernando Botero: Recent Oils, Watercolors, Drawings.* October 30–November 25. Catalogue.

1959

Bogotá, Biblioteca Nacional de Colombia, Sala Gregorio Vásquez. *Botero: Obras recientes.* November 5–21. Thirty works. Catalogue.

1960

Washington, D. C., Gres Gallery. *Botero.* October 15–November 12. Catalogue.

1961

Bogotá, Galería de Arte El Callejón. *Botero.* June 26–July 10. Twenty-seven works.

1962

Chicago, Gres Gallery. *Botero.* February 15–March 10. Catalogue.

New York, The Contemporaries. *Botero.* November 6–24. Catalogue.

1964

Bogotá, Galería Arte Moderno. *Fernando Botero: Bosquejos realidades.* Twenty-nine works. Checklist.

Bogotá, Museo de Arte Moderno. *Fernando Botero: Obras recientes.* March 2–31. Thirty-three works.

1965

Los Angeles, Zora Gallery. *Botero: Recent Works.* April 25–May 15. Catalogue.

1966

Baden-Baden, Staatliche Kunsthalle. *Fernando Botero.* January 16–February 13. Catalogue, text by Daniel Robbins. Traveled to Munich, Galerie Buchholz.

Hanover, Galerie Brusberg. *Fernando Botero: Ölbilder und Zeichnungen.* September 13–October 20. Thirty-five works.

Milwaukee Art Center. *Fernando Botero: Recent Works.* December 1–January 15, 1967. Twenty-four works. Catalogue, foreword by Tracy Atkinson.

1968

Madrid, Galería Juana Mordó. *Botero.* February 5–24. Catalogue.

Munich, Galerie Buchholz. *Botero.* May 7–31. Twenty-one works. Catalogue, introduction by Ernst Wuthenow.

1969

New York, Center for Inter-American Relations. *Fernando Botero.* March 27–May 7. Twenty-two works. Catalogue, foreword by Stanton L. Catlin, essay by Klaus Gallwitz.

Paris, Galerie Claude Bernard. *Botero: Peintures, pastels, fusains.* September 29–November 9. Sixteen works. Catalogue, text by Fernando Arrabal.

1970

Baden-Baden, Staatliche Kunsthalle. *Fernando Botero: Bilder 1962–1969.* March 20–May 3. Seventy works. Catalogue. Traveled to Berlin, Haus am Waldsee; Düsseldorf, Städtische Kunsthalle; Hamburg, Kunstverein; and Bielefeld, Kunsthalle.

London, Hanover Gallery. *Fernando Botero.* October 6–November 20. Fifteen works. Catalogue.

Munich, Galerie Buchholz. *Botero.* March 20–May 3. Catalogue, texts by Tracy Atkinson, Klaus Gallwitz, and Alvaro Mutis.

1972

Munich, Galerie Buchholz. *Botero: Bleistiftzeichnungen, Sepiazeichnungen, Aquarelle.* September 20–October 28. Forty-three works. Catalogue.

New York, Marlborough Gallery. *Fernando Botero.* February 5–29. Twenty-five works.

Catalogue, interview with the artist by Wibke von Bonin.

Paris, Galerie Claude Bernard. *Botero: Pastels, fusains, sanguines.* November 24–January 4, 1973. Fifteen works. Catalogue, introduction by Jean Paget.

1973

Bogotá, Colegio San Carlos. *Fernando Botero: Retrospectiva 1949–1972.* January 23–27. Thirty-two works. Catalogue, text by Tracy Atkinson.

Rome, Galleria d'Arte Marlborough. *Fernando Botero.* April 10–May 8. Seventeen works. Catalogue.

1974

Hanover, Galerie Brusberg. *Fernando Botero: Aquarelle und Zeichnungen.* January 19–February 23. Forty-four works.

Medellín, Biblioteca Pública Piloto, Sala de Arte. *Botero.* July 12–27. Catalogue, by Antonio Hernández Barrera.

Zurich, Galerie Marlborough. *Fernando Botero: Ein Kontinent unter dem Vergrösserungsglas.* October–November. Sixteen works. Catalogue.

1975

Caracas, Galeréa Adler Castillo. *Fernando Botero.* Fourteen works. Checklist.

New York, Marlborough Gallery. *Fernando Botero.* November 7–29. Forty-one works. Catalogue, introduction by Sam Hunter. Traveled to Toronto, Marlborough Godard; and Montreal, Marlborough Godard (to February).

Rotterdam, Museum Boymans-van Beuningen. *Fernando Botero.* March 27–May 19. Thirty-seven works. Catalogue, introduction by R. Hammacher-van den Brande, interview with the artist by Titia Berlage.

1976

Bogotá, Arte Independencía, Galería de Colombia. *Botero.* August. Catalogue, text by Robert Pinzón.

Caracas, Museo de Arte Contemporáneo. *Fernando Botero.* April 2–May 31. Thirty-eight works. Catalogue, introduction by Sofia Imber.

Paris, Galerie Claude Bernard. *Botero: Aquarelles et dessins.* March 18–April 28. Forty-one works. Catalogue, introduction by Severo Sarduy.

Washington, D. C., Pyramid Galleries. *Botero.* May–June. Checklist.

1977

Medellín, Museo de Arte de Medellín. *La Sala Pedro Botero.* Opening of the artist's donation to the museum, September 16. Sixteen works. Catalogue, text by Belisario Betancur.

Paris, Grand Palais. Foire International d'Art Contemporain (FIAC). *Botero: Sculptures,* organized by the Galerie Claude Bernard. October 22 – 30. Thirteen works. Checklist.

1978

Hanover, Galerie Brusberg. *Fernando Botero: Das plastische Werk.* October 15 – November 18. Thirty-two works. Catalogue, text by Ursula Bode. Traveled to Marl, Skulpturenmuseum der Stadt Marl (to December 20).

1979

Brussels, Musée d'Ixelles/Museum van Elsene. *Fernando Botero.* June 28 – September 16. Catalogue, text by Marie-Françoise Carolus-Barré. Traveled to Lund, Lunds Konsthall; and Høvikodden, Sonja Henie og Neils Onstad Stiftelser (to March 16).

Knokke le Zoute, Galerie Isy Brachot. *Fernando Botero.* May 12 – July 5. Twenty-one works.

Paris, Galerie Claude Bernard. *Fernando Botero.* November. Twenty works. Catalogue, introduction by Marc Fumaroli.

Washington, D. C., Hirshhorn Museum and Sculpture Garden. *Fernando Botero.* December 20 – March 10, 1980. Catalogue, text by Cynthia Jaffee McCabe. Traveled to Corpus Christi, Art Museum of South Texas (to May 10, 1980).

1980

Basel, Galerie Bayeler. *Botero: Aquarelles, dessins, sculptures.* October 16 – December 31. Catalogue, interview with the artist by Ernst Beyeler.

Kruishouten, Fondation Veranneman. *Fernando Botero.* May 20 – July 24. Catalogue.

New York, Marlborough Gallery. *Fernando Botero: Recent Work.* November 7 – December 2. Catalogue, introduction by Carter Ratcliff.

1981

Osaka City, Municipal Museum of Fine Arts. Catalogue.

Paris, Grand Palais. Foire International d'Art Contemporain (FIAC). *Fernando Botero.* Catalogue.

Rome, Galleria d'Arte Il Gabbiano. *Fernando Botero: Disegni e acquerelli.* Catalogue, essay by Alberto Moravia.

Tokyo, Seibu Museum of Art. Catalogue.

1982

Bogotá, Galería Quintana. Catalogue.

New York, Marlborough Gallery. *Botero: Recent Sculpture.* April 30 – May 29. Catalogue, essay by Robert Rosenblum. Traveled to Houston,

Hooks-Epstein Gallery; Chicago, Hokin Gallery; Philadelphia, Benjamin Mangel Gallery; and Boston, Thomas Segal Gallery (1983).

1983

Basel, Galerie Beyeler. *Botero: Paintings, Drawings, Watercolours.* March – April. Catalogue.

London, Marlborough Fine Art. *Botero: Recent Painting.* Catalogue.

1984

Chicago, Chicago International Art Exposition. *Fernando Botero: Sculpture.* Catalogue. Traveled to New York, Marlborough Gallery.

Ithaca, N. Y., Cornell University, Herbert F. Johnson Museum. *Drawings and Sculptures by Fernando Botero.* Catalogue.

Utica, N. Y., The Munson-Williams-Proctor Institue Museum of Art. *Botero: Sculpture.* Catalogue. Traveled to Scranton, Pennsylvania, Everhard Museum; Ithaca, N. Y., Cornell University, Herbert F. Johnson Museum of Art; and Lafayette, Indiana, Purdue University.

1985

Coral Gables, Florida, Forma. *Fernando Botero: Drawings, Posters.* Catalogue.

New York, Marlborough Gallery. *Botero: La Corrida – The Bullfight Paintings.* Catalogue, text by Marcel Paquet.

New York, Marlborough Gallery. *Botero: Large-Scale Sculpture.* Catalogue.

Puerto Rico, Museo de Ponce. Catalogue.

1986

Caracas, Museo de Arte Contemporáneo. *76 dibujos de los últimos 4 años, 1980 – 1985.* Catalogue, text by Simon Alberto Consalvi.

Munich, Kunsthalle der Hypo-Kulturstiftung. *Fernando Botero: Bilder, Zeichnungen, Skulpturen.* July 4 – September 7. Catalogue, essays by Werner Spies, Mario Vargas Llosa, Alberto Moravia, and Edward J. Sullivan; interview with the artist; short stories by the artist. Traveled to Bremen, Kunsthalle; Frankfurt am Main, Schirn Kunsthalle; and Madrid, Centro de Arte Reina Sofía (1987).

Albany, N. Y., Museum of Art. *Fernando Botero: Drawings.* Catalogue.

1987

Bogotá, Centro Colombo-Americano. *Botero, dibujante.* October 25 – November 25. Catalogue.

Hamburg, Galeria Levy. *Fernando Botero: Oleos, acuareles, dibujos y esculturas / Fernando Botero: Ölbilder, Aquarelle, Zeichnungen und Skulpturen.* October 23 – December 4 / January 25 – March 30, 1988. Catalogue.

Milan, Castello Sforzesca, Sala Viscontea. *Botero: La Corrida.* December 15 – January 24, 1988. Catalogue, essays by Giovanni Testori and

Leonardo Sciascia, interview with the artist by Miriam Mafai. Traveled to Naples, Castel dell'Ovo; and Palermo, Albergo delle Povere.

Tokyo, Marlborough Fine Art. Catalogue.

1988

Knokke le Zoute, Casino Knokke. Catalogue.

1989

Coro, Museo de Arte. *Botero: La Corrida – Oleos, acuareles, dibujos.* January – February. Catalogue. Traveled to Caracas, Museo de Arte Contemporáneo.

Los Angeles, International Contemporary Art Fair. *Fernando Botero.* Catalogue. Traveled to New York, Marlborough Gallery.

Mexico City, Museo Rufino Tamayo. *Botero: La Corrida – Oleos, acuareles, dibujos.* May – August. Catalogue.

1990

Kruishouten, Fondation Veranneman. Catalogue.

Martigny, Fondation Pierre Gianadda. *Botero: Peintures, dessins et sculptures.* Catalogue.

New York, Marlborough Gallery. *Botero: Recent Sculpture.* October 18 – November 24. Catalogue.

1991

Berlin, Galerie Brusberg. *Botero: Der Maler – Bilder und Zeichnungen aus 30 Jahren.* March 16 – May 11. Catalogue, essay by Ursula Bode, interview with the artist by Ernst Beyeler.

Florence, Forte di Belvedere. *Botero: Dipinti, sculture, disegni.* June 28 – September 29. Catalogue, essay by Vittorio Sgarbi.

Tokyo, Marlborough Fine Art. *Fernando Botero: Sculpture and Drawing.* October 15 – January 18, 1992. Catalogue, text in English and Japanese by Tamon Miki.

Selected Bibliography

Arciniegas, Germán. *Fernando Botero*. Madrid, 1973. English translation by Gabriela Arciniegas, New York, 1977.

Bode, Ursula. *Fernando Botero: Das plastische Werk*. Hanover, 1978.

Caballero, Bonald, and José Manuel. *Botero: The Bullfight*. New York, 1990.

Engel, Walter. *Botero*. With an essay by Eddy Torres. Bogotá, 1952. Limited edition of 350 copies.

Gallwitz, Klaus. *Botero*. Munich, 1970.

Gallwitz, Klaus. *Fernando Botero*. Stuttgart, 1976. English translation by John Gabriel, New York and London, 1976.

Jean, Cau. *Fernando Botero: La Corrida*. Paris, 1991.

Jouvet, Jean. *Botero*. With an essay by Erwin Leiser. Zurich, 1983.

Paquet, Marcel. *Fernando Botero ou La Plénitude de la forme*. Paris, 1983.

Paquet, Marcel. *Botero: Philosophie de la création*. Paris, 1985.

Ratcliff, Carter. *Botero*. New York, 1980.

Restany, Pierre. *Botero*. Geneva, 1983. English translation by John Shepley, New York, 1984.

Rivero, Mario. *Botero*. Barcelona, 1973.

Soavi, Giorgio. *Botero*. Milan, 1988.

Sullivan, Edward J. *Botero: Sculpture*. New York, 1985.

Vargas Llosa, Mario. *Botero*. New York, 1985.

Vargas Llosa, Mario. *Botero: Dessins et aquarelles*. N. p., n. d. [ca. 1990].

Photograph Credits

The Palace, 1975. Diptych;
oil on canvas, 101¼ x 47¼″ (257 x 120 cm) (each).
Private collection